Cultural Studies

Theorizing Politics, Politicizing Theory

VOLUME 12 NUMBER 4 OCTOBER 1998

Special issue:
The Institutionalization of Cultural Studies

Edited by
Ted Striphas

T0347389

Editorial Statement

Cultural Studies continues to expand and flourish, in large part because the field keeps changing. Cultural studies scholars are addressing new questions and discourses, continuing to debate long-standing issues, and reinventing critical traditions. More and more universities have some formal cultural studies presence; the number of books and journals in the field is rapidly increasing. *Cultural Studies* welcomes these developments. We understand the expansion, reflexivity and internal critique of cultural studies to be both signs of its vitality and signature components of its status as a field. At the same time, cultural studies has been – and will no doubt continue to be – the subject of numerous attacks, launched from various perspectives and sites. These have to be taken seriously and answered, intellectually, institutionally and publicly. *Cultural Studies* hopes to provide a forum for response and strategic discussion.

 Cultural Studies assumes that the knowledge formations that make up the field are as historically and geographically contingent as are the determinations of any cultural practice or configuration and that the work produced within or at its permeable boundaries will be diverse. We hope not only to represent but to enhance this diversity. Consequently, we encourage submissions from various disciplinary, theoretical and geographical perspectives, and hope to reflect the wide-ranging articulations, both global and local, among historical, political, economic, cultural and everyday discourses. At the heart of these articulations are questions of community, identity, agency and change.

 We expect to publish work that is politically and strategically driven, empirically grounded, theoretically sophisticated, contextually defined and reflexive about its status, however critical, within the range of cultural studies. *Cultural Studies* is about theorizing politics and politicizing theory. How this is to be accomplished in any context remains, however, open to rigorous enquiry. As we look towards the future of the field and the journal, it is this enquiry that we especially hope to support.

Lawrence Grossberg
Della Pollock

January 1998

Advertising (UK):
Routledge Journals,
2 Park Square, Milton Park, Abingdon, Oxon, OX14 4RN

Transferred to Digital Printing 2005

Advertising (USA):
Susan Dearborn, Publisher's Communication Group
875 Massachusetts Ave., Suite 81, Cambridge MA 01239, USA
Fax: (617) 354 4804 email: sdearborn@pcgplus.com

Subscription Rates (calendar year 1999):
UK/EC individuals £30; institutions £108
North America: individuals $46; institutions $150
Rest of the world: individuals £30; institutions £108;
All rates include postage.
Subscriptions to:
Routledge Subscriptions (UK)
PO Box 362, Abingdon, Oxfordshire OX14 3WB.
Tel: (0)1235 401060 Fax: (01235) 401075

Subscriptions Department (USA and Canada)
Routledge Journals,
270 Madison Ave, New York NY 10016
Tel: (212) 216 7800 x 7822; Fax: (212) 564 7854
email: journals@routledge-ny.com

Periodicals class postage paid at Rahway, NJ

Single copies available on request.

ISSN 0950–2386

© 1998 Routledge

ISBN 0–415–18428–2

Typeset by Type Study, Scarborough

Contents

VOLUME 12 NUMBER 4 OCTOBER 1998

Special issue: The Institutionalization of Cultural Studies

Edited by Ted Striphas, UNC Chapel Hill, USA

Articles

Book review

Article

Ted Striphas

INTRODUCTION
THE LONG MARCH: CULTURAL
STUDIES AND ITS
INSTITUTIONALIZATION

THE CONVERSATION on the institutionalization of cultural studies generally proceeds from the rather guarded view that it is full of hazards and pitfalls. Stuart Hall echoes this sentiment when he states, 'the explosion of cultural studies along with other forms of critical theory in the academy represents a moment of extraordinarily profound danger' (1992: 285). But let me advance another – complementary – view, one that guides both this special issue of *Cultural Studies* and its introduction: despite this danger, possibilities still inhere in the prospect of institutionalization. Although this is by no means a grand claim, I suspect not everyone practising cultural studies would be attracted to it immediately. However, given the prospect, even the inevitability of institutionalization, danger, and perhaps more importantly, *possibility* exist alongside one another.

I begin by pointing to a gap evident in the published discourse on the institutionalization of cultural studies. Passing references to the Birmingham Centre for Contemporary Cultural Studies notwithstanding, most of the work in cultural studies tends to consider the 'question' of institutionalization with little or no reference to existing institutionalizations of cultural studies (see e.g. Green, 1996; Grossberg, 1996a; Grossberg, 1998; Grossberg *et al.*, 1992; Hall, 1992; Nelson, 1996; Rooney, 1996).[1] This 'oversight' suggests the need to examine the relationship between the meta-discourse of cultural studies and its institutional embodiments, particularly where the former and the latter seem to diverge. There is a tendency, I will argue, to privilege cultural studies' meta-discourse (i.e. what cultural studies *says* it does or should do) over its existing institutional practices. The result is that cultural studies seems to be failing perpetually, insofar as the real constraints – and possibilities – of practising cultural studies in institutions are measured against a more 'authentic' discourse that, on the surface, affords insufficient room for practices that take institutions seriously and work with/in them.

I am committed to the belief that studying the institutionalization of cultural studies must involve the study of specific institutions. Thus, the research for this

 © *Routledge 1998*

article comes from two sources: public information gathered from cultural studies centres and programmes (or programmes affiliated with cultural studies) world-wide; and interviews conducted with the directors and programme coordinators of Griffith University's Key Centre for Cultural and Media Policy (Tony Bennett), New York University's American Studies Program (Andrew Ross), Goldsmith's Department of Media Communications (David Morley), and Georgia Institute of Technology's School of Literature, Communication, and Culture (Anne Balsamo), among others.[2] Much work remains to be done documenting rigorously from the 'inside' the nuances of particular programmes, the strategies by which they have gone about institutionalizing, and how they respond to the ongoing challenges that institutionalization brings. My aim is to place the work and commitments of these centres and programmes alongside cultural studies' meta-discourse and, more specifically, some of its statements on institutionalization.

This article will explore the disjunctures between these discourses and prac-tices, with the larger goal of understanding their function. In the first section, I will argue that institutionalizing cultural studies provides an important, if over-looked mechanism by which we can begin to think about the concrete effects of the common claim that cultural studies, over and above its writing practices, involves intervention. The second section will juxtapose cultural studies' meta-discursive stress on anti- and interdisciplinarity with an emerging commitment to interdisciplinarity on the part of university administrations. I want to suggest that cultural studies' institutional practices run the risk of colluding with the uni-versity's new corporatist logic (of which interdisciplinarity often – and ironically – is a symptom), and that specifying more concrete practices at the institutional level offers a means to oppose this new logic. The third section investigates what I will call the 'performative' relationship between the meta-discourse of cultural studies and its institutional embodiments.[3] My goal is to reclaim and affirm insti-tutionally based practices of cultural studies, rather than simply underlining what on the surface appears to be their 'lack' when measured against cultural studies' meta-discourse. I conclude with some strategies for institutionalizing cultural studies.

Reinventing intervention

What I shall call the 'discourse of intervention' should be seen as poten-tially problematic, particularly in cultural studies on this side of the Atlan-tic [i.e. in the US]. Words like 'intervention' and 'interrogation' are meant to signify the cultural studies critic's serious 'oppositional' stance towards hegemonic traditions of knowledge production. . . . But . . . this discourse of intervention seems to *romanticize* the critic's academic role as sufficiently oppositional.

(Pfister, 1996: 296)

I think anybody who is into cultural studies seriously as an intellectual prac-
tice must feel, on their pulse, its ephemerality, its insubstantiality, how little
it registers, how little we've been able to change anything or get anybody
to do anything.

(Hall, 1992: 285)

One of the distinguishing, if not defining characteristics of the practice of
cultural studies is its mandate not simply to criticize, but more pointedly to inter-
vene actively in an effort to make, remake and unmake social, political and his-
torical contexts (Grossberg, 1997: 261). '[I]n virtually all traditions of cultural
studies, its practitioners see cultural studies not simply as a chronicle of social
change but as an intervention in it' (Grossberg *et al.*, 1992: 5). But at the same
time, as Pfister (1996) and Hall (1992) argue, cultural studies' claims to inter-
vention often are weak, even romantic, and hence must be measured critically.
'[P]olitical action and cultural studies are not interchangeable,' Cary Nelson
states. 'It should not be necessary to say this, but apparently it is: Cultural studies
is a set of writing practices; it is a discursive, analytic, interpretive tradition'
(1996: 278). In other words, we ought to be careful not to overestimate the
political effectivity of cultural studies, given that it is, after all, 'just' a set of
written critical practices. Or is it? Indeed, cultural studies practitioners are not
simply writers, as Cary Nelson would have it. They are also teachers, policy
makers, consultants, artists and activists. How one gauges cultural studies' inter-
ventions therefore depends on where one locates its practices, i.e. whether one
sees those practices limited to written, critical work, or whether one imagines
them extending into other areas: namely, into – and out of – institutions like the
university.

 I would like to argue that the political efficacy of cultural studies remains
underestimated when practitioners fail to notice that there exists a gap or dis-
juncture between cultural studies' ability to intervene as a set of critical writing
practices and its ability to intervene as a set of properly *institutional* practices.
The latter include: (1) its influences on cultural, media and other policy matters;
(2) its manifest political-activist involvement, often mobilized through
university-based projects; and (3) its pedagogical work, particularly in terms of
teaching future cultural producers. My sense is that specific, institutionalized
practices of cultural studies (particularly those in the university) engage in a
range of activities that could count as properly 'interventionist'.

 Cultural studies at the Key Centre for Cultural and Media Policy at Griffith
University, Australia, provides a telling case in point. Built upon Griffith's Insti-
tute for Cultural Policy Studies, the Key Centre was established in 1995 through
the financial support of the Australian Research Council's Research Centres
Program, an arm of the Australian federal government's Department of Employ-
ment, Education, Training, and Youth Affairs. It brings together faculty and
students from three institutions who maintain an interest in cultural studies and

cultural and media policy: Griffith University; Queensland University of Technology's Centre for Media Policy and Practice; and the University of Queensland's Centre for Media and Cultural Studies. The Centre has established ties to Australian broadcasting regulators, arts administrators, the Australian Film Commission, and even to pay-TV operators. The Centre has become a locus for what are, without question, highly institutionalized and connected practices of cultural studies.[4]

It should therefore come as no surprise that identifying cultural studies simply as a set of writing practices does not quite capture the confluence of activities characterizing cultural studies at the Key Centre for Cultural and Media Policy. Granted, a good deal of work coming from the Centre takes the form of written research: newsletters, books, reports and occasional papers.[5] Nothing would seem to be out of the ordinary until we consider – and these are the factors crucial to intervention – the particular policy orientation of this work and how it subsequently circulates. The Centre supports only works in cultural studies demonstrating a clear commitment to matters relevant to formulating and influencing cultural policy in Australia. 'The perspective that we've taken,' Tony Bennett, the Centre's former director notes, 'isn't to see policy as a convenient or expedient add-on to cultural studies; it is to say you *can't* do it, you're misunderstanding something significant about the role of culture in modern societies if you do not understand the degree to which it is a policy field' (1997: personal communication). This work thus presupposes its circulation through the institutions with which the Centre has established ties. It imagines itself, from the outset, as a direct intervention with particular destinations and effects already in mind, unlike what could be called more 'free-floating' practices of cultural studies.[6]

To be fair, the Centre's work does not produce 'an immediate, nitty-gritty payoff' (ibid.). Its effects are not as direct or as quantifiable as the signifier 'policy' might suggest. Cultural studies does not map so simply into cultural policy. The Centre's interventions are more modest – though they are certainly interventions where effects can be registered. As Tony Bennett puts it, 'It's not that we expect [cultural studies at the Centre] to dictate policy outcomes. We can't. That's not our role. But what we do want to do is to produce the kind of knowledge and argument, etc., that can influence, that can circulate and have a bearing upon the way these things are discussed' (ibid.). So while the Centre may not produce policy *per se*, given the prestige afforded by its national accreditation, and given its significant and direct ties to a range of national institutions, it does participate in policy formation that to varying degrees can bear upon the government of culture in Australia. The Centre's institutional ties enable the circulation of its work in a way that encourages and engenders effects over and above those possible in non-, less- or even differently institutionalized practices of cultural studies.[7]

Recognizing that New York is at once a cosmopolitan city and a locale, the

American Studies Program at New York University weaves issues specific to the city into a distinctly activist-inflected version of cultural studies.[8] American Studies at NYU is not characterized by the parochialism common to many forms of area studies.[9] Revamped considerably since its early days as an American Civilization Program, NYU's American Studies Program is, according to its director Andrew Ross, better characterized as 'post-national American Studies' (1997: personal communication). It offers students a multidisciplinary (or, as it touts itself, a 'postdisciplinary') approach to concerns ranging from science, technology and society to indigenous America, nations and transnationalism to gender, race and sexuality.[10] 'Most of the students,' Ross states, 'probably feel they're doing cultural studies rather than American Studies, although I think overall there's a different flavor to this program' (ibid.). What makes the programme unique, what gives it its 'different flavour', I would like to suggest, stems in part from its ability to register more than the 'vague effects' characteristic of written cultural studies interventions.

The written critical-theoretical documents that often typify the 'output' of cultural studies' work tend not to mark the end point for student projects at NYU's American Studies Program. Through collaboration on projects, students create connections with and among political constituencies and groups implicated in their projects. One recent group project, for example, produced not only essays but also a conference bringing together representatives from New York's garment industry, members of the garment union, activists and intellectuals to discuss sweatshops and labour reform in both theoretical and more immediately practical terms. Another collaborative student project on HIV, sexuality and queer politics developed prevention programmes out of their critical-theoretical work, which the students subsequently took to clubs and bathhouses throughout the city. In general, the work of cultural studies at NYU remains unfinished until it meets with those whose realities it describes and seeks to transform.[11] 'What we tell students is we're producing intellectual-activists here. . . . The work they do . . . is work they can't do outside the academy, but their work has to go beyond the academy' (ibid.). Like policy at Griffith, activism is not simply something added on to cultural studies after the fact; it is constitutive of its practices. The Program maintains an ongoing commitment to forging links among groups and institutions outside of the academy and subsequently to circulate (in various forms) its written practices of cultural studies through them.

Emphasizing cultural studies' written practices also tends to obscure the significance of pedagogy as a site of cultural studies' institutionally based practices. It may be true that pedagogical practices informed by cultural studies register nothing more than the 'vague effects' against which Stuart Hall (1992) cautioned us.[12] On the other hand, they do evince the *possibility* for a particular mode of intervention: specifically, teaching *future cultural producers* from a perspective informed by cultural studies. This suggests another way cultural studies can circulate and resonate – that is to say, how it is effective – outside of the academy.

The Georgia Institute of Technology's School of Literature, Communi-
cation, and Culture (LCC), particularly the graduate programme in Infor-
mation Design and Technology (IDT), represents a significant advance in this
direction. The LCC curriculum cannot be characterized as exclusively cultural
studies, given that it must also include a range of more traditional humanities
courses for students who are majoring in programmes in engineering and sci-
ences (Balsamo, 1997: personal communication). Courses and assignments are
apt to evince a bias towards issues related to science and technology, articulated
broadly to a humanistic concern with 'culture'. According to Anne Balsamo,
director of LCC's graduate programme, 'This is one of the fruitful ways in
which cultural studies can be worked into the curriculum. It can lend a ratio-
nale to a program that is trying to map a new area' (ibid.). It is precisely here,
I would add, that cultural studies registers its effects at (and beyond) Georgia
Tech.[13]

To be fair, LCC students for the most part do not produce work that is in
any obvious sense identifiable as cultural studies. IDT projects, for example,
tend to privilege the practice of multimedia design and project management
over, say, an interest in the theoretical underpinnings of such work, despite the
fact that theoretically inflected courses inform and complement the more
practical or applied dimension of student work. 'We give [students] critical-
theoretical tools that are drawn from cultural theory,' Balsamo states, but 'those
tools and those concepts [are always] cast in an applied, practical framework'
(ibid.). The work or intervention of cultural studies therefore occurs in the first
instance, i.e. in the pedagogical practices and perspectives inspiring and orient-
ing LCC courses. The effectivity of these interventions registers when we con-
sider how and where students, in the final instance, might carry on a cultural
studies *informed* practice:

> Our . . . practical concern, both at the undergraduate and graduate level,
> is that we know we are educating people who are going to go out and be
> cultural producers. . . . [Students] are going to be the ones designing the
> multimedia, designing CD-ROMs, and we think about the fact that these
> are cultural products that are going to circulate *very* widely and have a great
> impact on everything from entertainment and our leisure to our edu-
> cational materials.
>
> (Ibid.)

Thus, despite the fact that student work at LCC may not be exclusively 'cultural
studies', the latter none the less subtends and ultimately circulates into the field
of cultural production – a crucial terrain for making, remaking and unmaking
social, historical and political contexts.[14] All this is to say that institutionalization
clearly (but not unproblematically) holds a key for cultural studies to make good
on its promises to intervene.

Discipline and vanish?[15]

In this section I want to consider the question of disciplinarity, as it relates to institutionalization. What do we know about the relationship of cultural studies to the disciplines? On the one hand, a rich body of literature testifies to cultural studies' methodological, theoretical, practical, rhetorical, and even political 'open-endedness' (see Ang, 1996: 238; Grossberg, 1996a: 179; Grossberg et al., 1992: 3; Hall, 1992: 278; Johnson, 1996: 75; Nelson, 1996: 280).[16] On the other hand, many of the arguments against institutionalizing cultural studies turn on the fear that the disciplinary logic endemic to modern universities will close down (i.e. discipline) this productive openness that, like intervention, represents one of cultural studies' key commitments (see Hall, 1992: 285; Nelson, 1996; Rooney, 1996). A prolific (counter-)discourse has developed underlining and insisting upon the need for cultural studies to resist what would seem to be the university's disciplinary pull. These injunctions range from Grossberg et al.'s admonition that 'cultural studies is an interdisciplinary, transdisciplinary, and sometimes counter-disciplinary field' (1992: 4) to Cary Nelson's edict that 'If [cultural studies] is to be institutionalized at all, [it] might be better served by a variety of programs outside of traditional departments' (1996: 283). Ellen Rooney, for her part, issues a polemical plea calling for cultural studies to pursue, minimally, 'an anti-disciplinary practice defined by the repeated, indeed, endless rejection of the logic of the disciplines and the universal subject of disciplinary inquiry' (1996: 214). Evidently, then, disciplinarity represents a sore point for cultural studies, particularly as it runs counter to the openness and radical con-textualism characterizing its written practices (see Grossberg, 1998: 68; Slack, 1996: 125).

Cultural studies has gained considerable mileage from this now rather hack-neyed resistance to disciplinarity. I describe this argument as 'hackneyed' because it seems to have sedimented into a familiar stock of received knowledge. Or, to put it less delicately, cultural studies has developed something of a 'line', so to speak, in response to the 'question' of institutionalization – despite its professed disdain for ready-made answers. When the prospect of institutionalizing cultural studies gets posed, published reactions often tend towards some variation of 'Resist disciplinarity!' I wonder, however, how productive this response is, given the practical and historical exigencies facing cultural studies, particularly as it finds itself increasingly institutionalized. I would therefore like to problematize some of the assumptions undergirding how cultural studies conceives of and talks about its relationship to institutionalization and disciplinarity, in addition to how it describes the relationship between these two structures. Specifically, I want to consider: (1) how actual cultural studies programmes, practically speaking, go about negotiating the institutional/disciplinary space; (2) how, given recent transformations in (North American) universities, fears about disciplining cul-tural studies may prove less founded than in earlier moments in its history; (3)

how this transformation presents a new set of challenges to cultural studies' ongoing commitment to open-endedness; and finally (4) how cultural studies might respond at the institutional level to these challenges.

1 Practically speaking . . .

I am concerned by the polemical announcement of cultural studies' 'anti-disciplinarity', an injunction that, within the limits of my research, seems to lack a discrete or recognizable institutional embodiment. That said, it becomes all the more urgent to point to some of the limits in the written work relative to the pragmatics of institutionalizing cultural studies. To do this we will need to bracket for the time being the assumption that cultural studies somehow betrays its 'true' nature or has been corrupted when it fails to seize every opportunity to make a frontal assault on the disciplinary structures of the university. Suffice it to say for now that such assumptions prioritize and privilege cultural studies' written discourse over its institutional embodiments, as though the former were somehow a more authentic form of cultural studies than the latter.[17]

First of all, specific institutionalizations of cultural studies tend to evince a consistently *inter*disciplinary, as opposed to an *anti*-disciplinary orientation. For instance, Tony Bennett characterizes the Key Centre for Cultural and Media Policy as 'an interdisciplinary connector' joining faculty at various universities (1997: personal communication). The Cultural Studies Research Center at the University of California–Santa Cruz maintains a strong commitment to inter-disciplinarity by funding collaborative research 'clusters' of faculty and graduate students across the disciplines of the humanities and social sciences (Clifford, 1997: personal communication). Similarly, research centres to be established at my home institution, the University of North Carolina at Chapel Hill and at Goldsmith's College in London will at once tap a disciplinary base of faculty and graduate students while at the same time providing a space for them to under-take research outside of the constraints of their home departments.[18] In addition, at Goldsmith's, cultural studies has been grafted on to the Department of Media and Communications, which awards joint degrees with the sociology and anthro-pology departments. Finally, despite the fact that New York University's Ameri-can Studies Program touts itself as 'postdisciplinary' in its literature, all its faculty maintain appointments in more or less 'traditional' departments (Ross, 1997: personal communication).[19]

What I want to underline here is the fact that – and this should come as no surprise – faculty affiliated with cultural studies tend to remain tied to traditional departments. While I do not mean to claim that in maintaining those ties one cannot work to undo them, I think we need to recognize the strong and con-tinuing existence of disciplinary affiliations – and this is crucial – in order to measure the suggestion that cultural studies somehow is (or ought to be), in the last instance, fundamentally anti-disciplinary.

2 Undisciplining the university

Practitioners of cultural studies have invested a significant amount of energy cautioning against the centripetal pull of disciplinarity that seems endemic to universities. Yet this argument tends to identify institutionalization with disciplinarity and to ignore non-disciplinary forms of institutionalization. 'The threat is not from institutionalization *per se*, for cultural studies has always had its institutionalized forms within and outside the academy' (Grossberg *et al.*, 1992: 10). The problem is the conflation of institutionalization and disciplinization, and the reduction of the university to an empty bearer of disciplinary logic. Not only does this collapse competing 'diagrams' of power present within institutions into an abstract, indeed totalizing disciplinary regime, it also rests upon a conspicuously ahistorical view of the university. What the discourse of institutionalization needs, then, is a more refined and historicized understanding of the relationship between the university and disciplinarity.

Bill Readings' *The University in Ruins* (1996) documents recent political, economic and organizational transformations in universities.[20] The logic of disciplining knowledge, he claims, is one specific to the university under modernity.[21] He argues that this is being replaced with a new, economically driven impulse to de-emphasize disciplinarity in what he calls the 'post-historical' university or 'the University [*sic*] of excellence' (1996: 6, 17).[22] Whereas the modern university was built upon a characteristically bureaucratic imperative to compartmentalize, the university of excellence maintains a corporatist commitment to downsize and streamline. The reorganization of Georgia Tech's English Department into the School of Literature, Communication, and Culture and the consolidation of its history and sociology departments into the School of History of Technology and Society in the late 1980s are clear examples of this new logic in action. Rather than fixing knowledge into neat and rigid disciplinary units, the contemporary university increasingly seeks ways to undiscipline the disciplines, in an effort to conserve and consolidate resources. Promoting interdisciplinarity serves this efficiency mandate.

Readings' argument has a number of important implications. First, cultural studies' anxiety over disciplinarity begins to seem somewhat misplaced, perhaps even anachronistic, given the ability of the contemporary university to capitalize on interdisciplinarity. This shift in the university poses a new set of challenges to which cultural studies has remained uncharacteristically quiet. Second, the appropriation of interdisciplinarity raises the question of how cultural studies' commitment to interdisciplinarity colludes with the larger strategies of corporatization/capitalization in the university (for example, downsizing, union breaking, etc.). Cultural studies has operated under the assumption that interdisciplinarity necessarily represents something positive, insofar as it challenges disciplinary logics. However, as Readings reminds us, 'interdisciplinarity has no inherent political orientation' (1996: 39). It is precisely for this reason that the

contemporary university is quite capable of appropriating, for explicitly economic reasons, what historically has been cultural studies' measure to resist the 'organizing' logic of the university.[23]

3 Openness at what cost?

Cultural studies' openness may be considered to be both one of its most enabling commitments and the bane of its existence. While it enables cultural studies' ongoing evolution, its practical flexibility and its radical contextuality, it also runs the risk of evacuating any meaning of 'cultural studies'. Grossberg argues, for instance, that '[a]s cultural studies becomes something of an established position, it loses its specificity' (1996a: 178). Tony Bennett has noted 'the elasticity of usage the term "cultural studies" has acquired,' given that it 'functions largely as a term of convenience for a fairly dispersed array of theoretical and political positions' (1996: 307).[24] Similarly, one of the most striking features of the 'Alan Sokal Affair' was the ease with which cultural studies became a place holder for a number of related, though irreducibly different philosophical and academic formations, including postmodernism, poststructuralism, deconstruction, literary theory, critical theory, sociology and social constructionism.[25] Underlining this slipperiness, Readings (1996: 17) argues:

> Cultural Studies . . . arrives on the scene with a certain exhaustion. The very fecundity and multiplicity of work in Cultural Studies is enabled by the fact that culture no longer functions as a specific referent to any one thing or set of things – which is why Cultural Studies can be so popular while refusing general theoretical definition.

Practitioners of cultural studies have to contend with the proliferation of work to which cultural studies has been articulated or with which it has been identified directly. In other words, we need to attend to the ways in which the signifier 'cultural studies' increasingly finds itself emptied rather than occupied.

Clearly, 'what is' cultural studies is something struggled over actively. Not everything is nor can be cultural studies.[26] But I think it would be unwise, in this struggle, to turn a blind eye to the ways in which the contemporary university has been able to seize upon the commitments of interdisciplinarity and openness in order to implement its corporatist restructuring programme. How does the logic of the contemporary university encourage the signifier 'cultural studies' to slide in as the new interdisciplinary master-signifier for the humanities and social sciences?

> One form of . . . market expansion is the development of interdisciplinary programs . . . [T]his is a reason to be cautious in approaching the institutional claim to interdisciplinarity staked by Cultural Studies when it

replaces the old order of disciplines in the humanities with a more general
field that combines history, art history, literature, media studies, sociology,
and so on.

(Readings, 1996: 39)

Indeed, I cannot help but maintain some suspicion about how easily the Provost
at my home institution, the University of North Carolina at Chapel Hill, has
received and embraced the efforts of the incipient University Program in Cul-
tural Studies. His support suggests to me that either or both of the following
has happened: (1) that cultural studies is having some success in rearticulating
the imperatives of the university; (2) that it has become, if unknowingly, com-
plicit with some of the university's corporatist/capitalist impulses. As much as
I would like to believe optimistically in the former, I cannot entirely discount
the latter.

4 Specifying cultural studies

If in fact cultural studies is being appropriated into the new imperative of the
university, then its interdisciplinarity and openness are enabling this to occur.
Circumventing or struggling against the university's emergent logic, then, might
depend upon undermining one or both of these conditions. Despite the poten-
tial traps of interdisciplinarity, I am unwilling to suggest that cultural studies
forfeit this commitment. Cultural studies represents a powerful analytic due in
part to its ability to poach methods, theories, researches and so on, strategically,
from across the broad field of the humanities and social sciences, sometimes even
the natural sciences. Foreclosing on this commitment would limit the theoreti-
cal breadth and versatility characteristic of cultural studies.

Rearticulating cultural studies' openness, I would like to suggest, affords a
better strategy for resisting the new logic of the university. Cultural studies has
registered the tension between remaining open-ended and refusing a facile
pluralism. Despite attempts to struggle against the latter (see Grossberg, 1996:
179; Hall, 1992: 278), I think it is fair to say that cultural studies, as a set of dis-
cursive practices, tends in the direction of pluralism rather than specificity. The
ease with which cultural studies becomes a place holder for a range of academic
and philosophical movements is symptomatic of this tendency. Similarly, the con-
temporary university's ability to seize upon cultural studies speaks to the fact that
it remains too open – practically, theoretically and methodologically. Specifying
more distinct practices of cultural studies, then, might begin to provide a stra-
tegic way out of the threat of appropriation.

Of course, specifying cultural studies is a tricky and dangerous manoeuvre.

Those of us working in 'cultural studies' find ourselves caught between the
need to define and defend its specificity and the desire to refuse to close

off the ongoing history of cultural studies by any such act of definition. This
is, it must be said, a very real dilemma.

(Grossberg, 1996a: 179)

That said, I want to refuse to attempt to define cultural studies in any absolute
or narrow sense, favouring instead a 'weaker' form of specificity, something more
situated and gestural, as it were. A commitment to acknowledge the existing
institutionalizations of cultural studies becomes all the more paramount here,
especially insofar as some demonstrate 'an ongoing effort to define [their] own
local specificity' (Grossberg, 1996a: 181; emphasis added). Griffith University's
Key Centre for Cultural and Media Policy provides an excellent example. 'Cul-
tural studies', as an institutionally recognized body at Griffith, is defined around
the 'magnet' of policy. Policy orientates the practices of cultural studies, yet it
does not absolutize or circumscribe them altogether.[27] Georgia Tech's School of
Literature, Communication, and Culture, to take another example, turns to
science and technology as its lens to focus cultural studies. Finally, student work
at NYU's American Studies Program takes its cue largely from issues specific to
New York City, wedding them into a more 'intellectual-activist' kind of cultural
studies. These attempts to specify a practice or practices of cultural studies might
be taken as heuristic models.

Rather than doing cultural studies *per se* (a phrase that tells us very little) or
instituting programmes broadly dedicated to cultural studies (a project open to
appropriation by universities), we might be better off specifying our practices
locally and 'weakly', which, minimally, will entail qualifying or orientating the
practice of cultural studies.[28] While certainly an imperfect and limited strategy,
specifying practices of cultural studies none the less begins to narrow the field of
theoretical and methodological orientations, political commitments and, most
prominently, the subject matter that can be articulated to 'cultural studies' within
a given institutional locale. Closing down its openness, if only a little, makes it
more difficult for university administrations to encourage cultural studies to
stand in as an interdisciplinary master-signifier for humanities and social science
curricula. The larger and related 'payoff' amounts to reconstituting a more solid
ground upon which cultural studies might resist the university's shifting com-
mitments to (inter)disciplinarity.

Performing cultural studies

Throughout this article I have pointed to a series of gaps or disjunctures that exist
between cultural studies' written practices and its institutional practices. I have
privileged the latter over the former. Otherwise, I believe it becomes too easy
to underestimate the effectivity of cultural studies' interventions. I could thus
quite reasonably be accused of suggesting that cultural studies' institutional

practices are somehow more 'authentic', insofar as they seem to challenge what cultural studies says about itself in written form. This gap needs to be ameliorated rather than expanded any further. I would like to ask: How might we theorize the disjuncture between cultural studies' written practices and its institutional embodiments, such that neither term gets posited as any more real or authoritative than the other?

In fact, these disjunctures are not as absolute as the discussion thus far suggests. We need to explore the function of these disjunctures if we are to see how they might be considered productively, instead of re-inscribing a rigid theory/practice divide. I would like to suggest that cultural studies' meta-discourse serves in a *performative* capacity with respect to its institutional embodiments. Taking my cue from Judith Butler, I understand 'performative' to designate 'no ontological status apart from the various acts which constitute its [in this case, cultural studies' meta-discourse] reality' (1990: 136).[29] In other words, cultural studies' meta-discourse does not necessarily have 'to be'; that is to say, it need not map any 'reality', 'existence' or 'essence' of cultural studies, just as gender performance does not map real or essential characteristics of sex or sexuality. Like the discourse of gender, it is less a matter of whether cultural studies' meta-discourse *is*, but rather what it *does*, how it *functions*, the 'reality' it invokes (or tries to invoke) *discursively*. This I see as the explicitly political function of cultural studies' meta-discourse, particularly in relation to its institutional practices and embodiments. It is 'an illusion discursively maintained for the purposes of regulation' (ibid.). However, rather than understanding 'regulation' as a modality of discipline (i.e. to normalize or concretize cultural studies' practices and commitments), I see it as a means to pull cultural studies' institutional practices and embodiments away from the centring or normalizing tendencies of institutions such as the university.[30]

So, for example, while Richard Johnson notes rather pragmatically that 'We need definitions of cultural studies to . . . make claims for resources, to clarify our minds in the rush and muddle of everyday work, to decide priorities for teaching and research' (1996: 78), a claim indexing several institutional constraints proper to universities, he can simultaneously claim that 'a codification of methods or knowledges (instituting them, for example, in formal curricula or courses on "methodology") runs against some of the main features of cultural studies as a tradition: [notably], its openness and theoretical versatility' (ibid.: 75). Similarly, we might see Ellen Rooney's plea for cultural studies to maintain 'an anti-disciplinary practice' as a deeply politicized touchstone anchoring what seems to be cultural studies' drift towards (inter)disciplinarity (1996: 214).

I want to emphasize that institutionalizing cultural studies implies *necessarily* neither its untimely demise nor its enervation as a critical–intellectual–political praxis. Certainly, those risks are there. However, I want to reiterate that it is quite unproductive and limiting to view institutions as sites where only one modality of power (characteristically a disciplinary regime) governs at any given time. In

such a view, the only 'proper' place for cultural studies would be outside institutions like the university. Cultural studies would then become a kind of free-floating intellectual practice, thereby, at the very least, divorcing itself from one of its key sites for intervention (for example, through pedagogy, policy formulation, etc.). We also need to understand that every deviation cultural studies makes from its written discourse, as it infiltrates various institutions, should not be read as an index of its imminent de-politicization. Instead, we need to recognize the dialectical relation between cultural studies' written discourse and its institutionalized forms. We need to strengthen the performative aspect of cultural studies' written discourse, to the extent that it provides a kind of ongoing check, a sort of radical counterbalance, as it were, to the reformist impulses which cultural studies must assume, quite pragmatically, in an effort to negotiate institutional spaces. I see cultural studies' performativity as a way to maintain its political edge, precisely at those moments when and in those spaces where that edge gets threatened.

Strategies for institutionalizing cultural studies

As I mentioned at the outset of this article, I take as given the fact that possibilities inhere in the institutionalization of cultural studies. But institutionalization is also dangerous, due partly to the contingent and shifting configuration, commitments and alliances of the contemporary university. What follow, then, are some strategies by which to conceive of and go about the project of institutionalization. These are, it must be said, merely suggestions developed out of the context of this study. As such, they must be considered/critiqued/refigured alongside specific historical exigencies and local conditions of possibility.

- *Recognize the insufficiency in talking about 'institutionalization' as an abstract entity*. Rather, we ought to turn our attention towards the ways in which specific cultural studies programmes negotiate the pitfalls of institutionalization, for example, disciplinarity, definition, etc. This will entail engaging in a public conversation about the practical and everyday ways those affiliated with existing programmes have strategized and undertaken this process.
- *Utilize the institutional space to forge connections and alliances*. Cultural studies must always plug into something larger than and outside of itself to be effective. A hermetic or free-floating practice of cultural studies simply will not do, given its political commitments. Building an institutional base for cultural studies thus offers an important foundation for 'building bridges' with other institutions whose projects would be of concern to cultural studies. This will demand, of course, a significant amount of leg-work on the part of those committed to a strong institutional practice, i.e. their 'talking to people and learning what their concerns are and entering into a dialogue with them in that way' (Bennett, 1997: personal communication).

- *Recognize the relation between cultural studies' meta-discourse and its institutional practices.* The fact that some of cultural studies' meta-discourse seems to lack a discrete institutional embodiment does not necessarily guarantee that cultural studies, as a serious and committed left/intellectual/political praxis, has sold itself out at the institutional level. We need to recognize the dialectical, indeed, performative relation the former shares with the latter. This will involve, minimally, coming to terms with the fact that cultural studies simultaneously maintains radical and reformist impulses, which I map very roughly to its written and its institutional practices respectively.

- *Always historicize!*[31] Any attempt to institutionalize cultural studies in the university must account for historical transformations taking place there. We would be wise in this regard not to conflate institutionalization with disciplinization. The challenge for institutionalizing cultural studies may now stem from the fact that universities find themselves turning to interdisciplinary programmes – like cultural studies – as a means to create more surplus value.

- *Specify practices of cultural studies, particularly at the institutional level.* Organizing practices of cultural studies at the institutional level appears to be an urgent project. Such practices will need to be defined 'weakly'; that is to say, in a manner that orientates but does not homogenize the practice of cultural studies in any give locale. It is in this sense that I want to advocate a renewed localism.

It is my hope that these strategies provide a practical guide and, with that, a point of discussion for developing better institutionalizations of cultural studies.

About this issue

This introduction represents but one statement in an ongoing conversation about institutionalization, a conversation whose complexity is characterized by a profound and often contentious range of questions, responses, perspectives and practical initiatives. The articles that comprise this special issue of *Cultural Studies* dwell within this complexity and make unique contributions to the conversation.

Cultural studies – let's be frank – upsets a lot of people, especially to the degree that it challenges academically established and institutionalized ways of conducting intellectual work. One result has been its widespread public scrutiny, coupled with a series of strikingly vehement (and rarely constructive) attacks on its project. David Morley's article, 'So-called cultural studies: dead ends and reinvented wheels' reads some of these recent attacks on cultural studies symptomatically, for what they reveal of the critics' anxieties. His concerns derive from recent charges that, among its other sins, cultural studies evacuates politics

from its intellectual practices and/or retraces ground already (supposedly) theorized 'adequately' by its disciplinary antecedents.

Resisting the temptation to respond to all of these charges point-by-point, Morley, more productively, takes them as an occasion to reflect upon the relationship cultural studies shares with the more established disciplines, whose representatives now seem to feel threatened by its success. The emergence and influence of cultural studies, he argues, should not be interpreted as some kind of 'paradigm shift' cutting across the human sciences, superseding (some critics would say reproducing) all work that came before it. Instead, he calls for a more 'multi-dimensional model, which builds new insights onto the old, in a process of dialogue and transformation'. Morley's essay demonstrates how attacks on cultural studies require more sensitivity to the ways in which it holds in tension an appreciation of the strengths of a range of disciplinary 'traditions', alongside the need to move forward and build on the interdisciplinarity that is central to its own approach. Certainly, he concludes, there is no future in going back to the 'Good Old Ways' of the established disciplines, as now seemingly advocated by some of cultural studies' more embattled critics.

Meaghan Morris' article, 'Publishing perils, and how to survive them: a guide for graduate students' begins to demystify what for many young scholars is perhaps the most intimidating, frustrating, and indeed opaque aspect of professionalization: academic publishing. A practical 'insider's' guide, Morris' piece sets out to help students strategize where best to begin trying to publish and how then actually to get published. But crucially, her study does not stop there. It also explains how students might begin to get their work read and cited, in addition to how they can start to influence the intellectual agendas of their fields. Her article does all this against the backdrop of the transformations taking place in the publishing industry, transformations that increasingly militate against new and innovative research. Although intended primarily for graduate students, Morris' essay should also resonate with newly established academics, and even those who have published but whose work remains relatively unfamiliar to colleagues in their fields.

Institutionalization can present itself as a sort of blackmail: either you're for it or you're against it; either you're inside the institution and hopelessly co-opted, or you're outside of it, marginalized, but in the only possible 'authentic' position. Alan O'Shea's article, 'A special relationship? Cultural studies, academia and pedagogy' rejects this blackmail. He argues that practitioners of cultural studies always-already operate within and are invested by formal institutional structures. Hence, he takes issue with the alleged transparency of cultural studies' more textually minded or 'deconstructive' interventions. Imagining the critic as a 'semiotic guerrilla', for instance, obscures one's institutional embeddedness, inasmuch as it romanticizes one's marginality. The article turns its sights on pedagogy as a more clearly practical and institutionally self-conscious mode of intervention.

Pedagogy, as O'Shea sees it, promises to make good on cultural studies' desire to meet people 'where they are', while still acknowledging both the teacher's and the student's embeddedness in an institutionally sanctioned relationship of power – a relationship where there exists no clear outside.

Similarly, Tony Bennett's 'Cultural studies: a reluctant discipline' rejects the blackmail of institutionalization. But where O'Shea turns to pedagogy, Bennett moves instead to a re-evaluation of the question of disciplinarity. In a ground-clearing of sorts, Bennett argues that 'if we survey the scene today, cultural studies has all the institutional trappings of a discipline'. This is, indeed, a controversial, even a scandalous argument. And although his concerns lie predominantly with cultural studies in Australia, Bennett, in effect, asks all practitioners of cultural studies to come to terms with its rampant institutionalization and what may now be the antiquated rhetoric of anti/disciplinarity it hides behind. Bennett concludes by deriving a series of traits that seek to describe a cultural studies more confident in the fact that it is, as he puts it, an 'interdisciplinary discipline'.

Finally, the conversation on institutionalization often proceeds as though institutionalization just 'happens', i.e. as though university folk just wake up one day to find cultural studies has dropped out of the air and into the curriculum. But the fact is, as we all know, it just doesn't happen that way; institutionalization doesn't take place without significant forethought, planning, leg-work, reflection, explanation, compromise, and, yes, even a little luck now and again. Judith Newton, Susan Kaiser and Kent A. Ono's 'Proposal for an MA and Ph.D. programme in cultural studies at U.C. Davis' offers a model for what an initiative to institutionalize a graduate programme in cultural studies might look like. Its importance comes from, among other things, the methodological lessons that can be extrapolated from it. How does one describe or, to be glib about it, 'sell' cultural studies to an audience that might have no sense of what cultural studies is, much less what it sets out to do? What does it take to institutionalize cultural studies? What questions need to be asked and answered? What justifications need to be made, and to whom? Newton et al.'s article is offered, in conjunction with the resource/guide to cultural studies programmes that follows it, as an exemplar for how a group may go about laying the groundwork, proposing and then institutionalizing cultural studies.

Acknowledgements

I am grateful to J. Robert Cox, Anna McCarthy, Della Pollock and Phaedra Carmen Pezzullo for reading and commenting upon earlier drafts of this article. I am particularly indebted to Larry Grossberg for his advice, encouragement, insights and suggestions throughout the development of this project.

Notes

1 For a text that *does* consider specific institutions, see Berlin and Vivion, 1992; Tony Bennett's article in this issue also engages in this sort of work.

2 Interviews consisted of approximately one hour of taped telephone conversations, in addition to a series of e-mail exchanges with: Tony Bennett, former director of the Key Centre for Cultural and Media Policy, Griffith University, Australia; David Morley, head of the Department of Media and Communications, Goldsmith's, University of London; James Clifford, former director of the Center for Cultural Studies and Professor in the History of Consciousness Program, University of California–Santa Cruz; Andrew Ross, director of the American Studies Program at New York University; Dick Hebdige, Dean of Critical Studies, California Institute for the Arts; Anne Balsamo, graduate director at the School of Literature, Communication, and Culture, Georgia Institute of Technology; and Della Pollock, director of the University Program in Cultural Studies, University of North Carolina at Chapel Hill. Selection of these programmes was somewhat arbitrary, based primarily on the presence of key figures in cultural studies whose work leaves little doubt about their credentials. Inevitably this represents an incomplete list. So many other programmes and individuals come to mind: Janet Wolff and Lisa Cartwright at the University of Rochester's Department of Visual and Cultural Studies; Michael Green at the University of Birmingham's Department of Cultural Studies; an emerging programme at the University of California–Davis (see Newton *et al.*'s article in this issue); the programme in cultural studies at George Mason University, and so on. Relative to my selection process, I can only say that the scope of this project is finite and that my selections represent a series of arbitrary closures.

3 I will reserve my definition of 'performative' for later in this article.

4 It should be noted that there exist few significant foundations in Australia providing funding for research and research initiatives. Hence, most of the financial support for such initiatives comes from the Australian federal government (Bennett, 1997: personal communication).

5 Australian Key Centre for Cultural and Media Policy (1997) online, *http://www.gu.edu.au/gwis/akccmp/home.html*.

6 I am indebted to Tony Bennett for this particular phrasing.

7 This, of course, is subject to change, given the election of a conservative government in Australia.

8 The programme does not address only 'local' issues. Students also undertake projects of a more national and international scope. However, the majority of projects seems to maintain a more local or New York City-specific orientation and scope (Ross, 1997: personal communication).

9 Of course, the programme does open itself to a different charge of parochialism, given the emphasis placed on issues specific to New York City (ibid.). However, I think we need to point out in response to this charge the

cosmopolitanism of New York City. As the programme's information flyer points out, New York is a 'global city . . . that comprises many cultures'. See *Graduate Program in American Studies*, 1997.

10 Ibid.

11 These projects culminated in Ross (1997a) and Dangerous Bedfellows (1996).

12 It is in this sense that I cannot agree wholeheartedly with John Storey/bell hooks' claim that, 'the politics of cultural studies are to be found in its pedagogy' (Storey, 1996: 5).

13 California Institute of the Arts utilizes cultural studies in a similar manner, where a cultural studies inflected pedagogy informs student art practice.

14 While it would be easy to romanticize this sort of pedagogical intervention, we need to be careful not to overly idealize its effectivity. Not every student taking a course informed by cultural studies develops into a progressive and responsible cultural producer. There is (unfortunately) no one-to-one mapping from one point to the other. I also realize that the specific professional constraints may militate against a student's ability to continue to let cultural studies inform her/his practice once hired.

15 The title of this section header is appropriated from Ellen Rooney, 1996.

16 By open-endedness or openness I refer to cultural studies' unwillingness to 'standardize' methods, theories, objects of study, political commitments/ strategies, etc.

17 I will elaborate upon the reasons why in the section on 'performing' cultural studies.

18 I am indebted to David Morley for alerting me to the establishment of the cultural studies centre at Goldsmith's.

19 See *Graduate Program in American Studies* (1997).

20 I think it would be prudent here to acknowledge the scope of Readings' work. His discussion of 'the university' pertains largely to those in the Euro-American/North Atlantic part of the world. It would be interesting, in this regard, to consider other contexts as in, say, Australia (where universities tend to be newer) or those in developing/post-colonized nations for that matter.

21 Indeed, this logic of difference is a characteristic proper to modernism more broadly. See Grossberg, 1996b, esp. p. 89.

22 Readings quite consciously veers away from calling the contemporary university the 'postmodern' university. He states, 'I prefer to drop the term [postmodernism]. The danger is apparent: it is so easy to slip into speaking of the postmodern University as if it were an imaginable institution, a newer, more critical institution, which is to say, *an even more modern* University than the modern University. I would prefer to call the contemporary University "posthistorical" rather than "postmodern" in order to insist upon the sense that the institution has outlived itself.' See Readings, 1996: 6.

23 This is not meant to suggest that interdisciplinarity is now unfavourable *tout court*. Indeed, I still see the latter as an important, and for the most part still progressive attribute which cultural studies brings to the university. What I do

want to emphasize, however, is that we should not accept cultural studies' commitment to interdisciplinarity uncritically, unreflexively or ahistorically, i.e. as an inherent good.

24 Myriad other authors have made similar observations relative to cultural studies. See, for instance, Sparks, 1996. Sparks noted back in 1977 (when the essay was first published) that 'A veritable rag-bag of ideas, methods, and concerns from literary criticism, sociology, history, media studies, etc., are lumped together under the convenient label of cultural studies' (ibid.: 14). See also Cary Nelson, 1996. Nelson observes: 'Over the past several years, the phrase *cultural studies* has been taken up by journalists and politicians of the New Right in America as one of a cluster of scarce terms – the others include *multi-culturalism* and *deconstruction* – that have been articulated together to signal a crisis in higher education and American intellectual life generally' (ibid.: 284).

25 Alan Sokal, a physicist from New York University, published an article in the journal *Social Text* which he subsequently repudiated as a hoax in the pages of *Lingua Franca* back in the spring of 1996. His attack (generally a seductive, if ultimately unconvincing one), concerns what he perceives as the lack of rigour among the intellectual Left in the US, particularly scholarship drawing heavily on continental (for example, twentieth-century French) philosophy. His attack manages to encompass, in rather weak and conflated form, everything from cultural studies to postmodernism, poststructuralism, deconstruction, literary theory, critical theory, sociology and social constructionism. See Alan Sokal, 1996a, 1996b, 1996c; see also Begley and Rogers, 1996; Will, 1996.

26 See, for example, Hall, 1992, esp. p. 278; Grossberg *et al.*, 1992, esp. p. 3.

27 Cf. Deleuze and Guattari's notion of the axiomatic, which organizes flexibly rather than ordering rigidly. That is to say, axiomatics are directive (orientating) though not homogenizing. See Deleuze and Guattari, 1987: 435–7.

28 This is not to suggest that either or both of these institutions altogether avoid the dilemmas relative to interdisciplinarity posed earlier in this study. Georgia Tech's programme, for instance, grew out of the very corporatist/downsizing impulse against which I have been cautioning. What I want to emphasize here, however, is the fact that both of these institutions have managed to stake out practices of cultural studies that do not allow the latter to become an empty umbrella term for everything having to do with the humanities and social sciences. These institutions have managed to 'fill up' the signifier 'cultural studies' precisely at that moment when universities attempt to capitalize on that signifier by evacuating it.

29 This of course is not meant to suggest that Butler provides a foundation for the notion of performativity, given that the concept 'performativity' always refers to something in excess of gender or textuality – the two attributes that seem to ground Butler's use of the term. In a more general sense, I think my use of 'performative' here is quite consistent with Parker and Sedgwick's appropriation of the term from Austin, which they describe succinctly as 'how saying something can be doing something'. See Parker and Sedgwick, 1995.

30 Throughout this paragraph I have emphasized the performative quality of

cultural studies' written discourse for a particular reason: that is, to refuse to lend an air of authenticity to this work, as it is so tempting to fall into this trap (i.e. cultural studies must do what it says it does). This emphasis should be read as a response to what I perceive to be the tendency to place the authenticating moment in cultural studies' written word (see Nelson, 1996; Rooney, 1996) rather than as a suggestion that cultural studies' written work is a 'performance' of what it does in practice. Indeed, I think it would be equally valid to claim that cultural studies' institutional embodiments serve a similar performative function relative to the written work. In other words, both aspects are performances of cultural studies.

31 This phrasing is drawn from Jameson, 1981.

References

Ang, Ien (1996) 'Culture and communication: towards an ethnographic critique of media consumption in the transnational media system'. In John Storey (ed.) *What is Cultural Studies? A Reader*. London and New York: Arnold, 237–54.

Australian Key Centre for Cultural and Media Policy (1997) online, *http://www.gu.edu.au/gwis/akccmp/home.html.*

Balsamo, Anne (1997) Telephone interview, 12 March.

Begley, Sharon and Rogers, Adam (1996) ' "Morphogenic Field" Day: a P.C. academic journal falls for a physicist's parody of trendy-left social theory'. *Newsweek,* 3 June: 37.

Bennett, Tony (1996) 'Putting policy into cultural studies'. In John Storey (ed.) *What is Cultural Studies? A Reader*. London and New York: Arnold, 307–21.

Bennett, Tony (1997) Telephone interview, 10 March.

Berlin, James A. and Vivion, Michael J. (eds) (1992) *Cultural Studies in the English Classroom*. Portsmouth: Boynton/Cook–Heinemann.

Butler, Judith (1990) *Gender Trouble: Feminism and the Subversion of Identity*. New York and London: Routledge.

Clifford, James (1997) Telephone interview, 10 March.

Dangerous Bedfellows (eds) (1996) *Policing Public Sex: Queer Politics and the Future of AIDS Activism*. Boston: South End Press.

Deleuze, Gilles and Guattari, Félix (1987) *A Thousand Plateaus: Capitalism and Schizophrenia*, trans. Brian Massumi. Minneapolis and London: University of Minnesota Press.

Graduate Program in American Studies (1997) Information pamphlet, Graduate School of Arts and Sciences, New York University.

Green, Michael (1996) 'The Centre for Contemporary Cultural Studies'. In John Storey (ed.) *What is Cultural Studies? A Reader*. London and New York: Arnold, 49–60.

Grossberg, Lawrence (1996a) 'The circulation of cultural studies'. In John Storey (ed.) *What is Cultural Studies? A Reader*. London and New York: Arnold 1996, 178–87.

Grossberg, Lawrence (1996b) 'Identity and cultural studies: is that all there is?' In Stuart Hall and Paul duGay (eds) *Questions of Cultural Identity*. London, Thousand Oaks and New Delhi: Sage, 87–107.

Grossberg, Lawrence (1997) 'Cultural studies: what's in a name (one more time)'. In *Bringing It All Back Home: Essays on Cultural Studies*. Durham and London: Duke University Press, 245–71.

Grossberg, Lawrence (1998) 'The cultural studies' crossroads blues', *The European Journal of Cultural Studies*, 1(1): 65–82.

Grossberg, Lawrence, Nelson, Cary and Treichler, Paula (1992) 'Cultural studies: an introduction'. In their (eds) *Cultural Studies*. New York and London: Routledge, 1–22.

Hall, Stuart (1992) 'Cultural studies and its theoretical legacies'. In Lawrence Grossberg, Cary Nelson and Paula Treichler (eds) *Cultural Studies*. New York and London: Routledge, 277–94.

Hebdige, Dick (1997) Telephone interview, 19 March.

Jameson, Fredric (1981) *The Political Unconscious: Narrative as a Socially Symbolic Act*. Ithaca, NY: Cornell University Press.

Johnson, Richard (1996) 'What is cultural studies anyway?' In John Storey (ed.) *What is Cultural Studies? A Reader*. London and New York: Arnold, 75–114.

Morley, David (1997) Telephone interview, 14 April.

Nelson, Cary (1996) 'Always already cultural studies: academic conferences and a manifesto'. In John Storey (ed.) *What is Cultural Studies? A Reader*. London and New York: Arnold, 273–86.

Parker, Andrew and Sedgwick, Eve Kosofsky (1995) 'Introduction: performativity and performance'. In their (eds) *Performativity and Performance*. New York and London: Routledge, 1–18.

Pfister, Joel (1996) 'The Americanization of cultural studies'. In John Storey (ed.) *What is Cultural Studies? A Reader*. London and New York: Arnold, 287–99.

Pollock, Della (1997) Personal interview, 25 March.

Readings, Bill (1996) *The University in Ruins*. Cambridge and London: Harvard University Press.

Rooney, Ellen (1996) 'Discipline and vanish: feminism, the resistance to theory, and the politics of cultural studies'. In John Storey (ed.) *What is Cultural Studies? A Reader*. London and New York: Arnold, 208–20.

Ross, Andrew (ed.) (1997a) *No Sweat: Fashion, Free Trade, and the Rights of Garment Workers*. New York and London: Verso.

Ross, Andrew (1997b) Telephone interview, 11 March.

Slack, Jennifer Daryl (1996) 'The theory and method of articulation in cultural studies'. In David Morley and Kuan-Hsing Chen (eds) *Stuart Hall: Critical Dialogues in Cultural Studies*. London and New York: Routledge, 112–27.

Sokal, Alan (1996a) 'Transgressing the boundaries: toward a transgressive hermeneutics of quantum gravity'. *Social Text*, 46–7 (spring/summer): 217–52.

Sokal, Alan (1996b) 'A physicist experiments with cultural studies'. *Lingua Franca*, May/June: 62–4.

Sokal, Alan (1996c) 'Alan Sokal replies. . . '. *Lingua Franca*, July/August: 57.

Sparks, Colin (1996) 'The evolution of cultural studies . . .'. In John Storey (ed.) *What is Cultural Studies? A Reader*. London and New York: Arnold, 14–30.

Storey, John (1996) 'Cultural studies: an introduction'. In his (ed.) *What is Cultural Studies? A Reader*. London and New York: Arnold, 1–13.

Will, George (1996) 'The academics were wearing no clothes', Editorial. *The St. Petersburg Times*, 30 May: 14A.

David Morley

SO-CALLED CULTURAL STUDIES: DEAD ENDS AND REINVENTED WHEELS[1]

Abstract

In the UK we have recently witnessed a series of attacks on the overall project of cultural studies, both in the popular press and, within the academy, by scholars associated with the more established disciplines of sociology and anthropology. The critiques variously argue that cultural studies has led us into a political 'dead end' (in particular, in its emphasis on the study of cultural consumption); has abandoned 'politics' altogether (at least, in one definition of the term); has done little more than reinvent (in ignorance) the old (and indeed outmoded) theoretical wheels of an earlier intellectual tradition, and/or that, in general, the 'excesses' of its project have only confirmed the worst fears of those who were opposed to it in the first place. In these critiques it is argued that it is (somehow) both time to move 'beyond' cultural studies altogether, and time to return to the more secure disciplinary foundations and rigorous methodological procedures of sociology, and/or political economy and anthropology. This article considers the theoretical and political occasions of this interesting (hyper?) critical phenomenon, and considers whether, notwithstanding the very real current problems and divisions within cultural studies itself, the contributions of cultural studies over the last twenty years have now so transformed our field of study that the critics' proposed return to 'The Good Old Ways' may simply no longer be possible (even if it were desirable).

Keywords

sociology; anthropology; depoliticization; backlash; hindsight; teleology

It's only common sense

I TAKE AS MY starting point a review of a book which I co-edited on Stuart Hall's work (Rogers, 1996, reviewing Morley and Chen, 1996) in which the reviewer observed that cultural studies seemed to him to be no more than a series of truisms – such as that: 'our. . . . post-industrial societies are driven by conflicts based on sex, race, religion and region, as well as class – and that people's sense of identity is shaped not just by economic but by cultural factors' (so that politics has to work) 'by appealing not only to people's economic interests but to their sense of who they are'. The reviewer's problem, he explained, was that, in his view: 'this seems so obviously a move in the direction of common sense that it hardly deserves all this attention.' Against this, I'd just like to pose a quote from Stuart Hall's essay 'Culture, the media and the ideological effect' (1977a). There Hall argues that 'what passes for common sense feels as if it has always been there, the sedimented, bedrock wisdom of "the race". A form of "natural" wisdom, whose context has changed hardly at all with time. However, common sense *does* have a context *and* a history'. Hall goes onto argue that

> it is precisely its 'spontaneous' quality, its transparency, its 'naturalness', its refusal to be made to examine the premises on which it is founded, its resistance to change or to correction, its effect of insistent recognition which makes common sense . . . spontaneous, ideological and unconscious. You cannot learn, through common sense, how things are: you can only discover where they fit into the existing scheme of things. . . . Its very taken-for-grantedness establishes it as a medium in which its own premises and presuppositions are . . . rendered invisible by its apparent transparency.
>
> (Hall, 1977: 325–6)

My point is simply that if the things to which this reviewer refers are now 'common sense', they are so largely because work in cultural studies has made them so. Given the logical priority of the unsaid over the said, the study of the construction of common sense and of the changing nature of 'what goes without saying'/or can be taken-for-granted is, by definition, about as important a cultural issue as you could hope to find – not least because it traces the changing limits of what can be thought, within the terms of common sense.

The argument from common sense has, of course, also been a notable feature of the recent attacks on media studies in the UK. Here the argument runs that, given the banality of its object of study, it's clearly a senseless activity: who needs to study what is obvious to everyone? Evidently, the appropriate response is to point to the importance of the analysis of *how* particular things come to seem 'obvious' to particular groups of people, and to the media's role in the construction of the classificatory categories within which 'common sense' is formed.

That is why, if cultural studies sometimes seems to 'tell us things we already know in a language we can't understand' – none the less, the redescription of the everyday world of culture in the language of systematic analysis is the necessary form of the 'defamilarization' of the everyday which is essential to cultural studies work. From this perspective, studying the media's role in the shaping of contemporary common sense, through the analysis of the popular cultural forms which the media produce, is a far from trivial activity – it involves the analysis of how the limits of our common knowledge are continually constructed, patrolled and redrawn.

Another review of the *Critical Dialogues* book (Morley and Chen, 1996) by Stefan Collini (1996) picks up the difficult question of how to square the circle between the demands of theoretical rigour and the demands of accessibility. In this connection, Collini points to the sense in which a lot of the public (and especially journalistic) resistance to cultural studies amounts to little more than a 'lazy resistance to new ways of thinking' (Collini, 1996). As Collini argues, traditionally, a certain level of technicality of academic language has always been recognized as the price of disciplinary rigour. However, in the context of critiques of media/cultural studies, accusations that cultural studies analyses are unreadable or jargon-ridden are, as Collini puts it, 'just the small arms fire of the border-guards of journalism, pointing at academics suspected of colonising the ancestral lands of the common reader' (ibid.).

The attacks on media studies in the British press have been tediously repetitive. But the attacks also come from other sources. They come from within the media industries themselves – the left-wing television drama producer, Ken Loach, at a recent conference on television drama in Britain, called for the closing down of all media studies courses, on the grounds that their graduates were, in his view, illiterate. The attacks have also come from government – and not only the last (Conservative) government. Just as ex-government MP Chris Patten, in his comments on the 'decline' of higher education in Britain, jibed that media and cultural studies represented no more than 'Disneyland for the weaker minded', neither does the present Labour government seem too well disposed towards our field of study.

All of this, of course, has its echoes *within* the world of higher education itself, especially in relation to questions of funding. As the external attacks mount, so does the internal pressure to retreat from the interdisciplinary experiments of the last thirty years, towards a retrenchment into the more conventional, and now perhaps more 'respectable' disciplines which are more readily rewarded by educational funding institutions, such as the Higher Education Funding Council in the UK. Certainly, within the field, one can hear voices calling for a return to the (apparently) sounder and better established claims of the sociology of mass communications, or perhaps of sociology (or even anthropology) as the appropriate master (or mistress) disciplines of the terrain we study. It is precisely against these claims, which I take to be ill-founded, that I

feel the need to defend the centrality of interdisciplinarity to the project of cultural studies. In this respect, I am entirely in sympathy with Graham Murdock's reminder that the 'original project of cultural studies was precisely to disregard formal divisions between disciplines . . . (in) a celebration of trespass and border violations in the interests of constructing a more complete analysis of culture' (Murdock, 1995: 91). In this context, I would argue, to ditch the supposedly 'wilder' shores of cultural studies' interdisciplinary project for the safe havens of more (nowadays) 'respectable' disciplines such as sociology and anthropology and their 'tried and trusted' analyses of culture will get us nowhere at all.

Cultural studies and the social sciences

One of the most crucial balancing acts in matters of interdisciplinarity is, of course, that between the 'textualizing' tendencies of literary versions of cultural studies and the deterministic or essentialist tendencies of the more social science-based alternatives. Here I would point to one key and continuous thread in Stuart Hall's comments on these matters – a thread that stretches at least as far as between his essay on 'The hinterland of science' (1977b) and his (closing) contribution to the new Open University course, 'Culture, Media and Identities', where he addresses the recent 'Cultural Turn' in social science (Hall, 1997). The central issue here concerns the troubled question of cultural studies' relation to sociology.

In his 1977 essay Hall observes that: 'when Levi Strauss succeeded to the Chair of Social Anthropology at the College de France, and delivered the inaugural lecture which declared that the centrepiece of Social Anthropology should be the study of "the life of signs at the heart of social life," he was able to defend this enterprise as nothing more nor less than the resumption of the forgotten part of the Durkheim–Mauss programme' (Hall, 1977b: 23). In the 1997 version of this argument, Hall explains that 'the programme . . . inaugurated by Durkheim and Mauss . . . was defined for many years as "too idealist" for mainstream sociology . . . Durkheim's more positivistic work being preferred. . . . The much heralded "cultural turn" in the social sciences can more properly be read as representing a "return" to certain neglected classical and traditional themes' (Hall, 1997: 223). In this argument, cultural studies stands not against sociology *per se*, but rather against one particular, long dominant positivist tradition within it – and as the rescuer of a 'lost' tradition, the recovery of which has done much to reinvigorate contemporary sociology.

Hall himself has always argued that a crucial part of what was going on in Birmingham in the 1970s was the 'posing of sociological questions against sociology' (Hall, 1980: 21) as it then stood. In this connection, Greg McLennan has recently argued that 'if sociology is attractive today as . . . an increasingly eclectic forum, that is not least due to the impact of radical cultural studies and other

avowedly interdisciplinary currents' (McLennan, 1994: 128). However, as he also
notes, it does now seem to some commentators – who identify cultural studies
exclusively with its relativist, postmodern variant – that if, once upon a time,
cultural studies posed as the radical alternative to a moribund sociology, nowa-
days, sociology is perhaps in a position to wreak its revenge on cultural studies,
taking the theoretical and moral high ground, on account of its apparently greater
seriousness of moral (and critical) purpose (Tester, 1994). Thus, in a subsequent
article, McLennan notes that 'once the critic of surface empiricism, cultural
studies (in its post-modern, relativist/textualized mode – DM) appears to have
become its slave, content only to impressionistically describe contemporary
culture, rather than explaining it; observing the plurality of cultural styles but
avoiding considered moral evaluation of them; addressing a contemporary cul-
tural scene, but refusing to anchor analysis in any serious theoretical or political
stance, for fear of disciplinary totalisation, its "theory" merely simulating late
capitalist consumer images' (McLennan, 1998: 14). It seems that things have
reached the point where, according to some of its sociological critics, such as
Keith Tester, cultural studies is a 'discourse that is morally cretinous, because it
is the bastard child of the media it claims to expose. . . . Once a critical force, it
has become facile and useless . . . about nothing other than cultural studies itself'
(Tester, 1994: 3,10). According to Tester, McLennan notes, sociology by con-
trast is informed by 'a seriousness of moral and cultural purpose . . . moral com-
mitment and moral outrage' (Tester, 1994: 4, quoted in McLennan, ibid.).

The problem here, as McLennan adroitly observes, is that all this is as
dependent on a caricature of what cultural studies is, as cultural studies' own
earlier critique of sociology sometimes was. Certainly, neither McLennan nor I
would have a great deal of patience with the attempts of some within the field
of cultural studies to 'write off' sociology – on the grounds that its supposedly
totalizing, generalizing predilictions were somehow *ipso facto* reactionary. While
it has long been a minority position (and certainly so within the heavily textu-
alized American version of cultural studies) there has always been one thread of
cultural studies work which has maintained a commitment to sociological ques-
tions. To be sure, that work has always insisted on making a selective and criti-
cal appropriation of sociological theory, but it has always been there, as
McLennan notes. This is a perspective which is concerned to critique the inad-
equacies of particular sociological positions, rather than to entirely dismiss soci-
ology as a discipline.

Equally clearly, there is much in cultural studies, in both its postmodern
and poststructuralist variants, which does push the argument against socio-
logical theories of determination much further than I, for one, would want to
go. It is relatively easy to find cultural studies work which ends up seeming to
be so committed to questions of conjuncturalism and particularity that it
(implicitly or explicitly) forsakes the ability to use even limited forms of
categorization or generalization. However, these kinds of problems also pertain
to the post-modern variants of the sociology of culture which is now proposed

by some as the proper 'inheritor' of the cultural studies tradition – as McLennan notes, 'there is considerable confluence between social constructionist/post-modern variants of both sociology and cultural studies' (1998: 16).

The question is not whether cultural studies or sociology has the answer to all our problems: manifestly, there are all kinds of problems with work in both these fields. McLennan concludes by arguing that 'no solution to the crisis of sociology is to be found in cultural studies, unless it is the solution to cultural studies' own crisis'. The solution to that 'crisis' – if such there be – is for McLennan, as for me, to ensure that, in the face of the recent period of 'textualization' of cultural studies (what McLennan calls 'the comeback of English as the first parent of cultural studies' (1998: 12)), the genuinely multidisciplinary character of cultural studies is retained: including the best of the sociological perspectives on offer. However, both in the UK and the USA, there are a growing number of those who would claim that a reinvigorated sociology of culture (see e.g. Alexander, 1988; Alexander and Smith, 1993, and Smith, 1998), with sound and proper sociological protocols, is now in a position to move in on this field (which is, of course, recruiting students rather strongly) and 'clear up' a number of the unfortunate confusions created by cultural studies' various inadequacies. For some of us, and here I speak as one who has always defended sociological approaches in cultural studies, the price of that process of 'clarification by Social Theory' might well be rather too high. It all depends on how much store you put by 'Theory' with a capital T.

Anthropological anxieties

However, it is plain that it is not only sociologists who are exercised about cultural studies. In 1996, the 'Group for Debates in Anthropological Theory' in the UK organised a debate at the Department of Anthropology at Manchester University on the notion 'Cultural Studies will be the death of Anthropology'. The debate was originally motivated by the desire to explore the seeming convergence between the two disciplines, insofar as both 'are centrally concerned with meaning, experience and culture' (Wade, 1996: 2). However, some anthropological participants in the debate were very much more concerned with what Pnina Werbner characterized as

> a very real problem that anthropology faces vis-à-vis cultural studies. Cultural studies is attractive, fascinating and interesting. It sells, it is a commodity that has big sales markets; it's about issues and themes that speak to young people, to undergraduates, about gender and sexuality; it's familiar to them. Whereas good anthropology, serious anthropology, is a little bit dull; it's a bit slow; it talks about issues on the other side of the world that (students) may not be that interested in.
>
> (Werbner, in Wade, 1996: 52–3)

Werbner's point is plain: the problem is cultural studies' *superficial* attractiveness, notwithstanding anthropology's greater 'seriousness'; lest we misunderstand her, she glosses her point by explaining that this is one of those situations where, regrettably, 'bad money pushes out good money' (ibid.: 52; cf. Ferguson and Golding (1997: xx) who mobilize the same image of cultural studies as 'superficially glamorous').

Some participants in the debate also took the view that cultural studies is fundamentally parasitic on anthropology – insofar as, according to Aggers, 'a good deal of the momentum of cultural studies is provided by the cultural turn in anthropology' (Aggers, in Wade, 1996: 3). Some also took the view that, given that anthropology is (for some) by definition, queen of the sciences of meaning, because of its long tradition of expertise in matters of culture, it is also, by the same definition, the 'mistress' of cultural studies.

Certainly, in recent years there has been considerable cross trade between anthropology and cultural studies, perhaps most notably manifested in the 'turn to ethnography' as the prime method of empirical enquiry within cultural studies. Of course, this is complex territory, as this ethnographic turn within cultural studies occurred just when, within anthropology itself, the very possibility of ethnographic work had come under close scrutiny, in the wake of the interventions of James Clifford and George Marcus (cf. Clifford and Marcus, 1986). However, there are many within anthropology who take the view that cultural studies' attempt to import (or misappropriate) ethnography is seriously flawed, and who would question whether what passes for ethnography in cultural studies is anything like acceptable in terms of anthropological standards of depth and intensity of fieldwork. Indeed, there are also those within cultural studies, notably Paul Willis, who have argued exactly this case. Willis has argued that, for example, most of the work on media which describes itself as 'ethnographic' is in no sense ethnography proper:

> the media tradition of ethnography has truncated ethnography, whilst claiming its authority and power . . . audience studies [my own included – DM] do not actually produce, but more exactly fraudulently trade on, an assumed hinterland of ethnography and apparent anthropological knowledge of the communities, the groups, the cultures that are taking in the media messages under study.
>
> (Willis, in Wade, 1996: 39)

Indeed, for Willis, it is 'the lack of a really genuine (anthropological or) ethnographic root in cultural studies' which is the main problem with cultural studies itself, insofar as 'this engagement was, even in its heyday, not sufficiently empirical, nor sufficiently ethnographic. It lacked a firm basis in extensive fieldwork. . . . I don't think any cultural studies text has ever had a long-term field presence . . . (cultural studies) hasn't really had a genuine ethnographic tradition' (Willis, in Wade, 1996: 37–8).

My anthropological colleague at Goldsmiths College, Steve Nugent, in his introduction to an edited volume *Anthropology and Cultural Studies* (1997), similarly argues that the two disciplines' usages of the term 'ethnography' are quite incompatible. He quotes Marshall Sahlins to the effect that 'some cultural studies types seem to think that anthropology is nothing but ethnography. Better the other way round: ethnography is anthropology or it is nothing' (Sahlins, quoted in Nugent, 1997: 4). Nugent helpfully paraphrases Sahlins' argument thus: cultural studies is either redundant (anthropologists already do it) or it is out of the loop: 'Cultural studies practitioners are mistaken in thinking that what they do would be reorganised by anthropologists as ethnography' (ibid.: 4). Nugent goes on to pose the question that 'if it is the case – as Sahlins declares – that "ethnography is anthropology" where does this leave those in cultural studies . . . who would seek to ally themselves with such an ethnographic tradition?' (ibid.: 6).

Happily, from my own point of view, there are, however, also those such as Mark Hobart who, in the Manchester debate referred to above, took a less embattled position. In line with George Marcus' view that as the conventional anthropological project exhausts itself anthropology will be subsumed within an internationalized cultural studies, Hobart declared himself unworried by the fact that in his view 'anthropology has run out of episteme. It has had its' day' (Hobart, in Wade, 1996: 12). For Hobart, if anthropology and cultural studies are not already 'the same', he is quite happy to see anthropology turning into comparative cultural studies. As he notes, 'in the real world, that flagship department of anthropology, Chicago, has (already) become the Centre for Transnational Cultural Studies' (ibid.: 14). For him, cultural studies will broaden and reinvigorate anthropology, and 'the transnational will effectively toll the death of the old anthropology and the emergence of new kinds of intellectual practice . . . (in the form of) comparative cultural studies' (ibid.: 18). This interdisciplinary perspective is also echoed in Paul Willis' closing remarks, in his contribution to the debate. Having earlier averred that he could easily see reasons for voting either way on the motion under debate (as to whether cultural studies would 'be the death' of anthropology), he concludes, notwithstanding his earlier critical comments on the deficiencies of the ethnographic tradition in cultural studies, with the rallying cry 'Anthropology is dead. Long live "TIES": theoretically informed ethnographic study' (Willis, in Wade, 1996: 41).

The backlash: beyond cultural studies?

In a recent essay on this topic James Carey declared that he had 'no interest in once again waking up the past in order to sing it back to sleep' (Carey, 1995: 87). I am sorry to say that I do feel compelled here to wake up some of the recent past, in the (perhaps forlorn) hope that we can then perhaps get it to sleep better. As indicated earlier, there has recently been a series of very strongly worded critiques of the overall project of cultural studies, by scholars associated with a more

conventional form of the sociology of culture and mass communications, which I feel stand some need of reply. The critiques variously argue that cultural studies has led us into a political 'dead end' (particularly because of its emphasis on the study of cultural consumption); that it has abandoned 'politics' altogether (at least, in one definition of that term); that it has done little more than reinvent (in ignorance) the old (and indeed outmoded) theoretical wheels of an earlier sociological tradition, and/or that, in general, the 'flighty' excesses (see below) of its project have only confirmed the worst fears of those who were opposed to it in the first place.

In these critiques it is argued that it is (somehow) both time to move 'beyond' cultural studies altogether, and time to return to the more secure disciplinary foundations and rigorous methodological procedures of sociology (and/or political economy). My answer is that, notwithstanding the very real problems and divisions within cultural studies itself, its advances over the last twenty years have now so transformed our field of study that this proposed return to 'The Good Old Ways' (and their eternal veities) is simply no longer possible, even if it were desirable.

As I have argued elsewhere (cf. Morley, 1997) there are important questions to be asked about the tendencies towards the over-'textualization' of some work in cultural studies, and about the creeping adoption of particular methodological and epistemological 'orthodoxies' within the field. However, as Greg McLennan (1998) has argued, these are questions about substantive positions within and across fields of study – not questions about whether cultural studies might be (just) a 'bad idea' altogether.

Let us take just a few samples of the backlash against (in the words of one critic) 'so-called British Cultural Studies (the Birmingham School)' (Frith, 1990: 233) just to get a flavour of it – so that we might then be able to read this discourse itself, symptomatically. In perhaps the most vitriolic of these critiques (Ferguson and Golding, 1997), we are told that the biography of cultural studies is a story of 'patron saints, superstars, hot gospellers and true believers' (p. xiv), characterized by an 'inward looking narcissism' (p. xv), an obsession with 'publicly re-examining its own entrails' (p. xvii) and a 'growing fascination with its own life story'. Ferguson and Golding remark scathingly that cultural studies scholars seem to be caught in a *folie de grandeur* which has 'all the appeal and significance of the premature memoirs of an adolescent prodigy' (p. xxiv) or, in Barker and Beezer's words, of an egocentric 'football star at 25 . . . busy writing (his) own autobiography' (Barker and Beezer, quoted in Ferguson and Golding, 1997: xxiv). All this 'picking over the ground of 1960's Birmingham', to Ferguson and Golding's stern gaze, is quite unseemly. To them, it seems that cultural studies scholars have made the unforgivably egocentric error of mistaking the work of the Birmingham Centre for Contemporary Cultural Studies for something equivalent to the 'mysteries of daily life in Plato's academy' (p. xxiv). If the tone of Ferguson and Golding's introduction to their edited volume is striking, it reads all the more oddly to one (such as myself) who was invited to contribute

to what I had understood to be a debate about the future of cultural studies, but finds his contribution (Morley, 1997) framed by an introductory essay which reads to me more as a straightforward attack on cultural studies altogether, notwithstanding the editors' tactical use of others' critical quotes to carry the cumulative weight of their own implicit argument.

As if all this was not enough, we are further told that this narcissism has (apparently) led those working in cultural studies to be 'ignorant of significant developments elsewhere in academia', and to thus end up, in their ignorance, 'reinventing the conceptual wheel of cultural analysis' (Ferguson and Golding, 1997: xix). Even worse, this egocentricism is apparently compounded by obscurantism, so cultural studies is further charged with the use of a pointlessly obscure and convoluted style and with producing a 'literature of growing opalescence and distinguishing clarity' (p. xxi). At the same time, cultural studies has also been characterized as 'a sort of intellectual equivalent of rap' (Eagleton, 1996) and has been accused of suffering a 'narrowing of vision . . . exemplified by a drift into an uncritical populist mode of interpretation' (McGuigan, 1992: 244); or, in another critic's words, drifting into 'a near celebration of the ephemeral and superficial' (McQuail, 1997: 40).

In a similar vein, Frith and Savage, in their combatively titled article 'Pearls and swine' (1993) argue that cultural studies, through its supposed mistaken identification of consumption with resistance (cf. also Frith, 1990), can effectively be reduced to the forms of populism to which, they claim, it has regretfully (but it seems inevitably) led. In this respect, they argue 'The great failing of our age is the idea . . . that to be popular you have to be populist, which means an uncritical acceptance of an agenda set by market forces . . .'. They go on to claim that the language of cultural studies

> is irrelevant to pop culture producers . . . to consumers, and to those of us who would like to see a new language of pop culture: one derived from anthropology, archetypal psychology, (and) musicology. . . . It is time to reclaim pop from the populists: they have said much of nothing, but their chit-chat still poisons the air.
>
> (Frith and Savage, 1993: 116)

For these authors this kind of 'cultural populism is more a journalistic than an academic project' (ibid.: 110). Neatly substituting 'studies' for 'populism' they can thus conclude that this 'helps explain the uneasy symbiosis between cultural studies and the *Modern Review*' (ibid.). Frith and Savage's attempt to lay the blame for Julie Burchill *et al.*'s later rantings in the *Modern Review* on cultural studies is succinctly echoed in the very title – 'Burchill's Daddies' of Ben Rogers' (1996) review referred to earlier of mine and Kuan-Hsing Chen's edited volume on Stuart Hall's work. I will return below to the question of who, in these matters, can reasonably be held to blame for whose subsequent tears and disappointments.

Dead ends ?

In their denunciation of cultural studies, 'Cultural compliance: dead ends of media/cultural studies and social science' Greg Philo and David Miller (1997) begin by pointing a truly bleak and depressing picture of the transformation of the UK during the period of Conservative rule – a picture which seems to me to be entirely accurate. The problem is that they somehow seem to imagine that cultural studies is to blame for all this unhappiness. Mimimally, their charge is that because scholars in cultural studies have not stuck to the narrow confines of the 'public knowledge' project (cf. Corner, 1991) and to the detailed study of 'bias' in TV news and political reporting, they are culpable in failing to resist Thatcherism (notwithstanding Hall's own pathbreaking work on the analysis of Thatcherism itself) as strongly as they might have done (and as strongly as the members of the Glasgow Media Group presumably did do).

Philo and Miller's paper is characterized by a rather odd combination of despair, blame and virulent denunciation of cultural studies for all these wrongs, alongside a seemingly intransigent conviction that they were right all along, and that all would have been well, if cultural studies had not 'seduced' media studies scholars into the study of popular culture. Their perspective on the supreme (and exclusive) 'reality claims' of the traditional public sphere, and of the unquestioned superiority of the traditional social scientific approaches to the study of phenomena in that sphere, is strikingly monocular. Indeed, they seem to be incapable of accepting that anything else is worth studying at all, or that phenomena exist in more than one dimension. Thus, they are highly critical of Gillespie's (1995) study of young 'Punjabi Londoners' for concentrating on issues such as the symbolic function of commercial spaces, such as McDonald's, as places to escape parental supervision. Gillespie's failing, in their eyes, is that she does not address either McDonald's low wage policies, or their relation to questions of animal welfare. Certainly, these are important issues, but they were not what Gillespie's study was about. For Philo and Miller it clearly should have been, and they seem to be unable to grasp that any questions other than narrowly economic or conventionally 'political' ones are of significance.

Philo and Miller's central target is, in fact, a certain variety of postmodern relativism. However, first, they equate this particular perspective with cultural studies as a whole, and fail to recognize currents of cultural studies work which are sceptical of the claims of both postmodernism and relativism. Second, in a classic 'post hoc ergo propter hoc' argument, they assume that cultural studies is to blame for the emergence of the various associated 'evils' with which they are primarily concerned. They quite fail to recognize that there are no necessary correspondences between being 'in' cultural studies and operating with a relativist epistomology and a commitment to postmodernism (cf. Morley, 1997). The fact that, conjunctually, this has been the predominant position within (especially North American) cultural studies over a certain period does not mean that it is

a 'given', nor that other positions are not possible. Nor, indeed, do Philo and Miller address the problem that scholars outside the field of cultural studies also hold relativist/post-modern views – which would seem to indicate that holding them is not necessarily the fault of being 'in' cultural studies.

Among the 'dead ends' of media research within which Philo and Miller are concerned is research such as my own (and implicitly that of other scholars, such as James Lull and Roger Silverstone) which pays attention to the material, domestic context of media reception. They complain of scholars such as these, who have 'examined the "social texture of media consumption" – which could *come down to* [my emphasis – DM] asking people if they listened to the radio while they doing the ironing' (Philo and Miller, 1997: 13). This, according to Philo and Miller, is the sad and mistaken result of the long journey from the (apparently now halcyon) days of the 'encoding/decoding' model of the media to the sad days of 'television as toaster' (p. 13). As I have argued elsewhere (see Morley, 1986 and 1992), the whole point of my own research into the domestic context of reception was not to 'abandon' questions of media power, textuality (or indeed ideology) but rather to complement that perspective on the 'vertical' dimension of media power, with a simultaneous address to its 'horizontal'/ritual dimension. As to the implied obviousness of the idea that toasters are not worth analysing, it would seem that Philo and Miller are simply unfamiliar with the extensive anthropological literature (cf. for one starting point Appadurai, 1986) on the importance of the symbolic dimension of domestic objects (cf. also my own analysis of the television set as a 'visible object', rather than a 'visual medium': Morley, 1995).

Philo and Miller quote Gitlin approvingly, when he claims that the problem with cultural studies theorists is that, for them, 'the unstated assumption is that popular culture is already politics' (p. 33). Quite right. It is. The question of whether it necessarily follows (*pace* Frith, 1990) that popular culture is only of interest for its moments of 'resistance', or whether an improperly celebratory account of certain forms of consumption as 'symbolic insurgency' is necessarily entailed, is quite another question. Certainly, to imagine that popular culture is *not* 'already politics' is, it would seem to me, politically disastrous. As for the authors' further assumption, that cultural studies' attention to questions of consumption necessarily represents either a misguided attempt to celebrate the abilities of ordinary people, or a 'search for a replacement for the lost proletariat' (Philo and Miller, 1997: 34) that seems, at least to me, a moot and largely unproven point.

Guilty as charged?

The charge of cultural studies' supposed narcissism runs alongside, as I have noted, the charge that it offers not only a 'complacent relativism', but also (in the words of my colleague at Goldsmiths College, James Curran) in its approach

to media consumption an ignorant form of 'new revisionism' in which 'old plu-
ralist dishes' are rehearsed and presented as 'nouvelle cuisine', saying only things
that good sociologists have 'long known' (cf. Curran, 1990). Here, it seems, we
are back again, if in a more theoretical vein, with the question with which I began,
concerning the construction of common sense and its changing historical limits
– only this time, within the field of academic media studies. Thus, a number of
scholars principally associated with the mass communications perspective (cf.
Garnham, 1995) have lately been heard to say that, of course, they have always
recognised that there was more to life than questions of class and economic
determination; that questions of culture and meaning have always been impor-
tant to them; that, of course, questions of race, gender and sexuality have always
been prominent among their concerns; that, naturally, the analysis of low-status
forms of fictional media production is important; and that, certainly, they have
never thought of audiences as passive dupes or zombies. Tell it to the marines,
say I. A look back at some early debates between these scholars and those
working in cultural studies (see Murdock and Golding, 1977; Connell, 1978,
1983; Garnham, 1983) shows quite a different story, in which all these things
that now, it seems, mass communications scholars have 'long recognized' have,
in fact, had to be fought for, inch by inch, and forced on to the research agenda
by those primarily within the cultural studies tradition, against the background
of much wailing and gnashing of teeth on the part of the political economists.[2]

One interesting issue here is that of the teleological structure of the argu-
ments of many of cultural studies' critics. Greg McLennan has observed that, for
some (e.g. Harris, 1992) it seems that 'once Gramscianism took off in cultural
studies, postmodernism was (the) logical consequence' (McLennan, 1994: 28).
In a similar vein, Simon Frith rhetorically poses the question of 'whether a popu-
list approach is the logical conclusion of sub-culturalism' in cultural studies, and
avers that he 'fears that the answer is, yes' (Frith, 1991: 104). Certainly, in my
own field of research, critics of the supposedly 'pointless populism' of 'active
audience theory' have tended towards a similarly *post hoc* structure of argument,
in which, having identified some particular case in which subcultural/consumer/
audience 'activity' is uncritically celebrated by an author with cultural studies
allegiances, they then retrospectively declare that this is the kind of (bad) thing
to which cultural studies, in general, was bound to lead and that therefore (con-
veniently reversing the terms of the argument) we can now see that the whole
cultural studies enterprise was, from the start, misconceived, as it has (in fact)
led to whatever example of bad practice they have identified. Which, of course,
leaves cultural studies' critics in the happy (or perhaps smug?) position of saying
that they always knew it would end in tears.

So much for teleology. The other issue, as I have argued in my response
(Morley, 1996) to my colleague James Curran's criticism of the 'new revision-
ism' in audience research, concerns the historiographical problem of the wisdom
of hindsight. My argument is that while the history which Curran offers of the

sociological precursors of cultural studies work on audiences is a very illuminating one, it is one which could not have been written, by Curran or anyone else, before the impact of the 'new revisionism' (of which Curran is so critical) transformed our understanding of the field of audience research, and thus transformed our understanding of who and what was important in its history. My own view is that it is precisely this transformation which has allowed a historian such as Curran to go back and reread the history of communications research, in such a way as to give prominence to those whose work can now, with hindsight, be seen to have prefigured the work of the 'new revisionists'. The point is that it is only now, after the impact of 'revisionist' analyses, that the significance of this earlier work can be seen. Previously, much of it was perceived as marginal to the central trajectory of mainstream communications research. The further problem, as Kim Schroder (1987) has argued is that, if sociologists already knew these things, why has it required cultural studies scholars to excavate this 'lost' sociological tradition? The answer that Schroder offers, and with which I, for one, incline to agree, is that in spite of the tributes now paid by Curran *et al.* to those who can, retrospectively, be identified as the forgotten 'pioneers' of qualitative media audience research, 'the fact remains that, until the 1980's, their qualitative work (was) the victim of a spiral of silence, because they attempted to study what mainstream sociology regarded as unresearchable – i.e. cultural meanings and interpretations' (Schroder, 1987: 14).

The gender of the real

Among some of those who call for a return to the eternal verities of political economy and the sociology of mass communications, it has now become fashionable to denounce the supposed depoliticization of cultural studies work as irresponsible, for redirecting attention away from the 'real' world of parliamentary politics, hard facts, economic truths (and their ideological misrepresentation by the media), towards the (by contrast) 'unimportant' realms of the domestic functioning of the media and of the consumption of fictional pleasures. In one version of this critique, it is argued that media power as a political issue has simply been allowed to slip off cultural studies' research agenda, as it has descended into 'a form of sociological quietism . . . in which increasing emphasis on the microprocesses of viewing relations displaces an engagement with the macro structures of media and society' (Corner, 1991: 4). This formulation seems to me to mal-pose the relation between the macro and the micro, both reifying the macro and unproblematically equating it with the real. In this connection we might also note the implicitly masculinist imagery of the complaint that cultural studies work suffers from a 'loss of critical energy' – a complaint which calls to mind Richard Hoggart's deathless phrase about how popular culture is responsible for 'unbending the springs of action of the working class'. Shades of Viagra, perhaps.

Moreover, the critique of cultural studies work in this field quite fails to address the articulation of the divisions macro/micro, real/trivial and public/private with those of masculine and feminine. Ann Gray (forthcoming 1998) has perhaps captured the gendered spirit of this critique most sharply in her comments on Dennis McQuail's use of the words (which I referred to earlier) 'flighty and opinionated' (McQuail, 1997: 55, quoted in Gray) – to characterize cultural studies work. As Gray notes, the supposed 'loss of critical energy' involved in attending to the role of the media in the articulation of the public and private spheres, and in investigating the deep and complex inscription of the media in a variety of forms of (necessarily gendered) domesticities, could only ever be understood as an 'abandonment' of politics within a quite unreflexive and unhelpfully narrow definition of what 'politics' is (cf. also Brunsdon's comments on the problematic status, for some scholars, of television studies as a 'connotationally feminised field' (Brunsdon, 1998: 108).

As Gray (1998) rightly observes, in her critique of Corner, his perspective simply presumes the greater 'reality' and superiority of the 'public knowledge' project (as he terms it) of media studies. I would entirely support Gray when she argues that the definition of 'politics' and the valuation of 'public knowledge' uncritically enshrined in the very premises of this critique must be understood to be heavily gendered (and 'race'-ed – cf. Husband (1994), Modood (1992), Pines (1992) on the largely unexamined issue of the 'whiteness' of the 'public sphere'). As Gray argues, within this perspective the importance of current affairs programming, and of the 'public knowledge' project, is simply taken for granted as is the implicit (and largely naturalized) hierarchization of the power relations therein, which this representation of the field demonstrates. Perhaps Liesbet van Zoonen puts it most starkly when she notes that the central problem here, which badly needs addressing, is the way 'the public knowledge project tends to become a new male preserve, concerned with ostensibly gender-neutral issues such as citizenship, but actually neglecting the problematic relation of non-white, non-male citizens to the public sphere' (Van Zoonen, 1994: 125, quoted in Gray, 1998). And, one might add, thus far at least, the 'public knowledge' project has largely tended to ignore the cultural dimensions of the economic institutions, market mechanisms and legal processes which are, in fact, integral (and indeed crucial) to the effective functioning of this sphere (see below).

It would be a great mistake to concede too much to those who call for a return to the 'eternal verities' of sociology, as a way out of the supposed 'dead ends' (cf. Philo and Miller, 1997) into which cultural studies work has supposedly led us. To do so would be to accept a quite truncated (and unreflexive) definition of what constitutes the 'real' and/or the 'political', built on unexamined premises in relation to the construction of gender, race and ethnic identities. The study of the media's role in the construction (for some people) of a relationship between the private and the public is logically prior to the study of the media's coverage of and contribution to the internal dynamics of that public, 'political' world itself. The

sphere of political communication has as its necessary foundation the series of inclusions and exclusions, on the basis of which only the private, domestic experiences of some categories of people are connected or 'mediated' to the sphere of citizenship (cf. Morley, 1990). If traditional public service broadcasting news and current affairs programming can be characterized by a serious, official and impersonal mode of address aimed at producing understanding and belief, then we must also note that the 'believing subject' which it aims to interpellate is by no means always available for conscription. In societies such as ours, where increasing numbers of people are quite alienated from the processes of formal politics on which 'serious television' focuses, it would be politically suicidal to fail to take seriously the field of popular culture in which people *do* find their attachments and identities (unless, that is, we prefer on account of their inadequacies to 'dissolve the audience and elect another' – to steal a phrase of Brecht's). Neither will it do to scorn the work of those who take seriously the investigation of these supposedly 'trivial' or 'apolitical' matters (cf. Morley, forthcoming).

Consumption, culture and the economy

I want also to return briefly, in this connection, to the contentious issue of the analytical status and priority to be given to concepts of production and consumption. As Gray (1998) has argued, the critical literature on cultural studies is characterized by a repetitive figuration of 'active audience theory' as the source of all evil, insofar as it has supposedly led cultural studies into a trajectory of work which is banal, naively celebratory and politically irresponsible. Much of the responsibility for this regrettable state of affairs is routinely laid out at the door of John Fiske's popularization of certain aspects of de Certeau's work, but as Gray points out, this generalized scapegoat figure often comes to stand in for any serious or detailed consideration of the work in question. I have elsewhere (Morley, 1992) outlined my own differences with Fiske's occasional position, but it has to be said that the alternative offered by the political economists' dismal perspective on questions of consumption has certainly, up till now, left more to be desired than Fiske's work ever did, notwithstanding Fiske's lapses into romanticism. To still dismiss, as many of cultural studies' critics seem to want to do, the insights of recent work on consumption on the grounds of the deficiencies of some early examples of it, seems to me no more than wilful blindness.

In response to the continuing critique of work on consumption in cultural studies, it is worth noting that the origin of the model of the 'circuit of culture' and of the articulation of production and consumption outlined so elegantly in the Open University's recent course on 'Culture, Media and Identities' (Open University Course D318) can be found, in essence in Hall's (1973) 'Reading of Marx's 1857 'Introduction' to the Grundrisse' (Hall, 1973: 20-1). As that paper explains, for Marx, consumption was no secondary or dependent part of a linear

narrative in which 'in the beginning was production'. In Hall's exposition of Marx, he notes that 'consumption produces production in two ways. First, because the production's object (the product) is only finally "realised" when it is consumed. . . . But secondly, consumption produces production – by creating the need for new production (p. 21). As Hall notes, for Marx, neither production nor consumption can 'exist or complete its passage and achieve its result without the other. Each is the other's completion' (p. 20). So much for the political economists' claim that there is any warrant in Marx's account for treating consumption as a 'secondary' or inconsequential matter. As the introduction to the Open University course has it, 'rather than privileging one single phenomenon – such as the process of production – in its explanatory structure, this model involves a "circuit of culture" – so that 'it does not much matter where (on the circuit) you start, as you have to go the whole way round before your study is complete' (Du Gay et al., 1996: 4).

However, the critique of cultural studies' research on consumption continues unabated. Thus Garnham (originally 1995, republished in a new version 1997) simply restates the now well-worked accusations that 'in focusing on consumption and reception and on the moment of interpretation, cultural studies has exaggerated the freedoms of consumption and daily life' (1995: 14), and that 'the tendency of cultural studies – in its desire to avoid being tarred with the elitist brush – to validate all and every popular cultural practice as resistance, is profoundly damaging to its political project' (p. 24). For Garnham, the solution is clear: 'to fulfil the promises of its original project, cultural studies now needs to rebuild the bridges with political economy that it burnt in its headlong rush towards the pleasures and differences of postmodernism' (p. 2). Thus, Garnham is quite happy to explain 'where . . . cultural studies has gone wrong and why political economy can help to put it right' (p. 3).

The problem with Garnham's argument, as Grossberg (1995) has noted, is that 'cultural studies did not reject political economy, it simply rejected certain versions of political economy as inadequate' because of their 'reduction of economics to the technological and institutional contexts of capitalist manufacturing . . . their reduction of the market to the site of commodified and alienated exchange and (their) ahistorical and consequently oversimplified notions of capitalism' (Grossberg, 1995: 80). The difficulty is that there can be no solution to the problems we face in returning to the version of political economy which Garnham advocates because, in Garnham's model, as Grossberg notes, production is too 'narrowly understood as the practices of manufacturing' and too 'abstractly understood as the mode of production', which is itself 'too easily assumed to be the real bottom line' (Grossberg, 1995: 74). Even classical political economy recognized that it too involved cultural premises (e.g. the utilitarian philosophy underpinning economic models of consumer choice). As Grossberg argues, if cultural studies must take economics seriously, none the less 'the way in which it takes economics seriously must be radically different from the

assumptions and methods of political economy' (p. 78), if it is not to fall back into economic reductionism and reflectionism. This, after all, was a major part of the point of cultural studies' analysis of Thatcherism in the UK – as a political and economic project, which was dependent for its success on a set of cultural transformations, not only of economic organizations, but also of conceptions of the self and of subjectivity (cf. Du Gay 1997), involving the construction of both an 'enterprise culture' and of a widespread acceptance of forms of personal life founded on the notion of the 'entrepreneurial self'. This, then, is to address the cultural dimensions of the forms of economic life itself and to recognize that beneath the 'bottom line' of economic transactions there must always lie some cultural framework within which the economy itself is constituted. To fail to recognize this, as Carey (1995) observes, is to lock ourselves back into the perspective of 'an increasingly abstract economistic Marxism that eludicates laws that (apply) to everyone and no-one . . . in its rigid inability to adapt to local circumstances (or) understand local knowledge [or cultural forms – DM] whether of a religious, familial, aesthetic or political sort' (Carey, 1995: 85). As Carey observes, without this kind of attention to the cultural specificities of particular forms of economic life, 'political economy usually seems dedicated to the solemn reproduction of the indubitable – which is to say that it is highly predictable and redundant, and rarely surprising' (p. 87). As Paul Willis observed long ago in this connection, the possibility of 'being surprised, of reaching knowledge not prefigured in one's stating paradigm' is crucial to the project of cultural studies (Willis, 1981: 90).

The slippery slope of intellectual progress

There are endless dangers facing any attempt to develop a schematic overview of work in our field which attempts to establish too clear and one-directional a story-line of 'intellectual progress', characterized by a series of clear epistemological and/or methodological breaks. We have been down that road too often before. The problem, of course, is what happens to the ideas and theories which are critiqued and 'displaced': are they to be entirely discarded or rejected? If so, we are likely to enjoy a succession of exclusive orthodoxies, each themselves enjoying a brief, if absolute intellectual reign, prior to their being dethroned by the next intellectually fashionable paradigm and removed to the dungeons reserved for the intellectually *passé*. Clearly, rather than thinking in terms of a linear succession of truths, paradigms or models, each displacing the previous one in some triumphal progress, we are better served by a multi-dimensional model which builds new insights on to the old, in a process of dialogue transformation which, if necessarily at points selective, is none the less syneretic and inclusive by inclination. The point may seem simplistic, but the pressures of a competitive academic marketplace militate against this approach and encourage

us all to make our way not, as Clifford Geertz once put it, by 'vexing each other more precisely' in a process of genuinely productive debate, but simply by putting others down, in order to raise ourselves up.

It is always necessary to appreciate the value of previous analytical work in the context in which it was produced. One very good example of this can be found in Hall's own subsequent self-reflexive comments on the 'encoding/decoding' model, now so much reified in the field. When interviewed about the model, a few years ago, by Justin Lewis and his colleagues at the University of Massachusetts, Hall was at pains to stress the extent to which it had been developed, for quite specific polemical purposes, in the context of a particular debate with the dominant mass communications models of the time. Moreover, he insisted that if the model still has any remaining purchase, that's 'because it suggests . . . an approach; it opens up new questions. But it's a model which has to be worked with . . . developed and changed' (Hall, 1994: 255). I would like to say something about the kinds of 'changes' involved here – about how and why such change is necessary and what it implies about previous work. To put the matter in autobiographical terms, when my own research shifted in emphasis, from the focus on the interpretation of a particular programme in the *Nationwide* work to the study of practices of media consumption, in *Family Television*, this was not because I no longer believed that the interpretation of programmes mattered. Rather, I was attempting to recontextualize the original analysis of programme interpretations by placing them in the broader frame of the domestic context in which television viewing, as a practice, is routinely conducted. This was not to argue for the supercession of the one concern by the other, but rather to attempt to move towards a model of media consumption capable of dealing simultaneously with the transmission of programmes/contents/ideologies and with their inscription in the everyday practices through which media content is incorporated into daily life.

At a more general level, in the abstract of a paper prepared for the International Association of Mass Communications Researchers' Conference in Glasgow in July 1998, Richard Johnson explains that his paper, 'Cultural studies: the revival of polemic' argues that, in the face of recent criticisms of cultural studies work on 'the popular', the key point is that, in the formative period in which that work began 'there was a tangible political need to broaden our conceptions of power and politics . . . (so) the focus on culture, even at the expense of other forms of power, was a rational priority of those decades'. However, as Johnson then goes on to say, of course 'the priorities for today are different: to . . . re-embed cultural analysis in further accounts of the social'. But – and this for me is the key point –

> This will not succeed . . . unless we take advances in cultural studies seriously. This means taking on board implications for other approaches: the failure of communications studies . . . to grasp the characteristic pressures of cultural forms; and the challenge to political economy to see the

cultural-in-the-economic, especially the cultural values and forms of social identity that sustain 'economical systems and lend them their inevitability'.

Now that does sound (provisionally, of course) like a good way forward to me.

Notes

1 This article is dedicated to the memory of Ian Connell, who would probably have disagreed roundly with some of it, but who always enjoyed a lively polemic.
2 Sections of this argument have previously appeared in Morley (1996, 1997).

References

Alexander, J. (ed.) (1988) *Durkheimian Sociology: Cultural Studies*, New York: Cambridge University Press.

Alexander, J. and Smith, P. (1993) 'The discourse of American civil society: a new proposal for cultural studies', *Theory and Society*, 22.

Appadurai, A. (ed.) (1986) *The Social Life of Things*, Cambridge: Cambridge University Press.

Barker, M. and Beezer, A. (eds) (1992) *Reading into Cultural Studies*, London: Routledge.

Brunsdon, C. (1998) 'What is the "television" of "television studies?"'. In C. Geraghty and D. Lusted (eds) *The Television Studies Book*, London: Arnold.

Carey, J. (1995) 'Abolishing the old spirit world', *Critical Studies in Mass Communications*, 12.

Clifford, J. and Marcus, G. (eds) (1986) *Writing Culture*, Berkeley: University of California Press.

Collini, S. (1996) 'The globalist next door' (Review of Morley and Chen (eds) 1996), *The Guardian*, 15 March.

Connell, I. (1978) 'Monopoly capitalism and the media'. In S.Hibbin (ed.) *Politics, Ideology and the State*, London: Lawrence and Wishart.

Connell, I. (1983) 'Commercial broadcasting and the British left', *Screen*, 24 (6).

Corner, J, (1991) 'Meaning, genre and context: the problematics of "public knowledge" in the new audience studies'. In J. Curran and M. Gurevitch (eds) *Mass Media and Society*, London: Arnold.

Curran, J. (1990) 'The "new revisionism" in mass communications research', *European Journal of Communications*, 5 (2,3).

Du Gay, P. (ed.) (1997) *Production of Culture/Cultures of Production*, London: Sage.

Du Gay, P., Hall, S., Jones, L., MacKay, H. and Negus, K. (1996) *Doing Cultural Studies*, London: Sage.

Eagleton, T. (1996) 'The Hippest', *London Review of Books*, 7 March.

Ferguson, M. and Golding, P. (1997) 'Cultural studies and changing times', Introduction to their co-edited volume *Cultural Studies in Question*, London: Sage.

Frith, S. (1990) Review article, *Screen*, 31:2.

Frith, S. (1991) 'The good, the bad and the indifferent – defending popular culture from the populists', *Diacritics*, 21:4.

Frith, S. and Savage, J. (1993) 'Pearls and swine: the intellectuals and mass media', *New Left Review*, 198.

Garnham, N. (1983) 'Public Service versus the market', *Screen*, 24:1.

Garnham, N. (1995) 'Political economy and cultural studies: reconciliation or divorce?', University of Westminster; reprinted (1997) as 'Political economy and the practice of cultural studies', in Ferguson and Golding (eds) 1997.

Gillespie, M. (1995) *Television, Ethnicity and Cultural Change*, London: Routledge.

Gray, A. (forthcoming 1998) 'Audience and reception research in retrospect: the trouble with audiences'. In P. Alasuutari (ed.) *The Inscribed Audience*, London: Sage.

Grossberg, L. (1995) 'Cultural studies versus political economy', *Critical Studies in Mass Communications*, 12.

Hall, S. (1973) 'A Reading of Marx's 1857 'Introduction' to the Grundrisse', *Centre for Contemporary Cultural Studies*, University of Birmingham.

Hall, S. (1977a) 'Culture, the media and the ideological effect'. In J. Curran, M. Gurevitch and J. Woollacot (eds) *Mass Communications and Society*, London: Arnold.

Hall, S. (1977b) 'The hinterland of science', *Working Papers in Cultural Studies*, 10.

Hall, S. (1980) 'Cultural studies and the centre'. In S. Hall, D. Hobson and A. Lowe (eds) *Culture, Media, Language*, London: Hutchinson.

Hall, S. (1994) 'Reflections upon the encoding/decoding model'. In J. Cruz and J. Lewis (eds) *Viewing, Reading, Listening*, Boulder, CA: Westview Press.

Hall, S. (1997) 'The centrality of culture'. In K. Thompson (ed.) *Media and Cultural Regulation*, London: Sage.

Harris, D. (1992) *From Class Struggle to the Politics of Pleasure: The Effects of Gramscianism on Cultural Studies*, London: Routledge.

Husband, C. (1994) 'The multi-ethnic public sphere', paper to *European Film and TV Studies Conference*, London, July.

Johnson, R. (1998) 'Cultural studies: the revival of polemic', paper to *International Association of Mass Communications Researchers Conference*, Glasgow, July.

McGuigan, J. (1992) *Cultural Populism*, London: Routledge.

McLennan, G. (1994) 'Margins, centres', *Sites*, 28.

McLennan, G. (1998) 'Sociology and cultural studies: the rhetoric of disciplinary identity', *Department of Sociology*, Massey University, New Zealand.

McQuail, D. (1997) 'Policy help wanted: willing and able media culturalists please apply', in M. Ferguson and P. Golding, (eds) 1997.

Modood, T. (1992) 'Not easy being British: colour, culture and citizenship', London: Runnymede Trust.

Morley, D. (1986) *Family Television*, London: Comedia.

Morley, D. (1990) 'The construction of everyday life'. In D. Nimmo and D. Swanson (eds) *New Directions in Political Communications*, London: Sage.

Morley, D. (1992) *Television, Audiences, and Cultural Studies*, London: Routledge.

Morley, D. (1995) 'Not so much a visual medium, more a visible object', in C. Jenks (ed.) *Visual Culture*, London: Routledge.

Morley, D. (1996) 'Populism, revisionism and the "new" audience research', in J. Curran, D. Morley and V. Walkerdine (eds) *Cultural Studies and Communication*, London: Arnold.

Morley, D. (1997) 'Theoretical orthodoxies'. In Ferguson and Golding (eds) 1997.

Morley, D. (forthcoming) 'Finding out about the world from television news: some difficulties'. In J. Gripsrud (ed.) *Television and Common Knowledge*, London: Routledge.

Morley, D. and Chen, K.H. (eds) (1996) *Stuart Hall: Critical Dialogues in Cultural Studies*, London: Routledge.

Murdock, G. (1995) 'Across the great divide', *Critical Studies in Mass Communications*, 12.

Murdock, G. and Golding, P. (1977) 'Capitalism, communications and class relations'. In J. Curran, M. Gurevitch and J. Woollacot (eds) *Mass Communications and Society*, London: Arnold.

Nugent, S. (1997) 'Brother, can you spare a paradigm?'. In S. Nugent and C. Shore (eds) *Anthropology and Cultural Studies*, London: Pluto Press.

Philo, G. and Miller, D. (1997) 'Cultural compliance: dead ends of media/cultural studies and social science', *Glasgow Media Group*, University of Glasgow.

Pines, J. (ed.) (1992) *Black and White in Colour*, London: British Film Institute.

Rogers, B. (1996) 'Burchill's Daddies': review of Morley and Chen (eds) 1996, *Independent on Sunday*, 18 February.

Schroder, K. (1987) 'Convergence of antagonistic traditions?', *European Journal Of Communications*, 1:2.

Smith, P. (1998) *The New American Cultural Sociology*, Cambridge: Cambridge University Press.

Tester, K. (1994) *Media, Culture and Morality*, London: Routledge.

Van Zoonen, L. (1994) *Feminist Media Studies*, London: Sage.

Wade, P. (ed.) (1996) *Cultural Studies will be the Death of Anthropology*, Group for Debates in Anthropology, University of Manchester.

Willis, P. (1981) 'Notes on method'. In S.Hall *et al.* (eds) *Culture, Media, Language*, London: Hutchinson.

Meaghan Morris

PUBLISHING PERILS, AND HOW TO SURVIVE THEM: A GUIDE FOR GRADUATE STUDENTS

Abstract

As the corporatization of universities worldwide proceeds, the opportunity gap is widening between students pursuing a research career from environments already rich in professional expertise, and students left to work out the rules for themselves. This article is a basic introduction to the practicalities of getting published in academic journals. After discussing why and how journals matter, it describes the three main types of publication that students will encounter: community-oriented magazines, refereed accrediting journals, and board-reviewed 'project' journals; suggests how best to approach them, and explains the rewards and drawbacks of each.

Keywords

graduate education; academic publishing; education industry; professionalism; refereeing; rhetoric

A word of warning

IN 1995, THE Graduate Centre of the University of Melbourne asked me to give a talk about publishing at a vocational conference for students 'involved in all aspects of journal production'.[1] I was very grateful to the organizers of *Publish or Be Damned!* for inviting me to fulfil an old wish. For years, I've been muttering about the need for humanities faculties and centres in Australian universities to run self-promotion seminars for aspiring research academics. 'Self-promotion' can be a harsh word. However, as the ideal of a tenured life of leisurely

contemplation fades into the past, it is crucial for universities to admit that practical skills are required to negotiate the world of competitive research, and that most of these skills can be taught and learned. If we fail to admit this, allowing students to expect that academic merit alone will succeed, then we help to foster an *invisible* elitism, charisma based, favouring those who 'just know' what the right thing to do might be – or who have family, friends and experienced or influential advisers to help them.

A word of warning to begin with: the following guide is oriented towards students who are new to academic publishing or are working in institutional contexts where experience and influence in these matters may be in short supply, so it will be too basic for some readers. It does not deal, for example, with the tricky rhetorical problems that getting published 'internationally' can pose for scholars writing in English but working outside the US or, in some instances, Britain (Morris and Muecke, 1995: 1–3). Nor does it deal in detail with the profound changes in intellectual agenda setting (of which the shift from 'criticism' to 'research' is but a symptom) that follow when work in the humanities is judged by funding and assessment criteria initially developed for the sciences. Nevertheless, beginning from basics is the only way to help students reach a position where such problems may arise, and many excellent teachers are not easily able to do so when the academy in which they themselves were trained is vanishing around them.

In countries where the corporatization of higher education[2] has entailed not only a proliferation of new institutions and interdisciplinary programmes (not always well funded or resourced), but also the reformatting of a once distinctive culture of state or 'public' education to mimic what is taken by reformers to be an American competitive ideal, universities are struggling to emerge from a period of great upheaval and rapid professionalization. In Australia the Oxbridge-derived model of what it meant to be a scholar, still dominant when I was a student, has definitively gone. Being brilliant but lazy, or learned but light in publications, is not a career option any more.

It seems likely that in future, research in the humanities as well as the sciences will be increasingly the province of specialists *at* 'research' – academics willing and able to sacrifice job security in exchange for the time to read, think and write. Under these conditions, the business of funding your research, even simply making a living, takes more than an aptitude for scholarship. You also need networking and budgeting skills, grant, application and CV-writing skills, telephone skills and even, in some circumstances, skills at 'doing lunch'. Above all, first and foremost, you need to know how to publish.

The rapidity of these changes has left many of us embarrassed about how to name them ('self-promotion', for example, sounds cynical) and this in itself can be disabling. So I focus here on two basic realities of journal publication: first, why writing for journals is worthwhile for students; second, what kinds of journal you can approach, and how.

Why do journals matter?

When I began thinking about this question, most of the answers I came up with resembled the contorted explanations I was given in the 1960s for studying Latin at high school. The real reason for doing so was that when I started high school (though not by the time I had finished), Latin was compulsory for entry to Sydney University – or at least, my family thought so. Perhaps they were wrong. Either way, Latin was seen as a gateway to the university, and I simply had to go through it.

Rarely was this spelled out. Instead, I was given a range of creative incentives: Latin helps you to learn French and Italian more easily (as though anyone who could handle Latin, as it was taught in those days, would have trouble taking French or Italian straight); Latin helps you to decode the labels on medicine bottles and to feel comfortable with the botanical names of plants; Latin gives you 'a tidy mind'. Years later, I realized that this last explanation was the best one, if 'a tidy mind' is taken as a euphemism for an intellectual killer instinct for solving seemingly intractable problems. I may have forgotten all my Latin, but reciting Cicero in the backyard at dawn while my friends went surfing and my grandmother fed the chooks taught me a lot about facing the irrational and unintelligible with equanimity.

So, too, there are many broad or displaced 'good reasons' for getting involved in journal publishing, many ways in which doing so will help you in whatever career or profession you eventually take up. The main reason, however, is the direct one. Journal publication is a gateway to the research academy. It isn't just a matter of accumulating CV items, although that is now as crucial an activity as completing a Ph.D. and it is disingenuous and foolish to treat it with contempt. Writing for and publishing journals is also a way to learn, in a contained environment, the basics of professional academic life – the social procedures, the protocols, the routine psychological and political conflicts as well as the ethical issues. It is also the best way to find out where the famous 'cutting edge' of your discipline really is, and to begin to have a say in defining it. This means that the first step towards writing for scholarly journals is to acquire the habit of reading them.

Why is this worthwhile? Many people wonder whether print journals have a future; they are perhaps more expensive to produce, and certainly much harder to sell, than ever before. Libraries facing funding cuts and storage difficulties are reluctant to maintain their journal holdings, let alone enlarge their subscription list. Clearly, the future for scholarly journals in general is electronic, and this is already affecting the very nature of journals and the uses we make of them.

Nevertheless, the journal *form* (as distinct from the journal object) will probably maintain its importance in the years to come, all the more so as it becomes easier to locate and order the items – whether articles or whole issues – that concern you. Alongside the rapid growth of electronic journals, it is possible to

browse through the holdings of a journal 'library' like CARL Uncover, have CARL e-mail you the contents of new issues of your favourite journals as soon as they appear, and have a copy of an article faxed to you in less time than it takes to go to your local inter-library loan facility.

The basic unit of the scholarly journal is still the article or essay, and for most of us the real question is not 'why journals?' but 'why articles?' Some people say that writing articles is a waste of time, that it's better just to write books. I think this is bad advice. New scholars need to do both. Journals are a good way, and may soon be the only way, for new scholars to become 'known', to develop a reputation as well as a CV. Journals are also a good way, and may soon be the only way, for new scholars to have a chance of reshaping their disciplines and of influencing the research agenda in their fields of study.

Let's begin at the most practical level – surviving as a researcher, and having some power to shape your future. The fact is that your prospects later in life may depend on having a convincing number of refereed journal publications on your CV. There are still ways around this in humanities-related areas; respect for the unusual path and for a broad range of achievements can sometimes carry the day, although it may take a long time to do so. It is also true that for graduate students the time when the issue of 'refereed articles' will arise as crucial is usually a long way off; but sooner or later the moment will come when a selection committee will start counting your refereed articles and comparing them to those of other candidates. All other things being equal (as they very rarely are), the candidate with three books and thirty articles is often in a stronger position than the candidate with four books and five articles, because of the esteem in which refereed articles are held. More to the point (when it comes to institutional realities), candidates without a strong showing in refereed journals are more vulnerable to selectors who want to block them for some other reason, which they then may not need to elaborate.

Journal publishing, then, is a formal requirement of a research career. A less straightforward but equally important reason for writing articles is that these days, book publishing does not alone suffice as a way to ensure that your work will be *read* by other practitioners of your discipline, let alone by other members of your profession. As in many other areas of academic life, the obscure mysteries of personal 'reputation' are here entangled with structural problems of power in the university and in publishing. How to become 'known', and how to have a say in what happens to the field, are overlapping, though not identical, issues.

Consider the changes in academic publishing over the past fifteen years. There was a time when academic books were published by heavily subsidized university presses and a few commercial publishers prepared to carry a prestige list at a loss. This system materially sustained the ethos of 'knowledge as intrinsically valuable'; a good book, containing original thought and research, carefully reviewed by experts and duly revised (often several times) for publication, could usually expect to find a home irrespective of its chances of making money. This

is no longer the case. By the end of the 1980s, academic publishing was an industry dominated by a few transnational corporations (Routledge is the best known) and a smallish number of large university presses either forced to live without subsidy, or drawing up plans to do so. Exceptions, like small presses, do remain. On the whole, most academic publishers are increasingly expected to be self-sustaining, and therefore to make a profit.

This changes the whole ethos of scholarly publishing. The 'Routledge' model has had a huge impact in diversifying the range of topics and approaches that academics can respectably take up, and in democratizing, to some extent, the market for academic books; for example, cultural studies books ideally may appeal to non-academic readers. On the other hand, this same model, variously adapted or modified, can involve a sacrifice at the level of editing and revision, which is often left largely to authors by some presses; intense pressure on new authors to invent fashionable, saleable topics which may have a short academic life once saturation point is reached in the market; and a tendency to pump out vast numbers of books while giving any one title only a few months to succeed before pulling it (or even pulping it) from the list.

The first two developments are survivable. For every academic milieu that regards a 'fashionable' product with disdain, there are now at least two more that value its public appeal and sense of social engagement. The last feature of the model – short distribution periods – is very dangerous for authors, especially for those working far from the conference circuits that give 'visibility' to new scholars in the US and Europe.

It means you can publish a book that few people – least of all the hyper-busy senior scholars whose decisions affect your career – may ever see before it disappears. Your book may be unobtainable by the time the slow machinery of academic reviewing has passed word out through the journals, two or three years later, that your work is important. This means that you are dependent on the quality and duration of your publisher's commitment to promoting you and your title, and this in turn means that the 'star' system in the academy today is not a by-product of our shallow, egotistical personalities but a structural feature of the publishing and research industry.

Most quality university presses still offer relief from these pressures; editing and revision are valued, areas of research that are rarely big sellers – such as textual criticism, fact-laden modes of social and economic history, educational theory – are more or less maintained, and books may have years rather than months to 'find a market'. Still, the combined effects of globalization and rationalization are taking their toll. For many publishers, sustaining the operation overall means selling as many titles as possible to as big a market as possible as often as possible. This is one reason why we have seen a huge growth in textbooks, primers and 'Introductions' on the one hand, and in giant anthologies (sometimes called 'doorstoppers') on fashionable topics on the other.

Primers can compete for the vast undergraduate textbook market in the US

and/or its much smaller (but, for us, relatively large) equivalent in Australia. Doorstoppers may also do that, and/or compete for use in graduate schools, and/or bundle together a number of niche markets, not all of them academic, across several English-reading countries – hence the attraction of blockbuster readers focusing on race, gender, sexuality, postcolonialism and multiculturalism. Given the wide social dispersal of interest in these topics, the prevalence of readers about them is not just a product of community pressure, or baby boomer power in the academy. Nor is it a political-correctness conspiracy. It is a commercial solution to a problem of supply and demand.

Taken together, these two publishing models define a difficult future for the budding academic author. I'll mention just two problems to consider, one to do with personal aspirations and the other with the dynamics of the profession, in order to say why I think that journals offer a provisional solution in each case.

First, part of the art of reputation lies in having your work included in other people's footnotes and bibliographies. This is one of those facts of academic life that embarrasses people: thinking about your reputation is shameful, like checking the footnotes to a text you haven't read. Well, as an untenured academic writer I live on my 'name', and I often check footnotes first. Footnotes attract your attention to new work as well as telling you about the circulation of your own; they are an intellectual map of the text you're about to read. Reputation is partly a matter of getting on to that map. While it is utterly self-destructive (really, it is) to put building a reputation before pleasure and integrity in your work, it is disingenuous and foolish to ignore it. Successful job, research grant and promotion applications all depend on being able to secure an ever larger number of testimonials from other scholars, some of whom, in competitive situations, will know you *only* by 'reputation'.

So beyond securing a contract with a publisher lies the more difficult task of having your book actually read, used and cited by other scholars. For this to happen in the economy of over-production we face now, it isn't enough that your book should be excellent. If scholars worldwide are not already reaching for your latest instant classic, there has to be some reason for your book to stand out in shops and catalogues from the dozens, perhaps hundreds of similar titles on closely related topics pouring out of Routledge, Duke, Minnesota, Cambridge, Oxford, Verso, Indiana, and Allen & Unwin. A good title, subtitle and book design helps. Mostly, I'm afraid, potential readers will be looking at your name.

How do you get a name? As I suggested before, giving papers at your discipline's annual convention, at special thematic conferences, and at large international marketplaces like the MLA, is one very important way. Equally important, and much cheaper, is publishing related essays and even fragments of your book across a variety of journals. There are many benefits to this. Senior scholars do tend to be obsessive about their patch; they check journals assiduously, monitoring new developments when they no longer have time to read books. Ambitious and/or passionate 'emerging' scholars read journals to gauge

the competition and to ensure that their own bibliographies are comprehensive and up to date.

Through this process, however sordidly pragmatic it may seem, you begin to acquire a readership, and thus, as letters and invitations begin to appear in response from strangers, a sense of professional belonging. People begin to make comments that are actually helpful to your work; sooner or later they start to quote your article. And this increases the chances that when your book finally takes its place on the shelves along with all the others, tiny bells will ring for shopping academics.

The second problem in publishing that journals can address is to do with intellectual innovation and generational power in the academy. I recently asked a senior editor where innovation might come from in a world of textbooks and doorstoppers. She answered, unequivocally, 'journals'. Both the writing of introductions and the compiling of anthologies are crucial academic activities; the profession could not survive without them. However, it is hard to imagine a vibrant future for academic books, or even academic life, should these become the dominant forms of publishing. Introductions rarely 'introduce' something new; they usually reinterpret and render accessible an existing area of work. Anthologies may include eccentric materials and foreground new voices; the essays are often drawn, in fact, from journals. But for a publisher to risk assembling a huge, unwieldy volume on a relatively specialized topic, the theme of the anthology needs to be saleable and safe. Hence the rhetorical sameness of all those readers on difference, and the conceptual homogeneity of most readers on multiculturalism.

Of course, publishers rarely order you to confine yourself to these forms. They will say that your excellent book on an unusual theme sadly 'doesn't have a market'. This usually means that they can find no one who teaches a course with a similar title to your book, or who expresses interest in ordering it for inclusion on a reading list. As teachers, we tend to order books with which we are already familiar, or new books and anthologies in areas that we already know. Something that doesn't quite fit the prevailing map is not really viable for most teaching purposes. Under the old dispensation, that did not prevent creative scholarship from being published and from staying in print. In the future, it may. It is already quite hard to publish anything original or heterodox in cultural studies, in this as in many other unheroic but significant worldly respects the 'cutting edge' of the humanities.

In this situation, journals are increasingly important as the places where new people can soften, as it were, the ground for change. No single essay in an issue, no one issue in a volume, ordinarily bears all the responsibility for the economic future of the project. If, as Tani Barlow (1995) predicts, journals melt quite soon into databases, this relative liberty of the individual item is not immediately likely to disappear.[3]

Which journals matter, and how?

There are broadly three kinds of journal for humanities researchers to consider: (1) the worldview-promoting journal that creates its own community (Australian examples are *Meanjin*, *Arena* and *Eureka Street*); (2) the well-established, refereed journal that accredits for a discipline or field (*Cultural Studies*, *Australian Historical Studies*, *Environment and Planning D: Society and Space*); (3) the special purpose or project-oriented journal created to make room for and legitimize a particular activity or perspective (*The Australian Feminist Law Journal*, *GLQ*, *The UTS Review*).

1 Community-creating journals

Journals like *Eureka Street* and *Arena* (progressive Catholic and post-Marxist publications respectively) are mini-public spheres, in which quite diverse people, including academics, interact. The circulation of any one of these may be small, from a few hundred to a couple of thousand copies (roughly the same, in fact, as the average academic book). Their power lies in the ways in which they connect to other media, including newspapers (by which their materials are sometimes reprinted), and the very mixed readership they attract. Spreading opinion through overlapping and interconnecting networks rather than accumulating a mass readership of their own, these journals can exert an influence that is wonderfully disproportionate to their size.

We hear much breast beating these days about the difficulties academics have with the media, and a supposed decline of the public intellectual ethos in an age of specialization. Community journals offer a relatively open and painless way for the most retiring scholar to go public. While there are far fewer of them now than in the past, as much because energy has passed on to zines and the Internet as because economic pressure has forced many journals to close, those that survive provide a bridge, quite directly, between the academy and the mainstream media (there are always journalists who read them), and they create pathways between many smaller interest groups. People who bemoan the good old days of the public intellectual (in historical practice, a leisured white gentleman) forget that a public is no longer the same thing as a mass market, let alone a homogenous milieu composed of bearers of a common culture. A 'general' public is a network, potentially infinite, of specialists – some academic, some not, some professional, some not, some forming larger social groups and some, constituencies of one. A community journal is a gateway to that network.

Despite all the breast beating, not much credit actually accrues, in our system, to the 'public' academic – unless he or she also has substantial professional qualifications. So it is fair for a new researcher to ask: what's in it for me? Well, apart from helping you to become known (and to a degree that you should not underestimate), publishing in community journals will give you two kinds of experience.

One is in learning to deal with the mismatch between your own passions and obsessions and those driving the rest of the world. To acquire an acute and relaxed sensitivity to the relative unimportance of your immediate interests in the wider scheme of things is advantageous to a researcher; as well as helping you to formulate problems that don't just surge from your unconscious, it will teach you to *frame* your projects in more sociable, realistic and thus potentially effective ways.

The other experience that working with community journals provides is perhaps a more technical version of the same thing. It forces you to learn to negotiate other, even alien worlds of discourse; it will help you to become 'multilingual' as an academic writer. Having a deep, practical knowledge of what it means to speak *differently with* (not for or to) different people in different contexts is more than a first step in being able to 'find' a decent readership. It is a way of acquiring the ability to create networks of discussion, to *form* those relationships that constitute a public.

In my view, this is the only sensible solution to the problem of jargon in cultural studies. The difficulty is not that we use jargon in our specialist journals and papers, unless we use it badly. Nor is it really that some of us expect newspapers and magazines to publish slabs of it in the letters column, or late night talk show hosts to croon it on public radio. The difficulty is that many of us forget how to tell the difference between our jargon and someone else's, or we simply never learn where our jargon begins and ends; and then, faced with recalcitrance to our talk of incommensurability, counter-hegemony and the play of the differend, we respond with the only other language we remember: baby talk; we abandon our knowledge and patronize our public. Whereas what we should do is learn to translate, as many of us do between varieties of English in everyday life – and that means learning *as academics* to use other social languages with grace, complexity and skill.

Writing for a community journal is one of the best ways to acquire what is becoming an increasingly vital capacity for translation; in this respect, the stylistic conservatism, simplicity and sobriety favoured by many such journals makes them an excellent training ground. For it isn't just a matter of learning, as an academic, to 'face' the media. As universities grow larger and more complex, it will be crucial for humanities researchers in future not only to know how to serve diverse publics if we wish to, but how to translate our interests effectively when necessary for other scholars, bureaucrats, benefactors and business people who know nothing about what we do and will need a reason to care.

2 *Refereed journals*

At the other end of the spectrum are the journals that administer what can count as a proper contribution to a discipline. Publishing in refereed journals has long been crucial in the soft as well as the hard sciences, and, even though the whole

notion of 'refereeing' is a contentious one, it is rapidly becoming crucial in the humanities as well.

What is refereeing? Humanities journals follow two basic models. The purer and more respectable model, science based, is 'double blind review', where your manuscript is sent out minus your name and address to readers (the number may vary) who write reports that will be forwarded to you as anonymous. In the second model, widely used in practice and often called 'peer review' in the hope of fooling scientists on committees, the author's name and location is supplied to the referees (thus providing basic information about gender, ethnicity, national context, etc. as the author wants these represented) but the referees remain anonymous.

Anonymous texts are funny things. There are powerful arguments for refereeing as a way to secure fairness in a hierarchical profession.[4] Nevertheless, paranoia haunts the system. Most of us play guessing-games, especially in a small society such as Australia's, and the danger of having an insane or eventually embarrassing over-reaction to a nameless piece of text is ever present for referees. Blind review was not designed for the rules of evidence and the criteria of evaluation that most humanities scholars actually use, working as we do in areas of speculative inquiry concerned with opinions and emotions. Anonymous reviews can be unfair and very harsh, so the immediate practical issue posed by refereed journals to new researchers is how to approach them effectively.

My main piece of advice is so basic it may sound trivial: USE YOUR SPELLCHECK and, if you have even the tiniest worries about your grammar and punctuation, use a grammar check as well. Then check your manuscript at least once more for those lucid mistakes (for example, 'it's' for 'its') that your computer can't pick up. Never let a manuscript go until it's as perfect as you can make it. There will always be typos and slips remaining for copy-editors to correct. The real point of checking, however, is to let the referees know you did it.

The whole issue of 'literacy', and what it means for whom, is a fraught one, I know. But let me leave aside the big debates about the causes, the validity and the future of the current malaise about literacy levels and the power-laden concept of 'standards' in higher education, and just focus on what actually happens when your manuscript reaches me, or someone like me, for refereeing.

The truth is – I don't really want to read your article. I *really* don't want to read it. It's one of a dozen nameless texts that I have sitting on my desk, and refereeing is one of more than a dozen demanding chores I'm supposed to handle regularly while producing competitive research myself. I can't do all the things I need to get through in a day; it isn't possible. I'm only reading your article now because the editor has rung me up, saying 'For God's sake! You've had it for weeks! This person is still waiting!' So I feel guilty, and that makes me cranky. I'll have to ring my own editor to admit that I'm going to miss another deadline. So I feel anxious, and that makes me even more cranky.

So if I can tell, within the first two or three pages, that you haven't checked

your work at the most basic level of presentation, your chances of getting past me are not great. I will form an image of you as 'careless', and I will wonder grumpily what else you haven't checked. If English is not your first or even second language, I won't know that, any more than I will know for sure what variety of English you speak and what your cultural background may be; and I will try not to guess, because I know how dangerous guessing can be with blind review – not least, these days, because of the possibility of pastiche, parody and fraud. Above all, if your grammar and punctuation are so hazy that I have to spend time every other sentence to puzzle out what you're trying to say, I will begin to hear my life ticking away and I will feel very strongly indeed that you are making me do work that you should have done yourself. So I will finally return your article – perhaps months after you first submit it – as 'not ready for publication'.

This is not the worst scenario you can encounter. I'm not a hard reviewer. Crabby as I may be, I'm not a pedant; I'm hazy myself about the finer points of usage; as a Research Fellow I have more time than teaching academics (and most referees are teachers) to puzzle over what you mean. I love linguistic diversity and inventiveness, and I don't believe that bad spelling or hazy grammar in any language will lead to the collapse of civilization as barbarians pour through the gates; I don't regard it as my special mission in life to smite each 'barbarian' who crosses my path. But if you submit an article to a refereed journal, especially an international journal, your chances of striking someone who really does think like that are, in most fields of research, quite high.

No one needs to suffer over spelling these days, so *use* your spellcheck, then read the manuscript slowly and carefully one more time before you post it. Grammar and punctuation are trickier. Grammar checks are agonizingly slow to use and turn all prose to identikit pulp. All things considered, you would lose far less time from your own life by learning grammar – or grammars – yourself. I know it's hard for people to seek help in this area. For many reasons it's fairly easy, even a bit macho, to admit to being hopeless at spelling, but it is much more painful to reveal uncertainty about how sentences and paragraphs work.

Nevertheless, it is worth getting help if you need it. It certainly isn't your fault or a failing if you do; it isn't shameful to need help; and it *is* easy to do something about it. No one should have to suffer over grammar and punctuation. If you can use a manual, if you can learn a new computer application, you can teach yourself the basics of 'standard' grammar and punctuation; in many ways it's a similar process with similar goals and outcomes. You do have to learn a few technical terms so that you can understand the manuals, but you don't need to master all the refinements to work well on an everyday basis. Nor do you need to change your own habitual styles in other kinds of writing.

This takes me back to the point I made at the beginning about invisible new forms of elitism. Most people will concede that to be 'computer illiterate' is a disadvantage these days. When it comes to sentences and paragraphs, however, we spin off into ideological debate and grand historical prediction; the

'proprieties' of writing, some of us say, are only instruments of hegemony and imperialism — and isn't all that breaking down anyway, being displaced by a hybridized babel of differing discursive practices?

Well — no, not within the immediate framework of your real lives as researchers; not when you submit an article without patronage to a refereed journal or send a book to a publisher where no one knows you; not when you have to compete, more frequently and directly as the globalization of publishing proceeds, with other, perhaps equally passionate critics of hegemony and imperialism from many countries who went to those select and excellent schools able to lay on both the latest computing equipment *and* the very best language teaching for their pupils.

Once you've submitted your article in fine shape and good faith to the journal of your choice, there is one more ordeal to endure: the reports. You will almost always receive criticism and be asked to make revisions. You may be fortunate: the reports may be fair, caring and constructive. They may also be cruel and stupid: some US-based journals and book publishers have developed a tolerance for highly personalized, parochial, politically emotive and argument-free reports that I find deeply shocking. If you receive one of these, do try not to feel that a lunatic rant demolishing your character and psychoanalysing every line you wrote (often on the assumption that you are or should be engrossed in American social conflicts) really is a personal attack. It isn't; blind reviewers joust with phantoms.

There are three things you can do if this happens, apart from extracting honest comments from friends and mentors. You can make positive use of the experience by working out what you did to trigger this tantrum, and whether or not you want to avoid doing it again. If you are sure that the report really is unjustified as well as intemperate, you can write a gentle, courteous and reasonable rebuttal of its claims (not a lunatic rant) to the editor, asking where he or she 'wants to go from here'; an editor is sometimes glad to have a pretext to try another reviewer. And you can immediately submit your article somewhere else.

3 Project-oriented Journals

These are usually the most exciting and inspiring journals to work with as well as to read. They're less stodgy than the disciplinary gatekeepers, while allowing you the space and academic depth that few community journals can handle. And they're flexible with forms and conventions.

Journals with a special theme or purpose may be refereed, or they may be directly edited by one person or a few people with a board to give advice when the editors need it. Since project journals usually aim to achieve legitimacy as well as to give expression to new academic interests, they may eventually become accrediting journals: this has happened with *Camera Obscura*, for feminist cinema studies, and with *Cultural Studies*, now edited from the US and published by Routledge but once the *Australian Journal of Cultural Studies* edited collectively in Perth.

Project-oriented journals create institutional space and an aura of serious-ness for an activity that the editors and writers really care about; they share some of the features of both community-creating and disciplinary journals. They tend to be most interesting when they are not systematically refereed; those who care most rigorously and idealistically about the activity do the work of inventing the values and standards that will shape research.[5] On the other hand, such journals involve an enormous amount of work. If they are not refereed, almost all of this falls on a very few people; for this reason (along with dodgy funding), they often collapse after a few splendid issues. If they survive, they tend to foster networks of patronage that overly influence or restrict what is published; when this happens, they turn into more or less stable coterie publications that may or may not maintain a wider readership.

This is the form of academic journal publishing in which graduate students can most easily participate themselves. Anyone with energy and enthusiasm can start a journal, even if very few of us can keep one going for long. Creating a durable institution is not, however, the only valid reason or aim we might have when bringing out a journal, and a journal doesn't need to last forever to have an effect. So I'll conclude with a few comments about why it can be rewarding to become an editor for a while.

Editing journals is perhaps the most direct way in which new scholars can influence or change a professional agenda. It helps you to acquire a greater ease with publishing yourself, although in practice you often don't write much while you're editing; it allows you to promote the kind of work you care about in a visible and organized way, and it gives you a platform from which to offer alterna-tive models of what your discipline could be doing, along with critiques of what it actually does. Editing gives you a licence to experiment, fool around, make mistakes in good company, and take risks that a lone researcher might be rash to contemplate.

I think that experiencing this 'licence' is becoming more, not less, important as professionalization proceeds. The highly competitive and oedipalized gradu-ate schools that we are developing can foreground mentor–disciple anxieties at the expense, sometimes, of common sense and collaborative thinking. There are many good things about this 'US' model; in the old, British-influenced system I grew up in, doing a doctorate was a test of your capacity to stay more or less sane for years of isolation. But it does tend to keep young scholars too preoccu-pied for much too long with what their teachers think is important and how their teachers perceive them. In this context, editing a journal is an effective and practical way of forming those powerful and lasting peer relationships (enmities included) that will, in the long run, matter most in the course of your academic life.

In other words, editing is a social experience that gives you an admirable preparation for responsible professional work. In that respect, it really is a bit like learning Latin. It won't necessarily give you a tidy mind, but it can certainly

train you to deal with the more irrational and unintelligible aspects of everyday academic life. To be an editor is in some ways to see that life at its worst, or at least to see it as bad as it gets before you too have to sit on committees 'referee-ing' other people's futures.

As a partial outsider (the Australian Research Council Senior Fellowship I hold now is the first full-time academic job I've ever had), I'm often struck by the infantilism of university culture – so many forty-, fifty- and sixty-somethings raging around with the sensitivities of babies. Perhaps part of the problem is that we are overtrained to *interpret*. In the process, we may come to lack imagination; we can't imagine that another person's actions or gestures hold no secret message for us. One of the first things you learn as an editor is that nothing you say or do is ever trivial or accidental; you are possessed of fantastic, sinister powers which you wield with the basest of motives. Misplace a manuscript, and you did it on purpose. Send an infelicitous e-mail, and you reveal your true self as an arrogant, power-hungry megalomaniac. Reject or criticize an article, and you declare your complicity in a multitude of hideous historical crimes.

Editing will not make you popular; paranoia is an occupational hazard for academics. I find that the hard part about this aspect of editing is not surviving the quarrels and denunciations, or even retaining that vital ability to ask yourself whether your critics may perhaps be right. The hard part is always remember-ing that most people don't actually think much about you and your journal – in other words, retaining your own capacity to imagine an academy full of people whose actions and gestures hold no special message for you.

If you can do this, work very long hours for no pay, work other long hours to make money and still produce your own research, all the while remaining cheerful and actively committed to scholarly values, then you will be able to cope happily with anything that the academy or any other institution can throw at you in later life. Happiness is important; publishing, whether writing or editing, should be something you enjoy. Economic rationalism has taught us to believe that 'realities' must always be punitive and grim. The reality of journal work – the bottom line – is that academic publishing is too perilous an activity to pursue without happiness and enjoyment.

Notes

1 My thanks to Genevieve Hassall for inviting me to participate. A first version of this essay appeared in *Publish or be damned! : Resource Materials*, a booklet com-piled from the conference proceedings by Eleanor Hogan for the University of Melbourne Postgraduate Association. This excellent guide includes material about 'Publishing your thesis as articles or a book', 'Editing', 'Getting a journal out to print', 'How to write a review', and a list of journals and other publi-cations that accept contributions.

2 For differing evaluations of this development, see Cohen, 1993; Hunter *et al.*, 1991; Readings, 1996.
3 Tani Barlow is the senior editor of *Positions: East Asia Cultures Critique*.
4 For a critical discussion of these, see Fish, 1989.
5 Sometimes called 'journals of opinion', project journals that are not anonymously refereed are often closer in spirit to 'the small magazine tradition that specialises in politically oriented cultural criticism' (Slack and Semati, 1997: 211) – that is, to what I have called 'community-creating journals' – than to the disciplinary gatekeepers. Slack and Semati's article discusses the well-known hoaxing of one such journal, *Social Text*, by physicist Alan Sokal, who treated the editors' decision to publish his text despite the criticisms they had of it as 'a decline in the standards of rigor in certain precincts of the academic humanities' (see Slack and Semati, 1997: 201). Given the ease with which this incident was widely assumed to reveal a failure of *refereeing* symptomatic of a field, rather than an error of judgement by a group of editors, it suggests that in certain precincts of the university and the media, the 'free-thinking' ethos and traditions of the journal of opinion – historically the richest seed-bed for innovative thought in the humanities – is no longer valued or even understood.

References

Barlow, Tani (1995) 'Triple double bind: editing *Positions*', *The UTS Review*, 1(2): 57–83.
Cohen, Sande (1993) *Academia and the Luster of Capital*, Minneapolis: University of Minnesota Press.
Fish, Stanley (1989) 'No bias, no merit: the case against blind submission'. In *Doing What Comes Naturally*, Durham and London: Duke University Press, 163–79.
Hunter, Ian, Meredyth, Denise, Smith, Bruce and Stokes, Geoff (1991) *Accounting for the Humanities: The Language of Culture and the Logic of Government*, Brisbane: Institute for Cultural Policy Studies.
Morris, Meaghan and Muecke, Stephen (1995) 'Editorial', *The UTS Review: Cultural Studies and New Writing*, 'Intellectuals and communities', 1(1): 1–4.
Readings, Bill (1996) *The University in Ruins*, Cambridge, MA, and London: Harvard University Press.
Slack, Jennifer Daryl and Semati, M. Mehdi (1997) 'Intellectual and political hygiene: the "Sokal Affair"', *Critical Studies in Mass Communication*, 14(3): 201–27.

Alan O'Shea

A SPECIAL RELATIONSHIP?
CULTURAL STUDIES, ACADEMIA
AND PEDAGOGY

Abstract

For all the vigorous debate within cultural studies, little attention has been paid to its own institutional practices and pedagogies. A misunderstanding of 'institutionalization' can lead to the idealist positioning of the cultural studies practitioner as an 'outsider' or a romantically marginal 'semiotic guerrilla'. Individual subjects (including deconstructionists!) are always positioned within various institutional practices (which are also crossed by wider sociohistorical forces), and hence are neither fully 'inside' nor 'outside' any of them. Why has cultural studies, which specializes in the analysis of closure, and also in pedagogy (cultural transmission), such an underdeveloped analysis of its own practices? There have been several pressures towards a pedagogic orthodoxy in the field: institutional marginality and the need to demonstrate 'scholarliness', pushing innovative energy into writing not teaching; increasing workloads, encouraging routinization and repetition; and political caution in the context of the minefields of identity politics and the critique of Eurocentrism.

But the expansion of higher education is pushing pedagogy back on to the agenda: new kinds of students are forcing academics to reconsider how to teach without taking either traditional cultural capital or literacy for granted. What now constitutes the cultural politics of their teaching? Giroux and colleagues have revitalized the discussion of a critical pedagogy which minimizes closure. But some of this work shares the weaknesses of an earlier 'student-centred' discourse in attempting to supersede the inevitably differential positioning of teacher and student. Academics should not (because they cannot) renounce their intellectual authority, their 'maps', and should remember that students only negotiate, rather than absorb, those maps. Making these differential positionings an object of

study for students is not only as 'open' as we can probably get, but also embodies the political 'project' of cultural studies, with its focus on critique, reflexiveness, inclusiveness, contingency and many-sidedness.

Keywords

cultural studies; academia; institutional practices; critical pedagogy; political project; deconstructionists

IF SELF-SCRUTINY has a reinvigorating effect on academic disciplines, cultural studies should be blooming with health and vitality. There has not only been a seemingly unending flow of accounts of its 'development', but also conferences and publications debating its possible agendas and futures (see e.g. Grossberg *et al.*, 1992). And in many respects the field is fighting fit. But while the intellectual agenda has had so much attention, discussions of the institutional practices of cultural studies are underdeveloped, particularly the question of pedagogy; surprisingly so, because its object of study is, in a strong sense, pedagogy itself: the production and dissemination of knowledges within institutional practices. One would expect that cultural studies would not only have conducted an extensive debate about pedagogic practices, but also about the practitioner's relationship to the academic institution. There have been recent attempts to discuss these matters (Bennett, 1996; Frow, 1995; Giroux, 1994; Giroux and McLaren, 1994), but though these studies offer valuable insights, they should be seen as initiating the debate rather than as mature and definitive accounts.

I want to push this discussion forward by attempting to pose the practitioner's relation to the academic institution (focusing on higher education) in a way which acknowledges tendencies towards self-reproduction but also assigns a place to historical contingency, in which effects are not pre-given but the outcome of specific struggles. I will also consider whether cultural studies, because of its particular project of pursuing a critical relationship to the academy and also to wider social relations, might be understood to have a *special* relationship to the institutions in which it operates. Finally, I suggest some pedagogic practices based on the perspective I have developed.

The constraining institutional practices, professional ideologies and forms of exclusion, self-protection and distancing which constitute the culture of academics and particularly social scientists and cultural analysts have been the object of much recent scrutiny (Bauman, 1987; Bourdieu 1984, 1988; Frow, 1995). It is clear that economic, industrial and institutional conditions determine (in Raymond Williams' sense of exerting pressures on and setting limits to) our social position – including our location within a class fraction (Frow, 1995: 98ff.) – and our cultural capital. No practitioner of cultural studies should be unaware

that however 'free' we feel in the choices we make in our work, the practices in which we engage constitute us as particular kinds of subjects and exclude other kinds. The more routinized our practices, the more powerfully this closure works.

There is, however, a danger in pushing the professionalization argument too hard. There is a tendency to overemphasize the extent of closure, even in the more sophisticated versions, such as that of Frow (1995, chs 3 and 4). Frow, drawing upon Apparadurai, argues that cultural institutions are constituted through and sustained by 'regimes of value' which regulate the practices within them and the grounds upon which judgements are made (p.144ff.); these are relatively autonomous regimes such that there is an 'incommensurability' between them. A key motive in his application of this argument to the field of cultural studies is to warn against cultural populism. We should, he argues, avoid espousing either the norms of high culture, which exclude those without cultural capital, or 'the norms of "popular" culture to the extent that this involves, for the possessors of cultural capital, a fantasy of otherness and a politically dubious will to speak on behalf of this imaginary Other' (Frow, 1995: 159). One can see why he wants to accentuate the gulf between 'regimes of value' in order to issue this salutary warning: the main thrust of the book is to make us aware that we cultural analysts are as fully caught up in knowledge/power relations, and hence 'distinction' (Bourdieu, 1984) as any other social group, and are always-already speaking for ourselves, even where we claim to be getting inside someone else's culture. However, the *relative* autonomy of regimes slips easily into 'incommensurability' – an apparently full autonomy, a closure of practices and cultural systems from each other. But Frow also knows that society/history is more complex than this, and makes it clear that people (especially cultural analysts) can buy into regimes of value to different extents, and move between them; he also acknowledges 'overlaps' between them. But neither of these points are developed: they are descriptive additions, rather than deriving from the 'regimes' model, which delivers an emphasis on closure. Pressures towards closure and differentiation do of course operate. But any account of the 'real relations' of cultural studies practitioners should also examine the social forces which produce these overlaps if we are to grasp the concrete complexity and contradictoriness of that experience.

A theoretical instability of this kind has been characteristic of various models of institutional power. Foucault, aware that his 'regimes of truth' do not encompass all social life without challenge, invents 'reverse-discourse'. Althusser, having produced a neatly functionalist account of 'ideological state apparatuses', realizes that there is no space for contradiction, struggle and change here, and adds a postscript saying, 'By the way, these effects/functions are only secured by class struggle' (Althusser, 1971). This self-correction is on the right lines, but there is inadequate reflection on why he seems to need two different kinds of explanation. The problem is one of levels of analysis. To understand how

practices perpetuate themselves we have to move in the direction of abstraction and functionalism, and ask, to the extent that a system does reproduce itself, how does it function? Marx subjected capitalism to this kind of analysis in *Capital*, Volume I, Part I, and elaborated his theory of the commodity form and the extraction of surplus value. But capitalism *doesn't* always 'function', in the sense of operating smoothly in the interests of capital – as we see when we read Part III, which moves into a different mode of analysis, directed towards, among other things, the historical struggles over the length of the working day (where, in some instances, capital loses battles over how much surplus value it can extract). It is sometimes important to produce an abstract, functionalist (or structuralist) account of a system: when it works unimpeded, what is its logic? But we must not mistake this level of abstraction, the one-sided, ahistorical identification of systems, for the real, for the concrete, contested multidimensionality of specific historical moments. From this perspective, discourses are struggled over in every terrain; even the bases of struggle can shift historically; certain practices achieve dominance, but that dominance is never fully secured; practices and struggles leak into each other, new forces emerge and new constellations of alliances. These struggles may be specific to the institution or to local conditions, but in others cases will represent the contestation of wider social forces and thus connect the institution to other institutions and tie it into broader historical processes.[1] This is the case for all 'historical' (in the sense of contested and changing) social formations and the institutions within them. In structuralist and functionalist representations of society, boundaries are tight, class cultures uniform and we all stay in our allotted places: there is no space to account for contestation and consequent changes in the balance of forces. Hence, what Frow (influenced by Bourdieu and Foucault) has in fact produced is an account of one kind of determinant on our practice: it may be one of the most powerful determinants, but it remains a one-sided abstraction rather than a characterization of the many-sided and often contradictory nature of our concrete experience. In order to understand the limits and possibilities of the conditions in which we work, we have to examine all the 'relations of force' (Gramsci, 1971: 177ff.) which bear upon them in any given historical moment.

The dominance of monolithic models of the institution, and indeed of similarly monolithic models of Western society (as an expression of bourgeois ideology, of the Cartesian ego, of bureaucratic rationality, of Eurocentrism, patriarchy or whatever other expressive totality one might substitute) have affected much poststructuralist, postmodernist and postcolonial writing in the field. If the institution/society is understood as one-sidedly reproducing those structures, then critique must come from 'outside' these. Much deconstructionist work displays this tendency. Deconstruction is, and must remain, a powerful (and disruptive) tool of cultural studies. But its effects can be weakened if its relation to institutionalization is misunderstood (and over-romanticized). The deconstructionist is often (self-)represented as an outsider or as a marginal figure, a 'semiotic

guerrilla'. There is a logic to the self-marginalization of the cultural analyst, the logic of distanciation, adopted in order to make visible and explicit the unspoken bases of knowledge/power relations which 'ordinary people' take for granted. Roland Barthes provides an early articulation of this lonely but somewhat romantic outsider position at the end of his 'Myth today' essay:

> I must, as a conclusion, say a few words about the mythologist himself . . . his status remains basically one of being excluded. . . . His speech is a metalanguage, it 'acts' nothing. . . . He can live revolutionary action only vicariously. . . . Also the mythologist cuts himself off from all the myth-consumers and this is no small matter. If this is applied to a particular section of the collectivity well and good. But when a myth reaches the entire community, it is from the latter that the mythologist must become estranged if he wants to liberate the myth. . . . His connection with the world is of the order of sarcasm.
>
> (Barthes, 1973: 156–7)

Dick Hebdige picks up on Barthes' dilemmas when he concludes his widely read *Subculture: The Meaning of Style* with this observation:

> The study of subcultural style which seemed at the outset to draw us back towards the real world, to reunite us with 'the people', ends merely by confirming the distance between the reader and the 'text', between everyday life and the 'mythologist' whom it surrounds, fascinates and finally excludes.
>
> (Hebdige, 1979: 140)

The prevailing tone of sadness here is, however, undercut by Hebdige's elaboration, in both introduction and conclusion, of his fascination for and identification with Jean Genet, thief, liar, sexual deviant and arch-'refuser' – a perspective which also informs his celebration of the anarchic tendencies of punk. This kind of 'romance of the margins' can be identified in the work of many cultural critics, not just in relation to writings on popular culture, but also in the positionings of feminists and postcolonial critics (Connor, 1989: 228ff.). Of course, many of these have indeed had to argue from marginal positions and against powerful odds, but this is different from celebrating that marginality.

It is crucial that the deconstructive urge, the drive to denaturalize everything, remains at the core of cultural studies. But although the figure of the cultural bandit offers our work a certain glamour and piquancy (and hence is popular with students), it misrepresents its social location. Distanciating methodologies applied to the culture in which one lives does produce difficult and even contradictory relations, but they are not as simple as the inside/outside logic, or even the centre/margin model offered here. The cultural critic is

always-already positioned *within* institutions. To speak publicly at all you do not have to belong to a *state* institution, but you do have to operate within one set or another of 'institutionalized' codes and practices, with historically determinate modes of production, distribution and consumption. Barthes, in fact, had his institutional base and his field of academic engagement, forging an interdisciplinary debate across the fields of cultural anthropology, structural linguistics and Marxism. 'Intervention' thus always has to be from within the social formation: if there are margins these are inside, not outside its field(s) of social and cultural exchange/struggle.

The counterpart of this argument is that the 'inside' is not monolithic – a single 'closure' which the analyst has to escape. Rather it is a field of contestation: in fact, the closer one gets to the detail and flux of concrete historical situations, the more it appears as a field of many kinds of interlocking contestations. I am simply arguing that dominant/subordinate relations are more usefully conceptualized as (unequal) struggles over power, rather than as inside/outside relations, or even centre/margin relations.

But even so, is there perhaps a case for seeing cultural studies as occupying a special relation to 'institutionalization', given that its whole project has been both to challenge specific institutional fixities, particularly in the humanities disciplines, and to mount a general critique of knowledge/power regimes? After all, cultural analysts are specialists in making visible what 'ordinary people' do not see. Could they perhaps thus be able to adopt a more distanciated relationship to their institution than other practitioners? In an important sense the answer is no: the freer we feel of institutional positioning, the more unconscious, and therefore effective, that positioning is likely to be: in this case, as Bourdieu would point out, this self-representation as an 'insider critic' would be the particular form our self-reproduction as an elite was taking. But a historical/conjunctural perspective, of the kind I have proposed, suggests that it is not a question of 'institutionalized or not?' For struggles take place within and across institutions, and, as we saw in the student movements of the late 1960s, the processes of (elitist) self-reproduction can be vigorously and effectively challenged. We will always be positioned; but perhaps our positioning within a cultural studies 'subculture' ('sub-institutional culture'?) will allow a different kind of practice from that of other academics to be sustained. One might expect the cultural studies teacher to be more thoughtful pedagogically than practitioners in older, more static disciplines without such a committed project. But we may not find this: other, countervailing forces may neutralize that potential.

In fact, if we turn our attention to the recent history of the positioning of cultural studies practitioners within institutions of higher education, we can begin to explain why there has been so much debate about the intellectual formation of the field and so little about pedagogy. So far I have made a general argument at the level of conceptual frameworks which can be applied to all institutional experiences. But the historical conditions in which practitioners of

cultural studies operate vary both nationally and between institutions. What follows is largely about the conditions I am familiar with – in a 'new university' in urban Britain. Readers from outside that context will be able to construct a modified account to grasp the particular balance of forces in which they operate.

First, and more generally, the intensity of the attempts to 'invent traditions' for cultural studies and to define or map the field can be understood in terms of powerful conjunctural determinants – economic, political, cultural and theoretical. Some of these manifest themselves at the level of the academic institution. John Frow notes, of work in cultural studies, both 'a commitment to the institutions of cultural capital, and simultaneously a set of anxieties about its place within these institutions' (Frow, 1995: 130). No doubt the investment in marking out cultural studies results in part from the instability of professional academics in a field whose parameters are not yet settled, in institutions where they are still struggling for recognition, in a sector which is expanding and simultaneously 'rationalizing' (cutting costs, setting performance indicators, quantifying research output, etc.), in the context of the sweeping class recompositions of a new phase of capitalism (of which the increased international migration of academics is a part). In other words, cultural studies academics are driven to legitimate and secure institutional positions and careers. There are also broader determinants – historical changes and theoretical reflections on those changes – which force uncertainty, revaluation and self-scrutiny. These include the crises (ecological and human) produced by an ever-accelerating technology-driven productivism; the shake-out from decolonization – including the new audibility to the Western intellectual of non-Western voices; the collapse of the Soviet bloc; the misting of a socialist vision; and the rise of identity politics. Theoretical responses to such changes – recent critiques of 'the project of modernity', and, in particular, postcolonial critiques of its Eurocentrism – have forced those academics who have taken these issues on board to be very cautious about who they can speak *for* and *to*. As Bill Schwarz points out, cultural studies is an *instance* of the turbulence of the postmodern and the postcolonial moment, as well as attempting to develop an analysis of it (Schwarz, 1994). All these instabilities make it attractive to withdraw our horns and settle for operating within an enclosed world of academia,[2] particularly if we examine more concretely the forms of 'rationalization' referred to above.

These have exerted particularly significant pressures against the kinds of practice cultural studies has proposed for itself in the past – collaborative, interventionist, pedagogically innovative, etc. In my own institution the forces for inertia – for the establishment of an orthodoxy which is then perpetuated uncritically – do not come, as can often be the case, from senior academics clinging on to traditional disciplines: we have a large and well-established department of cultural studies such that no humanities work in the institution operates outside a cultural studies framework. Rather, the most powerful forces against innovation are those arising from the inexorable decline in the funding of higher

education in Britain, and from the introduction of various methods of auditing 'performance'. The former produces heavier teaching loads, larger classes, more assignments to be marked. The latter involves both extensive bureaucratic work and a pressure to conform course structures into forms which facilitate measurement (i.e. modularization). This in turn restricts modes of teaching and assessment. This same culture *formally* encourages innovation both in terms of subject matter and pedagogy, and indeed assigns high value to these factors in teaching quality assessments; but in the face of the sheer volume of workload, the academic's line of least resistance is to repeat courses, materials and methods, to conserve energy by routinization and repetition.

These pressures are extended by the mode of allocation of state funding for research: a research assessment exercise which is primarily based on the grading of the published output of individual scholars. Since the funding for teaching is fixed, winning research funding is the only means of buying time away from teaching and administration. The assessors for research in cultural studies are our peers and hence already critical of canonization and how it can be sustained through a pecking order of journals: they have resisted any such mechanical ranking; nevertheless, they are required to assess the national and international influence of research output and cannot but reward what is already dominant. What is noticeable here is the focus on the individual researcher (a much smaller weighting is given to the collaborative research cultures which support individual output). And since research output can enhance funding, the individual's market value is determined by publications: advancement comes through publication, not through good teaching.

These tendencies have to be understood as part of a broader political culture. In the mid-1990s the New Right might appear to be rapidly losing its hegemony over political discourse, with political parties concerned to represent themselves as standing for a more 'caring' society, thus displacing Margaret Thatcher's figures of the thrusting entrepreneur and the more productive (i.e. more exploited) worker. The discursive climate has changed, but, in higher education at least, these figures continue to inform *policy* – the increased exploitation of the worker through the reductions in funding, the isolation of the activity of each worker through the focus on individual performance – through the (threatened) mechanisms of performance-related pay as well as through the research assessment exercise. Informing all this is the thrust of late 1980s Thatcherism – the much ridiculed but nevertheless insidious 'enterprise culture'. This is in fact an ambiguous concept and can open up useful spaces for innovation: there is, for example, a sense in which we do want our students (and ourselves) to be 'enterprising' – to work collaboratively with others, to communicate effectively, to identify imaginative ways of solving problems and achieving goals. These skills will help them to become critical and activist members of society. But the dominant articulation has been a competitive individualist one, in which financial gain, upward mobility and public display/recognition of success have been the primary goals.

Cultural studies academics have not been able to remain aloof from these tendencies, and in many cases have looked to enhancing their own institutional positions. This attention to career development is not simply self-seeking. The most vigorous forms of politics of the 1980s, outside of the New Right, were various kinds of identity politics. One of the strategies for validating an identity is to gain power: one feminist strategy has been to press for more women MPs, university professors, etc. This is a tricky route for any individual – once you have been received into the establishment, will you still want to change it? (See Walkerdine, 1996). It will also win praise from the Thatcherites: after all, you have pulled yourself up by your own individual effort. Some of the younger generation of academics, educated in the late 1980s, have tended to embrace careerism with less ambiguity, finding less conflict between the identity politics which energizes their research and an attention to personal advancement. This tendency is unsurprising, given the research culture which the new funding mechanisms promote. The point at which a vigorous commitment to teaching and research driven by an identity politics tips over into a careerism in which external recognition and personal promotion become the major motivation is an imperceptible one. In short, personal ambition on the conference circuit, as depicted some time ago in David Lodge's novel *Small World*, though still dominated by the USA, is now fully installed in the British cultural studies scene. Building up your CV is a rising preoccupation and the question is whether this can be sustained without inhibiting that other impulse – to tackle cultural problems because you want to achieve social change.

In the above conditions it is not surprising that any spare energy has gone into intellectual debate, conferences and publishing – no bad thing in itself, simply that it tends to turn attention away from the education of students. And if the former activities build careers, it is in the latter, in their teaching, where academics can lend their weight most effectively to changing social awareness – not by attempting to recruit their students to particular political positions, but by developing critical skills, sociocultural 'maps', and an awareness of the contingency of existing social relations, such that our graduates will be able to locate themselves in the cultural-political formation, and to devise effective interventions. In the context of 'mass higher education', mass lectures and stressed-out tutors, there is a real danger that these goals may not be realized for many students, and of slipping instead towards an education which consists of learning a body of received knowledge and repeating it back for assessment without turning it into tools to think with, into 'really useful knowledge', as the nineteenth-century working class self-educators called it.

These are the pressures towards a conservative pedagogy. But the resource reductions are so severe that even those traditional forms of teaching are beginning to fall into crisis. Mass higher education is not simply about the sheer weight of numbers. It also entails new kinds of students, whose early culture had no aspirations towards extended education, and who may anxiously see themselves

as educational failures, or alternatively may be aggressively determined to have an education on their own terms. There is also a generational shift in how people consume their knowledge (for example, less reading, more television). These factors make the literature of cultural studies more problematic for many students, especially because of its range of reference and its frequent (mistaken) assumption that we all have some kind of map of modern cultural history and know, in particular, what canons have existed. These factors too have forced pedagogy back on to the agenda. Alongside these tensions, the discourse of 'quality assurance' has raised student expectations about what they can expect from a course: they are not going to settle for some form of routinized neglect. Pedagogy has become a central theme for the latest wholesale review of higher education which is currently under way in Britain (the issue is frequently attached to the utopian technological solution of 'open' or 'distance' learning).[3] Within this broader debate, it is crucial that cultural studies practitioners contribute their special insights – their 'high theory' and their conjunctural groundedness – in order to sustain a pedagogy such that Stuart Hall's formulation of the field's central focus, 'to address the central, urgent and disturbing questions of a society in the most rigorous intellectual way we have available' (Hall, 1992: 11), becomes a project for our students too. This will involve summoning up energy, resources and imagination against the odds in particular sites, and learning from each other, through *debate*. For two decades, such a debate has been virtually non-existent in Britain. Judith Williamson (1981) poignantly pointed out that the concept of ideology, for all its radical implications, remains material to be learned passively and mechanically unless students come to understand that they themselves are positioned within ideologies (See also Johnson, 1980). Although courses (such as our own at East London) have quietly experimented with ways of encouraging students to consider their own positionings within social discourses and also to deploy the resources of cultural studies in interventionist projects developed by themselves, this work has not benefited from the clarification which published exchanges can bring. All the more reason for welcoming the recent, energetic reintroduction of such a debate in the USA by Henry Giroux and colleagues (Giroux, 1992a, 1992b, 1994; Giroux and McLaren, 1994; and in *Cultural Studies*, 1992, 17(1)). Giroux has argued for a critical pedagogy which goes beyond teaching a body of knowledge or particular skills, but which should be seen more in terms of a cultural production, with a central focus on students producing writing which addresses their own experience, all directed towards educating people 'to be active and critical citizens capable of fighting for and reconstructing democratic public life' (1992b: 199). No mean task!

 This work raises many important issues (for example, about the tension between expanding social horizons while connecting to experience, about teaching in an age of identity politics, etc.) which need further exploration as urgently as the single point I am able to pursue here. This follows through the question of the academic's positioning within the educational institution. Lawrence

Grossberg's introduction to the collection *Between Borders: Pedagogy and the Politics of Cultural Studies* (Giroux and McLaren, 1994) is full of insights about the distinguishing features of cultural studies as a pedagogic project; but one argument, in my view, still needs further clarification. He attempts to avoid all traces of an elitist presumption of what students need to know, and argues for a 'pedagogy of articulation and risk' in which the teacher renounces any monopoly of 'truth' to be imparted to students and even any claim to know in advance the skills a student will need to engage in 'emancipatory and transformative action', on the grounds that these will be contextually specific. We should therefore renounce our 'intellectual authority' while 'retaining responsibility for the production of knowledge in the classroom', providing instead a 'model of thoughtfulness', which works from 'the formations of the popular, the cartographies of taste, stability and mobility within which the students are located', and discovers

> what the questions can be in the everyday lives of our students, and what political possibilities such questions open up. . . . We must connect to the ethics and politics they already embrace and struggle to articulate them to a different position (without necessarily knowing in advance that we will be successful, or even what that different position will actually be). At the same time we must collectively articulate a common affective vision of a shared political future based on a politics of practice . . . rather than on a politics of identity.
>
> (Giroux and McLaren, 1994: 18–20)

My first concern is that the attempt to steer away from assuming knowledge of the students' needs appears to leave in place the assumption that the students *have* real needs, rather than, as Baudrillard and others have convincingly argued, seeing needs as always-already a social construction, and hence a site of contestation. Second, while Grossberg is explicit that teachers cannot give up their authority in the classroom, at times his argument suggests an intention to transcend the knowledge/power relations between student and teacher, rather than to reconstruct them. For all his efforts to avoid speaking for the student, he does not ultimately escape such elitism: it returns in the form of a (broad-based) political agenda which will be familiar to (and widely endorsed by) readers of this journal. This is not only carried in the 'common vision', but also in the assumption that the students' politics will *need* rearticulating. The proposed political terrain is one that critical intellectuals have been hammering out over the past twenty years. For all its openness, and the space in which students can negotiate their studies, it is *our* terrain – the terrain of our cultural competencies – upon which the students are invited to operate. Hence the knowledge/power relations remain weighted in the same direction; and rather than being presented as a justifiable level of closure, it is presented as a break with closure.

There is in fact no way out of an unequal power/knowledge relationship between teacher and student: certainly as long as the programme of study contributes to accreditation – that is, where the student is subject to assessment. But even where this is not the case, students (at least in non-compulsory education) come to a teacher because of the latter's expertise, and to subject themselves, however provisionally, to that expertise in order to extend their competencies in some respect. The 'real relations' of pedagogy thus involve an uneven, differently motivated encounter between the teacher's knowledge/culture and that of the students. There is no possible transcendence of this either by the teacher trying to 'purify' his or her own discourse before engaging with students, or by attempting to be an 'open facilitator'. An attempt to reach out to and rearticulate students' existing cultural formations still mystifies the differential positioning of teacher and student. Invisible authority, such as that shrouded in a discourse of openness and 'risk', is the most powerful kind. Furthermore, this Gramscian model of articulating what he called 'common sense' to a 'shared political future' might be appropriate for a political movement, but within an educational institution it feels too manipulative. The requirement upon us as public educationalists to be neutral is, of course, an impossible one; nevertheless, there is some consensus that, as a pedagogy, cultural studies should stop at the point of offering a terrain of debate and tools – analytic skills and knowledge of cultural processes – for whatever use the students wish to make of them, rather than offering a particular articulation of that terrain. The Giroux and McLaren collection displays a clear awareness of these points, and Grossberg's slip, if it is that, simply illustrates the difficulty of taking on board their full implications, and of maintaining a distanciated perspective on our own practices. The suggestions which follow may have the same kind of flaw.

Rather than trying subtly to include the students within the discursive framework of a 'common affective vision', we might more successfully reduce the extent of closure by accepting that lecturers and students represent different (and internally differentiated) social forces, with some common and some differing interests, who may forge alliances for some purposes but not for others. We can address this relationship by proceeding with our teaching programmes (which would offer not just strategies and skills but work on historically specific sociocultural formations, and also include an attention to existing student cultural competencies), but also by explicitly opening up the questions of knowledge/power that are at issue here. We should not (because ultimately we *cannot*) renounce our 'intellectual authority' – our 'maps' of theoretical debates and methodologies and of particular social formations and processes. Furthermore, when considering student learning, we should bear in mind how academics learn. As researchers, when we are attempting to refine our maps, a key moment is to locate and test the maps of other scholars, rather than attempting to reinvent wheels. This should also apply to students: they too can work by critique – of the 'regime of value' unavoidably built into our programmes, and in this way

refine their own maps and techniques of analysis, so as to become more effective 'critical citizens'. We can encourage this process by making the pedagogic relation one of their objects of study — such that they deconstruct our problematics alongside many others. We should not be too worried about framing their thought within a closed meta-discourse: such omnipotence is not within our grasp. Students only ever *negotiate* the discursive frameworks proffered by their course, rather than being inscribed within them. A course will not *produce* the student's future identity. It offers one set of understandings at one point in their lives. It could be a strong influence — people (of whatever age) tend to become students at formative moments in their lives. But it remains one element of many from which individuals forge their sociality.

I am not proposing endless and regressive navel gazing, but a regular return to reflexive review, so that our partiality, our system of inclusions and exclusions, is made as visible as possible, responded to and possibly modified as a result. The structures of power/knowledge are not of course dissolved by this relation. There is no pure solution: the formation of culture and language itself which inscribes both teacher and student precludes full transparency. And of course, by orchestrating this critique of what we offer, we are exercising a control. But (speaking from experience!) we may not be able to contain what such a space opens up for students: we will be confronted by responses which disturb us and pressure us to make changes. But (and here I fully endorse Grossberg's motivations) such democracy-in-practice and 'will to reflexivity' embodies and pre-figures the social relations which are inscribed in the cultural critique offered by cultural studies, and we should not shrink from applying them to our own situation.

How this is approached is not straightforward. The agenda which has been developed for cultural studies (critique, reflexiveness, inclusiveness, contingency, many-sidedness, etc.) is complex — it cannot simply be announced at the commencement of the course: students will need to understand something of the debates in order to grasp its logic. It will have to be elaborated at various points in the students' programme. There is no doubt that any concrete syllabus and pedagogy will fall short of those aspirations — they are, in the best sense, utopian. A key moment might be when the object of study is institutional closure itself, taking as an instance the students' own programme of study, and including a deconstruction and mapping of its openness/closures by the students, who can check these against its own expressed aims.

Finally, a point that really needs more exploration than is possible here: despite my quibbles, the emphasis of Giroux, Grossberg and colleagues on the connection with experience is crucial. Students do not 'learn', in the full sense of acquiring understandings which become part of their outlook and which they then use *to think with*, unless they connect that knowledge to their existing frameworks of reference — unless they 'make it their own'. We should encourage and facilitate this process, not only pointing out possible connections ourselves but

by instigating activities, including written assignments, which explore the relationship between personal engagements and bodies of knowledge. And if we wish to discourage a more cynical appropriation of the course materials and teaching inputs, we should avoid forms of assessment which merely require students to provide evidence that they have understood the arguments, in favour of work which sets the methodologies and knowledges they have encountered to work on projects which they have had a hand in devising.

In this outline of the conditions in which many cultural studies practitioners currently have to operate, I have tried to avoid the binarism, the either/or-ism, which still features in much cultural analysis (not at all surprising, given the influence structuralism has had): like all cultural phenomena, the institutions we engage with are many-sided, multiply determined (and hence only ever partially determined by any single relation), contradictory and polysemic; hence their effects will be historically specific rather than given by any aspect of their 'nature'. Similarly, because of our own multiple identifications, we are also, often contradictorily, 'both/and' rather than 'either/or' – neither fully 'inside' nor 'outside' the institution or any element of it. A 'pure' position – as a critic or as an educator – is impossible (and would in any case be a nightmarish positioning). All this is commonplace to readers of this journal, but it is so easy to forget when thinking about our own practices. But the politics of cultural studies (its agenda of social critique, reflexivity, etc.) can nevertheless serve as a yardstick for thinking through questions of pedagogy. The suggestions I have made here are tentative, incomplete and touched by the theoretical instability of which I have accused others, and will no doubt attract criticism. But since our changing material conditions will *force* new pedagogies anyway, it is important that cultural studies practitioners argue these issues through, and intervene where they can. In this way the politics which the field has declared for itself (and the variants of it which come through the different identifications of those working in the field) may become part of those material conditions and help to determine new practices.

Notes

1 See the CCCS Education Group *Unpopular Education* (London: Hutchinson 1981) for an analysis of the British school system as a site of struggle crossed by broader social and political forces. Even 'closed institutions' such as prisons are not exempt from this argument.

2 See Edward Said's (1985) scathing account of such a tendency in the field of literary studies.

3 This is not to disparage this mode out of hand. The Open University has played a key role in the development and dissemination of work in cultural studies and continues to do so with an excellent new programme on 'Culture, media and identities'. But as a pedagogic practice several issues are still to be resolved (Bennett, 1996).

References

Althusser, Louis (1971) *Lenin and Philosophy and Other Essays*. London: New Left Books.

Barthes, Roland (1973) *Mythologies*. St Albans: Paladin.

Bauman, Zigmunt (1987) *Legislators and Interpreters*. Oxford: Blackwell.

Bennett, Tony (1996) 'Out in the open: reflections on the history and practice of cultural studies, *Cultural Studies*, 10 (1): 133–53.

Bourdieu, Pierre (1984) *Distinction*. London and New York: Routledge.

Bourdieu, Pierre (1988) *Homo Academicus*. Cambridge: Polity.

Connor, Steven (1989) *Postmodernist Culture*. Oxford: Blackwell.

Frow, John (1995) *Cultural Studies and Cultural Value*. Oxford: Oxford University Press.

Giroux, Henry (1992a) *Border Crossings*. New York: Routledge.

Giroux, Henry (1992b) 'Resisting difference: cultural studies and the discourse of critical pedagogy'. In Lawrence Grossberg *et al. Cultural Studies*. New York and London: Routledge.

Giroux, Henry (1994) *Disturbing Pleasures*. New York and London: Routledge.

Giroux, Henry and McLaren, Peter (eds) (1994) *Between Borders*. New York and London: Routledge.

Gramsci, Antonio (1971) *Selections from the Prison Notebooks*. London: Lawrence & Wishart.

Grossberg, Lawrence, Cary, Nelson and Treichler, Paula (eds) (1992) *Cultural Studies*. New York and London: Routledge.

Hall, Stuart (1992) 'Cultural studies and its theoretical legacies'. In Lawrence Grossberg *et al. Cultural Studies*. New York and London: Routledge.

Hebdige, Dick (1979) *Subculture: The Meaning of Style*. London: Methuen.

Johnson, Richard (1980) 'Cultural studies and educational practice'. *Screen Education*, 34: 5–16. Reprinted in Manuel Alvarado *et al.* (eds) (1993) *The Screen Education Reader*. London: Macmillan.

Said, Edward (1985) 'Opponents, audiences, constituencies and community'. In Hal Foster (ed.) *Postmodern Culture*. London: Pluto. (Originally published as *The Anti-Aesthetic*, Bay Press, 1983.)

Schwarz, Bill (1994) 'Where is cultural studies?' *Cultural Studies*, 8(3).

Walkerdine, Valerie (1996) 'Subject to change without notice: psychology, postmodernity and the popular'. In James Curran *et al.* (eds) *Cultural Studies and Communications*. London: Arnold.

Williamson, Judith (1981) 'How does girl number 20 learn about ideology?' *Screen Education*, 40: 80–7.

Tony Bennett

CULTURAL STUDIES: A RELUCTANT DISCIPLINE[1]

Abstract

This article reviews recent debates regarding the disciplinary status of cultural studies. In doing so, it takes issue with the tendency for cultural studies to fight shy of characterizing itself as a discipline. This involves an examination of the respects in which, especially in Australia, cultural studies has now acquired all the institutional trappings of a discipline. It is suggested that those perspectives which view the institutionalization of cultural studies as tantamount to its co-option rest on a misreading of its earlier history and of its relations to the education system. In terms of its intellectual characteristics, it is suggested that cultural studies is distinguished by a number of traits regarding its approaches to the analysis of the role of culture in relations of power and subjectivity. It is these qualities, it is argued, that have allowed cultural studies to play a more general role as an interdisciplinary 'clearing-house' within the humanities. The article concludes by considering the qualities that have most distinguished Australian cultural studies, placing the stress on its strong feminist orientations, its contributions to our understanding of the relations between culture and nation, and its role in connecting cultural studies to the concerns of cultural policy.

Keywords

culture; institutionalization; interdisciplinary; multiculturalism; policy; power

IN A RECENT book review, Ann Curthoys summarizes her sense of what history has to gain from cultural studies as 'a consciousness of method, language, textuality and mode of address, a complex sense of the meaning of "culture" itself,

and cultural difference'. She is equally clear about what history has to offer cultural studies: 'a concern with the specificities of time and place, and the narrative techniques that can assist us in attempting the difficult tasks of exploring and trying to relate to one another those processes we call class, race and gender.' The place from which she herself writes, however, is somewhat less definitely identified. In a postscript to the review, Curthoys describes herself as among those who 'continue to live (if uncomfortably at times) at the history-cultural-studies intersection, with no fixed address' (Curthoys, 1996: 518). There are, perhaps, few fixed addresses left in the humanities. None the less, Curthoys' description is helpful for my present purpose in introducing cultural studies in a manner which emphasizes its intersections with another discipline. Other writers coming from different intellectual backgrounds and perspectives would have chosen different disciplinary intersections – for example, with anthropology, literary studies, or sociology. There are, however, few among those who describe themselves as working in cultural studies who would not share Curthoys' sense of doing so in a way which also involved working at a set of mobile interfaces between cultural studies and one or more other disciplines.

This suggests that a survey of cultural studies might need to take a slightly different form than might be appropriate in the case of more established disciplines. Its relative newness, the highly variable institutional settings in which cultural studies research and teaching take place, and the still relatively unsettled nature of its aspirations argue against the plausibility of a magisterial survey of its strengths and weaknesses. Instead, then, I have organized my survey in a manner calculated to identify the kind of place – intellectual and institutional – that cultural studies can now most usefully aim to occupy within the humanities. I have therefore concentrated on three matters.

1 First, I outline the general characteristics of cultural studies with a view to identifying its distinctive interdisciplinary qualities and the strategic value of those qualities in the changing contexts of higher education. I have, for this purpose, surveyed Australian cultural studies in the context of the international trends and dialogues that have influenced its formation.
2 I then concentrate on the distinctive characteristics of Australian cultural studies as determined by both the intellectual traditions on which it has drawn and the institutional circumstances in which it has been developed.
3 Finally, I turn to the question of the directions that might most usefully be plotted for the future development of research and research training in cultural studies and of the measures that might be taken to support these.

Before coming to these matters, however, some comments are in order regarding what has been a marked reluctance, on the part of many working within the field, to define cultural studies as a discipline. While there are undoubtedly important issues at stake here, a good deal of this opposition to conventional forms of disciplinarity has rested on questionable premises and led to

unacceptable conclusions. It is, then, to a preliminary sorting out of these matters that I address myself first, as I see a reasoned and realistic assessment of what is involved in the claims of cultural studies to be interdisciplinary as being crucially important to the futures it might wish to develop for itself, and which representatives of other disciplines might be inclined to support, in the broader context of the humanities.

A reluctant discipline

Although accounts of its formation vary on particulars, it is generally agreed that cultural studies has developed through a process of critical engagement with the assumptions and procedures of earlier, more established disciplines which have shared its concerns with, loosely defined, the patterns of interaction between culture and society. As a consequence, there has been a tendency to fight shy of claiming a disciplinary status for cultural studies. This opposition to disciplinarity has been based partly on the view that the intellectual strategies of cultural studies have been, and should continue to be, mobile and adaptive in ways that militate against their codification as a set of disciplinary methods. It has also reflected the view that the institutional connections of cultural studies should accord more importance to its relationships to social movements and constituencies outside the academy than to its position within universities and the education system more generally.

Yet, if we survey the scene today, cultural studies has all the institutional trappings of a discipline. It has a recognizable and increasingly prominent place in university curricula in Australia, the United States, Canada and Britain, and is acquiring an increasing institutional momentum in universities in the Asia-Pacific region and in South Africa. In all cases, however, cultural studies has acquired its initial institutional bases in newer universities. In Australia, for example, institutions like Murdoch University, Griffith University, and, as it was then, the New South Wales Institute of Technology were primarily responsible for nurturing the early developments within Australian cultural studies. It has since, however, spread rapidly through the higher education system with some of the older universities like the University of Melbourne, the University of Sydney and the University of Queensland making significant cultural studies initiatives in the late 1980s and early 1990s. However, it has still to make any appreciable headway at Adelaide University, the University of Western Australia, the University of Tasmania and James Cook University. Its influence is evident at most other universities, however, with positions at Chair level having been established in a good many cases: for example, Griffith University, Queensland University of Technology, Central Queensland University, the University of Melbourne, The University of Queensland, the University of Western Sydney and the University of Technology Sydney. While departments of cultural studies are rare (the

institutional settings in which cultural studies is taught are varied, including departments of English, sociology, anthropology, and communications and media studies), degree programmes in the field are quite common at both the undergraduate and graduate levels. Equally important, cultural studies subjects or majors now comprise significant elements of interdisciplinary degree programmes just as they often contribute to programmes in disciplines such as history and sociology. Such subjects are also frequently included in other interdisciplinary curricula contexts – for example, those of women's studies and postcolonial studies – while they also have a place in the curriculum of the Open Learning Agency of Australia.

There are a number of international refereed journals associated with the field and, in Australia, at least three refereed journals that are closely associated with cultural studies and a good many more that regularly publish cultural studies work. The most relevant journals in Australia are *Continuum: The Australian Journal of Media and Culture* produced by the Department of Media Studies at Edith Cowan University; *Culture and Policy*, produced by the Australian Key Centre for Cultural and Media Policy and now merged with *Media Information Australia*; and *The UTS Review: Cultural Studies and New Writing*, produced by the Faculty of Humanities and Social Sciences, University of Technology, Sydney. *Continuum* has recently been adopted by the Cultural Studies Association of Australia as its official journal. Other Australian journals which have regularly featured cultural studies issues and debates are *Southern Review*, produced from Adelaide University, *Social Semiotics*, produced from Central Queensland University, *Meanjin,* produced from the University of Melbourne, and the independent *Arena* and its successor *Arena Journal*. The major international journal is *Cultural Studies*, currently edited from the University of North Carolina. However, *New Formations*, edited from the University of Bristol, has also played an influential role in the development of the field while two new journals – the *European Journal of Cultural Studies* and the *International Journal of Cultural Studies* – have recently been announced. A number of series have been published with a cultural studies focus, the most influential, in Australia, being the Australian Cultural Studies list developed by Allen & Unwin and the Interpretations series published by Melbourne University Press.

There are also cultural studies associations in Australia and Britain. Although neither of these is especially effective as a professional organization, they do organize conferences, circulate newsletters, etc., and, in doing so, have played a role in helping to construct a sense of shared intellectual concerns, national and international networks, etc. The Cultural Studies Association of Australia was founded in 1990 when it held its inaugural conference – 'Cultural Studies: Practices and Positions' – at the University of Western Sydney. Since then, the Association has held an annual conference on a diversity of themes. It has also, although only intermittently, published a newsletter and, as of 1996, lent its support to a journal. Beyond this, however, the Association has had little impact on the

development of cultural studies and is unlikely to do so given its current organiz-
ational form which connects responsibility for the Association to the responsi-
bility for organizing its conference. As this latter task shifts annually from one
university to another, this arrangement significantly reduces the likelihood that
the Association will ever prove able to provide effective national leadership or
be able to play a coordinating and advocacy role that has the long-term and stra-
tegic interests of cultural studies in view. I shall return to this issue later.

There are also, finally, a number of research and graduate centres with either
major or minor interests in cultural studies. Indeed, cultural studies has often
commenced its institutional career at particular universities via the establishment
of research centres aiming to serve as intellectual catalysts for the generation of
innovative interdisciplinary work by providing a common point of focus for
faculty and graduates from a variety of different disciplinary backgrounds. The
introduction of cultural studies curricula, especially at the undergraduate level,
has, in such cases, typically come as a later development. Australian research
centres with an identifiable cultural studies focus include the Centre for Research
in Culture and Communication at Murdoch University; the Centre for Cultural
Risk at Charles Sturt University; the Media and Cultural Studies Centre, the Uni-
versity of Queensland, and the Centre for Comparative Literature and Cultural
Studies at Monash University. Centres with interests which include, but are not
limited to, cultural studies include the Centre for Asia-Pacific Studies at Victo-
ria University of Technology; the Asia and Pacific Research Centre, Central
Queensland University; the Centre for Cultural Heritage Studies, Curtin Uni-
versity of Technology; the Media and Telecommunications Policy Research
Group at the Royal Melbourne Institute of Technology; the Power Institute at
the University of Sydney, and the Communications Law Centre, affiliated to the
University of New South Wales. There are also now two research centres funded
by the Australian Research Council – the Special Research Centre for Cross-
Cultural Research at the Australian National University and the Australian Key
Centre for Cultural and Media Policy at Griffith University, Queensland Uni-
versity of Technology and the University of Queensland – both of which have a
significant cultural studies focus. Both centres, to anticipate a point to which I
shall return, have developed strong external connections and are committed to
developing their work in association with cultural industries and institutions.

Viewed in terms of the nature and extent of its institutionalization, then,
there is little to distinguish cultural studies from many other areas of work in the
humanities. The picture is more complicated so far as the intellectual aspects of
disciplinariness are concerned. For the most part, definitional discussions of cul-
tural studies have focused on certain styles or ways of doing intellectual work
and the kinds of political commitment that these entail. Attempts to describe
cultural studies in terms of particular theories, methods of enquiry or analytical
procedures remain relatively rare, although less so in Australia than elsewhere.
Indeed, many of those whose definitional accounts of cultural studies have proved

influential have suggested that attempts to define it in terms of definite theoretical or methodological characteristics are mistaken in principle. Richard Johnson, a member and, subsequently, Director of the Birmingham Centre for Contemporary Cultural Studies, provides a convenient summary of this line of argument:

> A codification of methods or knowledges (instituting them, for example, in formal curricula or in courses on 'methodology') runs against some of the main features of cultural studies as a tradition: its openness and theoretical versatility, its reflexive even self-conscious mood, and, especially, the importance of critique. I mean critique in the fullest sense: not criticism merely, nor even polemic, but procedures by which other traditions are approached both for what they may yield and for what they inhibit. Critique involves stealing away the more useful elements and rejecting the rest. From this point of view cultural studies is a process, a kind of alchemy for producing useful knowledge; codify it and you might halt its reactions.
> (Johnson, 1986/7: 38)

The concerns that inform this passage – and there are many like it in the literature – are clear enough. Cultural studies, having accused other humanities disciplines of 'fixing' knowledge into particular intellectual and institutional frameworks, must fight shy of both institutionalization and codification if it is not simply to become just another discipline of the kind it had earlier pitched itself against. Such arguments are understandable given the length of time – twenty to thirty years – it has taken for cultural studies to establish its credentials. However, this construction of cultural studies as an 'anti-discipline' or, less extremely, a 'reluctant discipline' is questionable on many grounds. Two of these might usefully be singled out here.

First, the resistance to codification has often meant that intellectual authority has been organized in other terms and has consequently often taken what are, in Max Weber's sense, traditional or pre-rational forms. The lack of a clear set of methodological precepts and theoretical principles has made cultural studies particularly prone to the organization of forms of authority based on the personal qualities of intellectuals. Of course, this is not uniquely true of cultural studies. In many humanities disciplines the organization of intellectual authority has been, and in many cases remains, connected to the cultivation of a particular kind of persona: for example, the prophetic authority of some kinds of history writing, or, in literary studies, the forms of authority associated with a trained sensibility. In cultural studies, by contrast, there has been a tendency for intellectual authority to be attached to socially marginal positions. Marginality is thereby transformed, epistemologically speaking, from a blight into a blessing in conferring a privileged authority which derives from their social biography on those who can, and want to, claim such a status. This has had the unfortunate consequence that intellectual debates within cultural studies have sometimes

been impeded by a tendency to dissolve questions of theory and method into an ethical-cum-epistemological privileging of particular social positions and the intellectual vantage points these produce.

The second matter concerns how questions about the disciplinary status of cultural studies have been connected to the question of its institutionalization. Were it to become or to think of itself as a discipline, it is often suggested, cultural studies would fall prey to a process of institutional co-option and thereby run the risk of losing its critical potential. Assessments of this kind rest on a questionable account of the history of cultural studies as an intellectual practice initially developed mainly outside, or on the margins of, educational institutions. Acceptance of such accounts has resulted in a tendency for questions of institutionalization to be posed in the form of a double bind — institutionalize and perish, don't institutionalize and perish anyway — whose terms have seriously impeded the ability of those working in the field to recognize, or think seriously about, the real institutional conditions of their own intellectual practice.

A satisfactory understanding of cultural studies, of what it is as a set of intellectual practices and of where it sits institutionally, can only be arrived at if these two aspects of its anti-disciplinary ethos are called into question. This means recognizing that cultural studies is indeed characterized by particular ways of codifying and producing knowledge. That these do not exhibit the same form as those humanities knowledges we are accustomed to call disciplines is, in the final analysis, a nominalist matter. It is equally important to recognize that the development of cultural studies has depended on definite institutional conditions. The fact that these do not happen to be entirely the same as those which have sustained the development of other disciplines is again no reason to characterize them as extra-institutional.

Further consideration of the interdisciplinary claims that have been made on behalf of cultural studies, and of how these might most usefully be understood, will provide the best means of pursuing these matters. Here again, there are different views. In one argument, cultural studies is said to have disabled more conventional disciplinary enterprises in the humanities as a result of the cumulative effects of the criticisms it has made of different disciplinary frameworks and their founding assumptions. In another argument, cultural studies comprises a synthesizing and holistic approach to knowledge which, in integrating the findings of different humanities disciplines within a totalizing framework, compensates for their one-sided partiality and incompleteness. In this latter argument, cultural studies functions as an antidote to the fracturing of knowledge that results from the division of intellectual labour and the consequent development of intellectual specializations.

Neither of these accounts is particularly plausible. Although it is clear, if we recall Ann Curthoys' remarks, that some historians have incorporated cultural studies perspectives into their concerns to produce a more nuanced appreciation of the role of language and textuality in historical enquiry, there is little evidence

that this has seriously called into question the viability of history as a specialist enterprise using particular disciplinary techniques. The same point could be made in relation to the whole range of disciplines that have, in some measure, renovated their concerns by incorporating cultural studies insights and arguments into their procedures. Literary studies and art history have undoubtedly been influenced by cultural studies in expanding their concerns beyond the literary and artistic canons of high culture. However, this has not resulted in any sustained challenge to the view that there are, in each of these areas, special issues needing attention through the application of specialist forms of knowledge and research techniques. There is equally no evidence that cultural studies now stands on the brink of organizing some integrating synthesis of knowledge in the humanities – an argument which, in any case, too clearly betrays its romantic lineage, not to mention a perhaps outmoded aspiration to be king, or queen, of the epistemological castle.

Clear and productive thinking about the role of cultural studies in relation to other humanities knowledges (whether or not these take a disciplinary form) is possible only if its interdisciplinary qualities are viewed in less vauntingly ambitious terms. It neither displaces disciplines nor integrates their partial findings into some higher-order, more complete knowledge. Rather, the role it has played – and it has, and continues to be, an important and valuable one – has been that of acting as an interdisciplinary clearing-house within the humanities, providing a useful interface at which the concerns of different disciplines, and of other interdisciplinary knowledges, can enter into fruitful forms of dialogue. If cultural studies is able to perform this role – the role, essentially, of both stimulating and managing certain kinds of intellectual traffic in the humanities – this is by virtue of the disposition of the concepts which define it, owing to the respects in which these have opened up areas of enquiry which straddle different disciplinary fields.

Cultural studies: defining characteristics

The import of the above is to suggest that cultural studies is most usefully viewed as an 'interdisciplinary discipline' characterized by a number of definite and specifiable traits. Six such traits might usefully be identified here.

1 Cultural studies subscribes to a broad concept of culture which, while encompassing the high arts and literature, is not limited to these and does not accord them any a priori privileged status as objects of analysis. Rather, cultural studies typically folds these into a broader field of analysis which, depending on the theoretical formulations chosen, includes the role of cultural forms and practices in the organization of everyday life (Michel de Certeau) or culture as a whole way of life (Raymond Williams). This lends

an inherently interdisciplinary ambit to its concerns to the degree that these have centred on the logic of the relations between different components of the cultural field and the forms of their interactions with one another in the context of historically specific social processes and relationships. These might concern the role of established cultural hierarchies in organizing relationships of social distinction, an issue which requires that account be taken of the intersections of literary, filmic and artistic hierarchies, and of their imbrications with one another in the context of particular processes of class formation. Or they might concern the ways in which different media and forms of cultural expression (film, television, painting, writing) share certain formal or thematic properties in particular historical contexts: for example, common ways of envisaging and addressing a public. Either way, cultural studies approaches the study of culture in a manner which is always contextually situated with regard to the places which the cultural practices under investigation occupy in relation to other cultural practices. In doing so, it organizes a field of study which, in crossing disciplinary boundaries, does not dissolve those boundaries but serves rather to open new points of connection between work which takes place on their different sides.

2 This concern with a contextual situation of the study of culture is carried through into a concern to relate developments in the cultural field to those in adjacent fields – for example, the social and political fields. This again means that, in its approach to its object of analysis, cultural studies is obliged to draw on methods and findings from adjacent fields of scholarship to describe and account for the modes of interaction between cultural forms, processes and institutions and particular social and political conditions. As a consequence, work in cultural studies involves a good deal of interdisciplinary traffic across the boundary lines which conventionally separate the humanities from the social sciences. Its interactions, within the social sciences, with sociology have proved especially significant in this respect although there are also interesting lines of collaboration emerging between cultural studies scholars and geographers in their converging interests in the relations between culture and space.

3 In the assessment of cultural studies, particular forms of culture are always tangled up in, and form a part of, the organization and exercise of particular forms of power.[2] There have, however, been significant differences of emphasis regarding the forms of power that should be accorded pride of place within such concerns. In the early years of cultural studies, particularly in Britain, the primary concern tended to be with the role of culture in organizing and reproducing relationships of social class. Over the intervening period, the privileging of class relationships over other relations of power has been questioned, with the result that the balance of debate has shifted significantly to bring into focus the role of culture in the organization of gender and race-based forms of power. The more recent stress has been on the modes of

interaction between different fields of power and especially, in the context of postcolonial debates, on the ways in which the cultural aspects of forms of power associated with relations of class, race and gender have interacted within the cultural practices of colonialism. Cultural studies has developed these concerns alongside, and in interaction with, a range of new humanities perspectives – feminism, postcolonial studies, gay and lesbian studies – whose interests have focused on particular culture–power relations. Again, the commodious nature of its concerns has allowed cultural studies to operate here, as in relation to more conventional disciplines, as a useful clearing-house for related debates which might otherwise have followed more separated paths of development.

4 The manner in which culture operates in the context of particular power relations is always dependent on the ways in which it is inscribed within, and forms a part of, institutions. That is to say, the realm of culture is not definable simply as the field of texts and meanings. Nor is it adequately defined if regarded as comprising texts and meanings plus the institutional conditions on which they rest. On the contrary, cultural studies has disputed the value of such dualistic conceptions in which culture is thought of as a particular plane of activity (signification, say) and the conditions – important in themselves, but ultimately belonging to a different realm – on which that activity rests. Where such views prevail, the institutional aspects of culture's existence are likely to be regarded as external conditioning factors which, however much they may affect the contingent aspects of a particular form of cultural activity, do not significantly affect its essential *modus operandi* which is seen, rather, as deriving from some general properties – of signification, of language, or of the mind. Within cultural studies, by contrast, the textual and institutional dimensions of cultural forms and activities are more typically viewed as interdependent components of a complex set of interactive processes – of cultural production, dissemination and effect – which are simultaneously institutional and textual. A number of terms have been proposed to encompass this hybrid constitution of culture: the concepts of cultural technologies and cultural apparatuses, for example, as well as the Foucaultian concept of *dispositif* which compacts the institutional and discursive components of any practice into a complexly melded entity. Of course, these terms are not simply interchangeable. A good deal is often at stake in the choice as to which should be used. Be this as it may, they share an impetus to see culture as institution, culture as social and material process, and culture as social and semiotic relationships. Again, in constituting its object of culture in this way, cultural studies places a premium on the value of coordinating a broad range of disciplinary perspectives.

5 A central aspect of these accounts of the *modus operandi* of culture consists in the terms they offer for theorizing the manner in which culture connects with the realm of subjectivity. There are, however, many different ways in which

this realm is theorized and represented in cultural studies debates. It may be defined as the realm of the subject in either its philosophical or psychoanalytic guise; or in terms of debates about identity in which the fixity of 'the subject' is dissolved in the midst of fluctuating positions (or, in some formulations, positionalities) in language and discourse, or in terms which see the subjective properties of the person as the product of historically variable techniques of self-formation through which particular subjective forms and capacities are shaped. Whichever the case, cultural studies has been deeply involved in, and affected by, these more general debates in the humanities concerning viable and appropriate ways of theorizing and representing the human being.

6 Finally, there has been a strong insistence throughout the history of cultural studies that the motivation for scholarly work in the field cannot be only academic. This position has been argued not to devalue scholarly virtues but to stress the need for scholarly work to be conducted in ways that will allow it to connect with 'real-life' social and political issues in the wider society. There has, however, been sharp disagreement regarding the kinds of connections that cultural studies should seek to cultivate in order to put its perspectives to work in the world. An important part of cultural studies debate has accordingly been concerned to assess the implications of contrasting accounts of the role of intellectuals and of the different ways in which intellectual work can be developed to enhance its political and practical relevance.

Of course, cultural studies cannot claim an exclusive title to many of these traits. Debates concerning the role of intellectuals, for example, have been of central importance across the entire spectrum of the humanities for the last twenty years or so. What marks the field, then, is less each of these attributes taken one by one than their being clustered together as a set of concerns which interact with each other in the context of a broad and inclusive approach to the theory, practice and politics of culture. It is this that helps to explain the increasing appeal and attractiveness of cultural studies in higher education institutions. This is a common development in Anglophone countries: in Australia, Britain, Canada and the United States, cultural studies now has an escalating influence on university curricula, at both undergraduate and postgraduate level, and research programmes. For the institutional pay-offs of cultural studies are considerable where, as is increasingly the case, the relative value of single disciplinary trainings in the humanities has diminished owing to the decreasing likelihood that the majority of students will go on to employment contexts in which those disciplinary trainings can be used. This is partly a matter of disciplinary specialization now increasingly being seen as best related to the needs of those who progress to Honours and postgraduate studies. It also arguably related to the diminished value that is placed on the forms of intellectual and personal training associated with traditional forms of cultural capital in the contemporary management styles and ethos of government and industry. Whatever the reasons, however, the much

more varied employment outcomes associated with mass forms of higher education increase the attractiveness of interdisciplinary programmes such as cultural studies in view of their ability to be adapted to a wide range of occupational trajectories.

In addition, the concern with everyday culture which characterizes cultural studies and the associated critique of restricted canons of high culture has resonated well with the cultural experiences and horizons of students in the 1980s and 1990s. The broader demographic base of the student population means that fewer students now come to university with a close experience of, and involvement in, high culture. Equally, the overwhelming influence of commercial culture has diminished the social status of high culture with the result that distinctions between 'high' and 'low' culture, although still significant, now have less force than they used to. Cultural studies curricula which attend to the full range of cultural experience and expression are thus intuitively more plausible from the point of view of contemporary student experience. It needs only to be added that the forms of cultural knowledge associated with the concerns with everyday culture which characterize cultural studies are often more relevant to employment prospects in the new cultural and media industries for it to be clear why cultural studies has been a beneficiary of the changing social and cultural dynamics of higher education.

Distinguishing characteristics of Australian cultural studies

However much the points I have outlined above might constitute shared ground between different national traditions of cultural studies, there are significant differences of stress and emphasis between those national traditions. What, then, have been the distinctive characteristics of Australian cultural studies? Five areas of work can be distinguished.

1 The development of Australian cultural studies has been closely tied up with debates concerning the relationship between culture and nation. In itself, this is not especially distinctive: a good deal of British cultural studies has been concerned with diagnosing the cultural causes and effects of the 'decline of Britain'. What has marked Australian cultural studies as distinctive has been its concern with the cultural conditions necessary to support a progressive and independent path of development for the Australian polity. There have, as a consequence, been close – and, at times, tense – relations between cultural studies and Australian studies. Sharing similar concerns, their theoretical approaches have been distinctive, with Australian studies being more inclined to embrace essentialist conceptions of nation and national identity whereas cultural studies, although clearly originally owing much to the

essentialist formulations of the radical nationalist agendas of the 1970s, has since proved more responsive to postmodernist and poststructuralist perspectives on the relational nature of cultural identities in ways which have aligned its concerns more with those of postcolonial studies. Equally, Australian studies has centred closely on literary and historical studies and has not contributed to the study of Australian everyday culture to the same degree or in the same manner as cultural studies. That said, there are signs that the relationships between cultural studies and Australian studies are becoming increasingly fluid and permeable, a development that is as evident in the contents of publishers' lists as it is in the design of university curricula. Mutually productive relationships between cultural studies and Australian studies have been evident in the journal *Australian Cultural History* edited from Deakin University, and in curricula design at the University of Queensland and Griffith University.

2 Feminist concerns have marked the development of Australian cultural studies from the outset in ways that have had a lasting influence on its formation. This, again, stands in marked contrast to the British experience where a founding set of concerns centred on the relationship between culture and class significantly eclipsed questions concerning the relationship between culture and gender until well into the late 1970s. Rita Felski and Zoe Sofia (1996), in commenting on this aspect of Australian cultural studies, also usefully remind us that Australian cultural studies has been characterized by its openness to the influence of European theory and philosophy in ways which have marked it as a less chauvinist theoretical formation than its British and American counterparts. Work located at the intersections of cultural studies and women's studies has been most notably developed at Murdoch University and the University of Technology, Sydney, while it is also now an area of emerging strength at the University of Sydney.

3 Cultural studies has been in part shaped by its responses to the history and practices of multiculturalism understood as both a policy framework and a form of cultural diversity. This has defined the nature of its engagements with questions of ethnicity in identifiably distinctive ways which are increasingly alert to the extent to which many Australians form a part of transnational diasporic networks of communication and identity. For increasingly pressing geo-cultural relations, such concerns now centre principally on Asian Australians and on the new and emerging forms of cultural interaction between Australia and different parts of the Asian region. Indeed, there is now a significant body of literature concerned to place Australian cultural studies in an Asian context as well as several initiatives aimed at consolidating intellectual and institutional relationships between Australian cultural studies and the more nascent traditions of cultural studies being developed in a variety of Asian contexts: for example, Korea, Taiwan and Hong Kong. So far as multicultural studies within Australia is concerned, particularly important

contributions have come from the University of Technology, Sydney, Deakin University and the University of Western Sydney, where the recently established Centre for Inter-Communal Studies can be expected to further develop this area of work. Important work in connecting Australian cultural studies to Asian cultural studies has been undertaken at Queensland University of Technology, the Centre for Asia-Pacific Studies at Victoria University of Technology, the Department of Media Studies at Edith Cowan University and the Asia and Pacific Research Centre at Central Queensland University. The Australian Key Centre for Cultural and Media Policy has developed a research network connecting Australian and Asian researchers specializing in cultural and media policy studies. It is also likely that the Special Research Centre for Cross-Cultural Research will play a significant role in promoting collaborative projects that will draw on cultural studies inputs across the Asia-Pacific Region.

4 There are emerging patterns of interaction between cultural studies and indigenous studies. These are evident, on the one hand, in the intellectual perspectives on which indigenous intellectuals like Marcia Langton draw in order to analyse the ways in which indigenous peoples and their culture are constructed within Western systems of representation (Langton, 1993). There is also a significant literature of this kind by non-indigenous cultural studies scholars who have concerned themselves with identifying the distinctive aspects of contemporary indigenous cultural formations. Perspectives derived from cultural studies have also been influential in the reappraisals of the various Western knowledges (anthropology, archaeology) that have, historically, been tangled up in the administration of indigenous populations. Universities noted for their contributions to this area of work include Murdoch University and the University of Technology, Sydney, while significant contributions have been made to indigenous cultural policy studies by staff at Griffith University, initially through its Institute for Cultural Policy Studies and, since 1995, through the Australian Key Centre for Cultural and Media Policy.

5 Finally, as point 4 suggests, account needs to be taken of those strands within cultural studies that have sought to connect its perspectives to the concerns of policy analysis. While this was initially a contentious development, it is now a widely accepted component of the cultural studies landscape in Australia in a manner which has few echoes elsewhere except in Canada, which has proved a fruitful source of international collaboration in this area of work. The characteristic signature of cultural policy studies consists in its translation of the implications of the broad anthropological concept of culture into the sphere of policy analysis in recontextualizing the somewhat narrow concerns of arts policy and administration as part of a much broader field in which a concern with culture as industry intersects with a concern with the ways in which cultural resources are deployed as parts of programmes of

social management. A number of reasons have been advanced to explain why this area of work should have developed more rapidly in Australia than in other national traditions of cultural studies. Some of these have to do with historical contingencies. The fact that cultural studies experienced its major growth in Australia during the 1980s and early 1990s is relevant here in view of the importance accorded questions of cultural policy in the Labor administrations which prevailed at the federal level from 1983 to 1996. Others have to do with more enduring considerations: for example, the traditional permeability of the relations between universities and government in Australia as well as, in comparison with societies like the United States and Japan, the stronger role played by government in the processes of cultural policy formation. Whatever the reasons, however, cultural policy studies is now a significant area of work with active and leading contributions coming from the Communications Law Centre, the Media and Telecommunications Policy Research Group and the three universities responsible for the Australian Key Centre for Cultural and Media Policy which has also established a national network of researchers working in this area. The National Centre for Australian Studies has also been important here, especially for its work in the fields of heritage policies and new information technologies. There are, however, other important initiatives which have successfully related cultural studies perspective to other fields of policy analysis. This is especially true of the work in the field of community health policies that has been developed by the Centre for Cultural Risk at Charles Sturt University.

The international standing of Australian work is high in each of the areas of work I have identified above. That standing, however, is probably most distinctive for work done where the concerns of cultural studies and feminist scholarship meet and in cultural policy studies. It is important to add, though, that Australian scholars are engaged in, and make significant contributions to, fields of work that are not distinctively Australian. Work at the interface of cultural and literary studies is of particular significance here, with leading contributions coming from Monash University and the University of Melbourne. Australian contributions to international theoretical debates within cultural studies have also been strong – indeed, remarkably so.

Institutional futures

I have suggested that the factors responsible for the growth of cultural studies have primarily concerned the changing position of the humanities within the rapidly changing contexts of higher education, the changing social characteristics of the student body, and the changing interfaces between universities on the one hand and cultural and media industries and institutions on the other. Perhaps the

most crucial factor bearing on the future prospects for cultural studies will consist in the degree to which those working in the field will be able to do so from the perspective of a clearer and more objective sense of where cultural studies sits institutionally in these respects, of how it can interact usefully with other disciplines, and of the kinds of vocationally relevant trainings and knowledges it can offer students. Perhaps the greatest strength of contemporary Australian cultural studies is that it currently shows every sign of settling in for a period of productive and engaged work from within a realistic assessment of the institutional conditions of its existence and the possibilities that these open up.

In this context, the following points are likely to prove of particular relevance to the further development of the area.

1 As has already been noted, there are few departments of cultural studies in Australian universities. Where cultural studies does have an officially recognized existence at the level of department or school nomenclature it is always in the context of cultural studies and something else. This is unlikely to change in the foreseeable future and it is probably not desirable that it should, as this would limit its capacity to play the kind of interdisciplinary role I have described. It is, in this context, noteworthy that cultural studies has usually made less headway at those universities which have strong discipline-based departments and cultures. The future development of cultural studies, then, will depend on, and perhaps be a means of, developing institutional arrangements that will facilitate the development of graduate studies and research programmes which cross and interconnect the inputs of different disciplines.

2 A much stronger sense of professional organization and identity is needed at the national level. I have already touched on the weaknesses of the Cultural Studies Association of Australia – weaknesses, I should add, that are partly a reflection of its poor funding base. Assessments will differ as to whether this Association would prove able to take on the kinds of roles played by more conventional disciplinary association or whether the new Communications and Cultural Studies section of the Australian Academy of the Humanities might prove better able to do so. The need, however, for a body to play a lobbying role, to be concerned with standards, to develop networks, conduct benchmarking exercises, etc. is real.

3 Cultural studies has proved an attractive area for graduate students with some noticeable areas of specialization developing at one or two universities. By and large, however, the pattern of work here is very dispersed. As a consequence, few universities can claim a 'critical mass' of graduate students working in an identifiably distinctive area of cultural studies. So long as this remains the case, the prospect of developing world-class graduate programmes will remain remote. Mechanisms to encourage collaboration between universities with related areas of strength is the most realistic way of addressing this situation. There is an additional lack of mechanisms capable

of nurturing a graduate culture at the national level. The Australian Key Centre for Cultural and Media Policy runs a subsidised annual winter school for graduate students working in cultural and media policy studies. There is no equivalent provision for graduates working in other areas of cultural studies, yet the need for this is evident.

4 Cultural studies can be expected to play a continuing role in stimulating and coordinating interdisciplinary research collaborations. The potential for cultural studies research programmes to contribute to the needs of the cultural and media industry and policy sectors is also real and substantial. There is a good way to go, however, before this potential is fully realized. The extent to which this will happen will depend, in good measure, on a change in the research culture within cultural studies of a kind that will encourage more researchers to develop the team-based partnership approaches to research that are required by the Australian Research Council's various collaborative research funding programmes.

5 The potential for cultural studies to contribute to growing academic links between Australia and Asia is considerable. Australia's geographical location and the high regard in which Australian cultural studies is held in the region will make it an increasingly attractive destination for graduate students seeking an English-language training and qualification. At the same time, the climate is a good one for developing research partnerships across the region. However, if Australian universities are to take full advantage of these opportunities, closer attention will need to be paid to the development of productive forms of collaboration between cultural studies and Asian studies programmes.

Acknowledgement

I would like to thank Stuart Cunningham, John Frow and Meaghan Morris for their assistance in preparing this survey.

Notes

1 This is an expanded and modified version of an essay prepared for the Australian Academy of the Humanities as a contribution to a review of the humanities in Australia that the Academy coordinated on behalf of the Australian Research Council (ARC). This review has been published by the Academy and the ARC as *Knowing Ourselves and Others — The Humanities and Australia into the 21st Century*. Both the author and *Cultural Studies* gratefully acknowledge the permission of the Academy to publish this essay here. The sparsity of references reflects the brief that was given for the review.

2 I use the term 'power' with some misgivings in view of the suggestion, derived
 from Foucault, that the concept of relations of force allows for a more nuanced
 set of both political and theoretical possibilities.

References

Curthoys, Ann (1996) 'White, male and middle class'. *Cultural Studies*, 10(3):
 515–18.
Felski, Rita and Sofia, Zoe (1996) Introduction to 'Australian Feminisms'. Special
 issue of *Cultural Studies*, 10(3).
Johnson, Richard (1986/7) 'What is cultural studies anyway?' *Social Text*, 16.
Langton, Marcia (1993) 'Well, I heard it on the radio and I saw it on the tele-
 vision . . .'. Sydney: Australian Film Commission.

Judith Newton, Susan Kaiser and Kent A. Ono

PROPOSAL FOR AN MA AND PH.D. PROGRAMME IN CULTURAL STUDIES AT UC DAVIS

Abstract

The following proposal for an MA and Ph.D. programme at the University of California, Davis, is the culmination of four years of meetings and other organizing activities focused on the formal institutionalization of cultural studies at UC Davis. Groundwork for the proposed cultural studies programme began in a series of discussions held by an interdisciplinary group of faculty about how to create the opportunity for structured graduate teaching, advising and research in cultural studies at UC Davis. The Dean of Graduate Studies at that time encouraged this group to submit a pre-proposal for an MA and Ph.D. in cultural studies. Faculty involved in the original discussions subsequently drew up a pre-proposal and held further informal meetings. E-mail lists were created and information was disseminated. Eventually, an executive committee, whose charge it was to draw up a formal proposal, was formed. The following proposal grew out of the executive committee's early efforts. Cultural studies at UC Davis cuts across myriad units, programmes, clusters and centres in two colleges in the humanities, social sciences, and agricultural environmental studies and involves a unique collectivity of faculty and students interested in class, gender, race, ethnicity, sexuality, transnationalism, postcolonialism and related areas of enquiry. The UC Davis proposal, therefore, forges many connections across a wide variety of cultural studies interests.

Keywords

interdepartmental; feminism; graduate education; cultural politics; multicultural education; embodied scholarship

Section I: Introduction

Aims and Objectives

SIXTY-TWO FACULTY in the College of Letters and Sciences and in the College of Agricultural and Environmental Science are proposing to establish a graduate group in cultural studies which would offer an MA and Ph.D. in cultural studies at UC Davis. Our objective is to provide graduate students with training which would enable them to study culture in a critical and interdisciplinary way while also making them competitive for jobs both within the academy and outside. In California, where issues of identity are so fraught and cultural analysis so complex, training in cultural studies, which makes these issues central, seems particularly relevant.

Cultural studies is an interdisciplinary approach to the study of culture and society which responds to, and builds upon, critical analyses of traditional disciplines and epistemologies as well as upon developments specific to gender, ethnic and sexuality studies which have emerged over the last twenty-five years. Key to the cultural studies approach is the perception that language, gender, race, sexuality, nationality and class organize identities, complex social relations and cultural objects. Also key is the assumption that the study of culture in all its complexity requires cross-disciplinary work.

Cultural studies assumes that the object of knowledge will determine the methodologies to be used. It actively encourages the crossing of disciplinary boundaries and promotes the innovative interweaving of methodologies which have been traditionally associated with a wide range of different disciplines. Thus, for example, a scholar taking a cultural studies approach to the current debates over 'family values' might investigate the ways in which visual and literary texts, political debate, policy decisions, political and religious movements, and groups of people living their everyday lives produce different, overlapping and competing representations of family, family values and the social order generally. Such a study, therefore, might involve methods traditionally associated with sociology – such as quantitative and qualitative studies of family forms and dynamics – methods traditionally associated with literary and media studies – such as the close reading of literature, films, television programmes, advertising and political speeches – and methodologies traditionally associated with anthropology – such as ethnography – which might involve asking questions of groups of people and studying how they live. Cultural studies, therefore, flourishes within

formations that facilitate communication and collaboration among scholars from diverse fields.

Distinctive features of cultural studies as Davis

As in most fields, scholars in cultural studies share many assumptions, concepts and methodologies, but, as in traditional fields, there are different tendencies and emphases within cultural studies as a whole. Thus the specific configuration of any cultural studies programme will depend to a great degree on the interests and commitments of those involved. Our programme would have several distinctive features. It would be organized as a graduate group, an organizational structure which has proved successful at UC Davis. It would have great disciplinary breadth and depth, racial and ethnic diversity, and a global perspective. It would also, at several points, bring academic work into relation with communities outside the academy.

At Davis we propose to use the graduate group model for our proposed MA and Ph.D. programme. This model offers the flexibility of allowing scholars in related disciplines to work together across disciplinary and departmental lines and has been very successfully employed at Davis in the sciences and elsewhere. In addition, we propose to adopt a model for organizing cultural studies which has proved effective in programmes such as the History of Consciousness at UC Santa Cruz. Students entering the programme at Davis, for example, would take core courses which would train them in the theories, histories, practices and methodologies of cultural studies work. Then, in consultation with an initial advisory committee, they would assemble a research programme, choose a major professor, and, in consultation with the advisory committee and major professor, take courses relevant to their project. This model would make faculty diversity a distinct advantage, while also providing a coherent way for students to map their ways through the richness of the terrain.

Another distinctive feature of the proposed graduate group in cultural studies at Davis is that it would have unusual disciplinary breadth and depth. Our participants, for example, are drawn from twenty-five programmes and departments and from two colleges – Letters and Sciences, and Agricultural and Environmental Science. Although the faculty wishing to participate in the cultural studies graduate group at Davis are housed in units which have not always had much contact with each other, a survey of their research and publications suggests several coherent and overlapping areas of scholarship. (Most faculty, of course, work not just in one but in several of the following areas, and multiple faculty work in each.) The following areas are particularly well represented at Davis: (1) gender and sexualities; (2) race, ethnicities and cultural representation; (3) politics, religion, communities and cultural representation; (4) popular culture; (5) national cultures, transnationalism and globalization; (6) science and society; (7) historical studies; and (8) rhetoric and critical theory.

The proposed graduate group in cultural studies would also be distinct in the racial and ethnic diversity of its faculty and in its commitment to the investigation of the ways in which race/ethnicity, gender, sexuality, nationality and class co-construct each other. The graduate group would be especially well prepared to engage in collaborative, transnational analysis of global phenomena, past and present. In relation to most of the overlapping areas, for example, we have faculty working out of the following cultural contexts: African-American, African, American, Asian-American, Chicana/o, Latin American, East Asian, Southeast Asian, European, and Middle Eastern.

Several members of the proposed graduate group in cultural studies, moreover, have been involved with the UC Davis gender and global issues consortium and have established a visitor's programme, funded by the Ford Foundation, which has brought fourteen scholar/activists to UC Davis from Asia, Africa, Latin America and the Middle East. These scholar activists take seminars on such topics as gender and the environment and gender and violence, intern at local clinics and women's shelters, and exchange information and ideas with UC Davis faculty and graduate students.

A final distinctive feature of the cultural studies graduate group at Davis is that it would involve faculty whose academic research engages them in studying, and working with, local communities. Several cultural studies faculty, for example, have ties to the UC Davis International Center for Urban Research and Policy Studies, which focuses on race, ethnicity and immigration. Some of these faculty are currently participating in a multi-ethnic, multidisciplinary, community development project on urban farming, sponsored by HUD, which is bringing scholars and community people together over issues of urban agriculture, land use, the environment, youth and community development, and cultural traditions having to do with food production, processing and consumption. This project is now forming a collaborative relationship with cultural studies faculty involved in the science and society programme, which has received funding from the US Department of Food and Agriculture to develop curricula connecting the sciences with cultural values and ethics in everyday life.

Historical development of cultural studies

Cultural studies has emerged as a discrete field of enquiry over the last twenty-five years. 'Culture', for example, has long been the object of enquiry in anthropology, sociology and the arts, although often these objects of study have seemed to have little in common or to be defined against each other. But a growing desire to broaden enquiries into 'culture', born of the complexity of contemporary life, the necessity of analysing its operations, and the critical perspectives produced by the social and intellectual movements of the last few decades have converged to produce interdisciplinary research and teaching under the banner

of cultural studies across the world. (Cultural studies is well known as a field of study, for example, in the US, Europe, Australia, China, Africa, India and Latin America.)

The Centre for Contemporary Cultural Studies at Birmingham is considered to be one of the originating sites of the investigations which have gained the name 'cultural studies'. In the 1960s and 1970s, social scientists and humanists integrated their methodologies to provide socioeconomic and political analyses of high and low culture, new communication technologies and the structures of everyday life. Early work on television and popular culture provided some of the first exciting examples of this new work. In the United States, cultural studies emerged from the new perceptions produced by national liberation movements and other social movements in which questions of identity formation, cultural representation, racial, ethnic, and gender theory and critique have been central. These movements have generated vital new avenues of enquiry concerning epistemology as well as gender, race, sexuality and class.

Historical development of programmatic strength in cultural studies at UC Davis

For some decades Davis has been the home institution for a number of internationally and nationally known cultural studies scholars. In recent years, moreover, hiring in this area has been highly successful. Indeed, few, if any institutions can match the depth and diversity of the Davis faculty in cultural studies. Existing faculty, however, are spread over two dozen departments and programmes in two colleges, none of which has primary responsibility for research or graduate education in cultural studies. Graduate students pursuing cultural studies research have been trained and supported through various *ad hoc* means.

The health of research and graduate education in cultural studies at Davis is severely hampered by the lack of identifiable institutional units, most importantly a well-focused graduate programme, in cultural studies. A graduate programme in cultural studies would provide a vehicle for the Davis campus to bring together its excellent faculty in this area in a way that nourishes the further development of cultural studies on the campus, enhances the probability of fruitful interactions and collaborations, serves the needs of the numerous departments and programmes with ties to this mode of research, fulfils the increased demand on the part of graduate students for training in this field, and makes 'Individual' Ph.Ds unnecessary. ('Individual' Ph.Ds are designed by graduate students in consultation with faculty sponsors and are submitted to the Graduate Division for approval.) A cultural studies programme would also bring new and highly qualified graduate students to Davis given the growing interest, nationally and internationally, in cultural studies work. History of Consciousness at UC Santa Cruz, for example,

the closest programme in the UC system to cultural studies, currently receives over 300 applicants a year but takes only twelve students.

Timetable for the development of the graduate group in cultural studies

Individual faculty at Davis have been doing research in cultural studies for many years, and several programmes and departments regularly offer graduate level cultural studies courses – American studies, critical theory, drama, English, Chicana/o studies, landscape architecture, textiles and clothing, and women's studies, to name a few. None, however, offers a graduate degree in cultural studies. Formal groundwork for the proposed cultural studies group began four years ago in a series of discussions held by an interdisciplinary group of faculty about the possible institutionalization of cultural studies on the undergraduate and graduate levels. These discussions began in the winter and spring of 1994 and continued through 1995. In autumn 1995, the Dean of Graduate Studies, having heard of these deliberations, asked the group to submit a pre-proposal for a cultural studies MA and Ph.D. Information about this pre-proposal was circulated to a large group of faculty who we had reason to believe identified their work with cultural studies. The faculty we contacted were asked to propose the names of other colleagues who also identified their work with cultural studies, and they in turn were asked if they wished to join. Some forty-four faculty expressed interest in the initial proposal and filed letters of intent to participate that autumn. The group continued to grow during the winter of 1995 and numbered over fifty by the spring.

In spring 1996 an executive committee of twelve volunteers was formed with faculty from American studies, anthropology, art studio, Asian-American studies, Chicana/o studies, critical theory, dramatic art and dance, English, French, German, sociology, textiles and clothing, and women's studies. This committee drafted the proposal for a graduate group in cultural studies which was then circulated electronically to the larger group for comments. The executive committee continued to contact other faculty as additional names were proposed. In autumn 1996 the proposal was submitted to Graduate Council, which thoroughly reviewed and approved the intellectual content of the proposal during the 1996–1997 academic year. Because so many faculty at Davis are already involved in the emerging graduate group, because so many cultural studies courses exist, and because at least thirty graduate students have expressed interest in seeing a cultural studies programme at Davis, we will be ready to begin this programme as soon as it is approved. Since Davis is slated for general growth and since it is not enrolled to capacity at graduate level, we would expect our proposed programme to have no negative impact on the enrolment of other programmes and departments. We would expect to enrol five students a year for five years for a total of twenty-five students.

Relationship of the proposed programme to existing programmes

While many departments and programmes on campus attend to particular aspects of the interdisciplinary study of culture and society, none has cultural studies' synthesizing goal. Most departments focus on conveying the history and scope of a discipline while many interdisciplinary programmes (broadly defined) focus on a particular identity category (gender, race or ethnicity), a particular culture (American), or a theme (nature and culture). There are, of course, designated emphases – critical theory, feminist theory and research, native American studies, and social theory and comparative history – which feature cultural studies approaches. But these are emphases, not Ph.D. programmes, and none offers a core curriculum in cultural studies, broadly conceived. Nor do or could they have the range of faculty or courses which our proposed graduate group would offer. It is a major strength of our proposed group that it would bring the faculty allied with these emphases into a Ph.D. programme which would draw upon and augment their separate strengths. Our proposed graduate group in cultural studies, indeed, seems to us precisely the kind of project which the Chancellor called for when he recently recommended that campus work at the 'interface' between disciplines and engage in extra-departmental and cross-divisional planning.

Twenty-four of our faculty, moreover, are in programmes or departments which have no Ph.D. programmes. Most lack regular opportunity to direct Ph.D. theses. Our proposed graduate group would provide an important opportunity for these faculty to do more advanced work with graduates, an opportunity which would benefit undergraduates as well, by enriching and deepening the intellectual environment which faculty and students create together.

There are many ways in which our students would interact with and contribute to existing programmes and departments. Most cultural studies students, for example, would develop plans of study that regularly involve them in taking individual courses from different programmes and departments. In addition, we propose to offer students the option of taking an 'emphasis' in traditional disciplinary studies and/or of completing one of the existing designated emphases (critical theory, feminist theory and research, native American studies, and social theory and comparative history). Thus our proposed MA and Ph.D. programme would strengthen emphases and departments by increasing enrolments in their courses. At the same time we plan to offer students from traditional departments the option of pursuing an emphasis in cultural studies, thereby inviting traditional departments to draw upon the resources of our graduate programme in return.

International focus

Our proposed cultural studies programme would directly engage us in the campus' globalization initiative, for cultural studies as a field – whether the focus

is on gender, race, economic systems, institutions or social movements – increasingly presupposes a global context for teaching and research. A major strength of our graduate group in cultural studies lies in its national and transnational breadth.

Community outreach and the land grant tradition

The cultural studies Ph.D. programme would address the campus goal of fostering outreach to the larger public, by critically and creatively addressing the cultural forces that shape everyday life. Everyday life, indeed, is one of the central interests of cultural studies. Scholars at UC Davis, using the theoretical and methodological tools of cultural studies, have frequently analysed and interpreted what people eat, how they dress, their involvement with the arts and media, and their community and political involvement. Our programme in cultural studies would therefore help bridge the gap between theory and practice, between the academic and non-academic communities and would contribute to the development of forms of knowledge which would be of great benefit not only to graduate students but to undergraduates as well.

Interdisciplinary and intercollege connections on the campus, moreover, would be strengthened by the graduate group's focus on subjects of concern both to the College of Letters and Science and the College of Agricultural and Environmental Sciences: food security; community life; changing modes of communication; consumer cultures and preferences; clothing and fashion; visual culture; perceptions of environmental quality; youth development, and the interface between production and consumption. In providing a collaborative, cross-campus structure for faculty engaged in the respectful, interdisciplinary analyses of ongoing cultural practices and challenges, finally, the cultural studies Ph.D. programme would forge links with the existing network of academic staff in the UC Cooperative Extension who presently address these and related issues at the community level throughout California.

Interrelationship of cultural studies at Davis with other University of California programmes

Interdisciplinary Ph.D. programmes in various modes of cultural studies are emerging at research universities throughout the United States. Following from the History of Consciousness programme at UCSC, the oldest and most internationally acclaimed of these, programmes and centres are in various stages of development at Stanford University (society, literature and theory), NYU (American studies and contemporary cultures), Carnegie Mellon University (cultural and rhetoric studies), Rochester University (visual and cultural studies), University of Wisconsin Milwaukee (twentieth-century studies), Brown University (semiotics, modern culture and media), and Claremont College

(cultural studies) to mention only a few. Harvard University is in the process of beginning a cultural studies undergraduate programme.

One of the most important contributions of these programmes is that they have served as the meeting ground between critical theoretical models of analysis grounded in structuralism, poststructuralism, psychoanalysis and postcolonial studies – models developed largely outside the US – with feminisms, ethnic and race studies, new historicist and mass media studies which have developed primarily within the context of the US academy. It is one of our most important advantages in planning our Ph.D. programme that we have faculty across this very broad range of cultural studies, a range not encompassed by any of the other programmes.

The disciplinary breadth and depth of UC Davis, its large and racially diverse faculty, the fact that its participants are drawn from two colleges, and that several of its faculty study and work with local communities, make it a very different programme from History of Consciousness at UC Santa Cruz and from two recently proposed Ph.D. programmes, UCLA's World Arts and Cultures and Dance, and Santa Barbara's East Asian Languages and Culture. These are also interdisciplinary programmes, but they are far more narrowly focused than is our proposed graduate group.

Cultural studies is also emerging as a new configuration for research and graduate study within the University of California as a whole. Several consortia, for example, have been formed around such emergent interdisciplinary areas as Chicano cultural studies, classical cultural studies, German cultural studies, Jewish studies, Italian studies, and Mediterranean basin studies. We are organizing our proposed cultural studies programme in ways which would allow us to link with these interdisciplinary programmes.

Group which would administer the programme

In keeping with the Davis model for graduate groups, this programme would be administered by the graduate group in cultural studies. The staff and student mailboxes for this group would be housed in Hart Hall, and in keeping with the staff organization plan for the College of Letters and Sciences, the half-time staff person would function as part of the central administrative support centre for the Hart Hall programmes. The half-time staff position would be supported by the office of graduate studies and by the academic deans for agricultural and environmental science, HACS and social science.

Plan for evaluation of the programme

The programme would be evaluated, as are other graduate programmes, by the programme review committee of graduate council. These reviews are expected

to occur two to three years after approval of the programme and approximately every eight years thereafter.

Section II: Programmes

While most students would be admitted to the cultural studies programme as candidates for a Ph.D., recent trends in higher education suggest that there will be growing interest in cultural studies work at the Master of Arts level among those who have or plan careers in education, state government, the media and the arts. Increasingly, moreover, those working outside the academy are returning to it in order to obtain higher degrees. History of Consciousness Ph.Ds, for example, work in such areas as foundations, community groups, publishing, museums and public policy as well as in academic departments such as English, philosophy, women's studies, American studies, anthropology, science and society, history, French, communication, media studies, education, political science, art, African-American studies, sociology, ethnic studies, Hebrew literature, comparative cultural studies, environmental studies, feminist theory/cultural studies, film studies and psychology. We are proposing, therefore, both a Ph.D. and a MA programme with the intention of preparing students for employment within the academy and outside.

Ph.D. programme

Admissions

To be considered for admission to the doctoral programme, a student must show a strong aptitude for scholarly work and intellectual maturity. The admissions committee would review all available evidence to select qualified students for admissions in cultural studies, including excellent undergraduate academic record (especially in substantive social science or humanities courses), high graduate record examination scores, samples of applicants' scholarly writing and/or multi-media projects, relevant recommendations, and a one- or two-page statement of purpose.

Language

Given the comparative and global interest of cultural studies and given the fact that knowing more than one language is a valuable asset in obtaining teaching positions, students are required to have a fluent reading knowledge of a language other than English. Ideally, this language should be one relevant to the field of dissertation research. Students may satisfy this requirement either by passing an upper-division undergraduate course in the language with a grade of B or higher or by passing the Graduate School Foreign Language Test. The language requirement should be

passed by the end of the second year of study, and must be completed before the student would be approved to take the qualifying examination. Students passing the language requirement with course work taken at another institution must demonstrate that this course work is sufficiently recent to provide a useful working knowledge of the language for scholarly purposes.

Programme of study
Specific fields of emphasis: Davis faculty doing cultural studies work have particular strengths in the following areas: (1) gender and sexualities; (2) race, ethnicities and cultural representation; (3) politics, religion, communities and cultural representation; (4) popular culture; (5) national cultures, transnationalism and globalization; (6) science and society; (7) historical studies; and (8) rhetoric and critical theory. These cluster names, however, serve to identify areas of expertise and are not meant to formally delineate fields of emphasis or sub-programmes. In consultation with their course advisory committee, each student would draw on these clusters as well as on the designated emphases and traditional departmental and programmatic curricula, in order to develop her or his plan of study.

We intend to provide a core of rigorous courses useful to all students in cultural studies and to supplement the offerings of other departments in teaching the critical skills needed to do cultural studies work and to compete for jobs in several fields. We expect that students and advisory committees would design individualized programmes of advanced study from the many advanced courses being offered from a cultural studies perspective on the Davis campus.

Advisory committee: During the student's first quarter in residence, the executive committee of the graduate group in cultural studies would appoint an advisory committee consisting of a first-year guiding professor and two other members to advise the student on course work and other requirements. The advising committee would play a major role in ensuring consistency and balance in course work and intellectual preparation. The advising system would also ensure that all entering students have a 'home' and at least one faculty member assuming responsibility for that student while simultaneously allowing flexibility for growth and change of the student's interests. One faculty member would be appointed as a first-year guiding professor upon entrance of each student; the other two members of the advisory committee would be faculty with interests related to those of the student. Ordinarily, students would be expected to select a major professor for their dissertation no later than the middle of the second year of advanced course work, sufficiently in advance of the qualifying exam and preparation of a research proposal.

The student, in conjunction with his or her advisory committee, would recommend names for the qualifying exam and dissertation committees to the graduate adviser who would forward the names to the Dean of Graduate Studies. The course advisory, qualifying exam and dissertation committees would evaluate the student's progress in the specific fields of emphasis by reviewing performance in courses, in the research seminar paper and the qualifying exam and by making recommendations to the graduate adviser. The graduate adviser would

verify the student's progress towards completion of the dissertation and the degree.

Unit requirements: A candidate's total programme for the Ph.D. degree must include a minimum of sixty-four units of graduate courses and seminars relevant to teaching and research in his or her area of emphasis. Twelve of these units may be from upper division undergraduate courses. These units include directed research (CST 270 a–c) and the research seminar (CST 250) but not the cultural studies colloquium (CST 290) or research (CST 299). The student must also produce a research seminar paper, judged by the executive committee to be of publishable quality, give a satisfactory presentation at a cultural studies colloquium and pass a preliminary exam. In addition, the student must take eighteen units of cultural studies colloquium over nine quarters, produce a satisfactory dissertation prospectus, pass a qualifying exam, produce a satisfactory dissertation, and maintain a minimum cumulative GPA of 3.0 throughout all graduate work at UC Davis.

Required and recommended courses: Students would pursue course programmes chosen in consultation with their advisory committee (see Tables 1–3).

First-year sequence: During the first year, students would take the three required courses, CST 200a, CST 200b or CRI 200a, CSTc, in consecutive quarters. These courses introduce students to basic cultural studies concepts, issues and arguments within the field. CST 200a would be taught as a pro-seminar and is intended to introduce students to the multiple histories and traditions of cultural studies. CST 200b and CRI 200a would introduce students to the significance of and challenges to critical theory in cultural studies. CST 200c would introduce students to the approaches, perspectives and methodologies of cultural studies, such as critical ethnography, deconstruction and psychoanalysis.

Preliminary exam: During the second year, students would be expected to produce a paper of publishable quality which would draw upon and apply materials to which they have been introduced in their first year of study. This

Table 1 Required core courses

CST 200a	Theories, Histories and Practices of Cultural Studies (4) (Kaiser, Mechling, Newton and others)[1]
CST 200b	Studies in Theoretical Traditions (4) (Chabram-Dernersesian, Ono and others)[1]
or	
CRI 200a	Introduction to Critical Theory (4)(Van Den Abbeele)
CST 200c	The Practice of Cultural Studies (4) (Kuhn, Projansky and others)[1]
CST 250	Research Seminar (4) (Staff)[1]
CST 270(a–c)	Directed research (4) (twelve units required) (Staff)[1]
CST 290	Cultural studies colloquium (2) (eighteen units required) (Staff)[1]
CST 299	Research (Staff)[1]

[1]Denotes courses in the process of being proposed

Table 2 Recommended courses: regular offerings (partial list)

ANT 207	Ethnographic Writing (Lavie)
ANT 229	Gender, Identity, and Self (Joseph)
CRD-246	Transnational Migration (Guarnizo)
CST 204	Studies in Sexualities[1] (Van Leer, Case)
CST 206	Studies in Race Theory[1] (Fregoso, Ono, Robnett, Stanfield)
CST 208	Studies in Nationalisms and Transnationalism, and Late Capitalism[1] (Joseph, Reinelt, Rouse, Smith)
CST 212	Studies in the Rhetorics of Culture[1] (Blair, Turner)
CST 214	Studies in Politics and Cultural Representation[1] (Frankenberg, Hamamoto, Kaiser)
CHI 230	Chicana/o/Latina/o Politics (Chabram-Dernersesian)
CHI 231	Comparative Feminist Psychology[1] (Flores-Ortiz)
CHI 232	Gender, Violence, Family, and the State[1] (Flores-Ortiz)
CHI 233	Transnational Feminisms: Caribbean, Mexico, Central and South America[1] (Chabram-Dernersesian)
CRI 200b	Problems in Critical Theory (Van Den Abbeele)
CRI 200c	Historical Issues in Critical Theory (Schein)
CRI 201	Special Topics in Critical Theory (Flavell, Ross)
DRA 265a	Theory of Dramatic Art: Modes of Production (Worthen, Reinelt)
DRA 265b	Theory of Dramatic Art: Signification and the Body (Worthen, Reinelt)
DRA 265c	Theory of Dramatic Art: Technologies of Difference (Reinelt, Worthen)
DRA 265d	Theory of Dramatic Art: (Reinelt, Worthen)
ENL 285	Literature by Women
GER 244	Gender and Comedy (Finney)
GER 262	Studies in Turn-of-the-century Culture (Finney)
HIS 147a	Modern European Intellectual/Cultural History, 1780–1870 (Saler)
HIS 147b	Modern European Intellectual/Cultural History, 1870–1920 (Saler)
HIS 147c	Modern European Intellectual/Cultural History, 1920–90 (Saler)
HIS 102e	European Modernism in Historical Perspective (Saler)
HIS 273a,b	Cross Cultural Women's History (Brantley, Mann)
NAS 212	Community Development for Sovereignty and Autonomy (Varese)
NAS 220	Colonialism/Racism and Self-Determination (Varese)
NAS 280	Ethnohistorical Theory and Method (Forbes)
SOC 215	Economy, Polity, and Society (Block)
SOC 227	Sociology of Reproduction (Joffe)
SOC 230	Ethnic (Race) Relations (Robnett)
SOC 202a,b	Comparative Methods in Historical Sociology (Hall)
SOC 265b	Theory in Contemporary Sociology (Hall)
SOC 292 b	Field Research (Hall, Wolf)
STH 250	Historical Models of Western Modernity. What Happened in the Twentieth Century? (Hagen)
STH 250	Culture and History (Hall, Walton)
TXC 230	Interpreting Social Meaning (Kaiser)
WMS 200a	Contemporary Issues in Feminist Theory (Fregoso)
WMS 200b	Problems in Feminist Research: Feminist Cultural Studies (Newton, Projansky)
WMS 201	Topics in Feminist Research (Wolf, Kaiser)

Note: [1]Denotes courses in the process of being proposed

Table 3 Recommended courses: recent special topics offerings (partial list 1995–97)

COM 210	Modernism and Postmodernism (Finney)
COM 210	Gender and Interpretation (Schein)
CRT 201	Special Topics: Studies in Gay and Lesbian Film Theory (Van Leer)
CRI 200b	Nietzsche and the 20th Century (Finney)
CRI 200b	Theories of Comedy and Laughter (Finney)
ENL 232	Problems in English Literature: 'Utopias of the British Enlightenment' (Johns)
ENL 256	Minority Experience and the Puritan Canon (Van Leer)
ENL 256	Identity in American Literature, 1636–1900 (Van Leer)
ENL 256	The American Renaissance and the Other (Van Leer)
ENL 233	Special Topics in American Literature: Foucault and New Historicism (Van Leer)
ENL 238	Special Topics in Literary Theory: Cultural Criticism (Van Leer)
ENL 238	Special Topics in Literary Theory: Minority Discourse (Van Leer)
ENL 238	Special Topics in Literary Theory: Theories of Sexuality (Van Leer)
GER 297	Gender and Fascism (Kuhn)
GER 297	Gender and German Cinema (Kuhn)
GER 297	(Re)Configuring National Identity (Kuhn)
GER 297	The German Democratic Republic Since 1989 (Kuhn)
HIS 201e	Medicine, Society, and Culture in the 18th and 19th Centuries (Kudlick)
HIS 201e	Nationalism in Modern European History: Ideologies and Political Practice (Hagen)
HIS 201	Gender and Culture (Rosen)
HIS 201q	Gender Trouble in History, 1997 (Kudlick)
NAS 200	Basic Concepts in Native American Studies (Crum)
NAS 202	Advanced Topics in Native American Studies (Macri)
SOC 225	Cultural Sociology (Hall)
SOC 230	Ethnic [Race] Relations 1996 (Robnett)
SOC 234	Gender, Family, and Society (Wolf)
STCH 290	Family Change and Politics, East and West (Stacey and Bill Skinner)
TXC 201	Style, Fashion, and Feminist Subjectivities (Kaiser)
TXC 293	Gender and Feminist Issues (Kaiser)
WMS 200b	Feminist Cultural Studies (Newton)
WMS 201	Gender and Popular Culture, 1996 (Fregoso)
WMS 201	Introduction to Cultural Studies (Frankenberg)
WMS 201	Gender and Global Issues (Joseph, Wolfe)

Note: In the case of special topics courses, some would not be taught again and some would. Still others may become cultural studies offerings. This list merely suggests the variety of cultural studies offerings which our faculty have produced in the past.

paper, which would be produced during course work in the first year, would serve as the basis for a written, two-hour preliminary exam. The student's advisory committee and two members of the executive committee (chosen by the advisory committee in consultation with the student) would read the preliminary exam and each reader would submit a written report and vote (pass/fail) on the examination. Faculty would submit reports to the executive committee which would make a decision in the case of a split vote. Successful completion of this exam would permit the student to continue the Ph.D. programme.

Directed research and qualifying exam: During the third year, the student would enrol in up to three-quarters of directed research (CST 270a–c) which would focus on the production of a dissertation prospectus. The dissertation prospectus is generally a document that frames the purpose and scope of the dissertation project, sets it in the context of relevant scholarship, and provides a chapter outline and a working bibliography. Defence of the prospectus would form part of the qualifying examination. The second part of the qualifying examination would focus on three fields. The examination fields are generally reading lists in three thematic areas that provide the critical, theoretical and/or historical contexts of the dissertation; they range considerably beyond the focus of the dissertation, and position the student's research interests in relation to the larger field. The thematic areas are defined in consultation with the advisory committee and approved by the chair of the examination committee. It is the responsibility of the chair to inform the other members of the qualifying examination committee of the nature of the three thematic areas. The two-hour, oral qualifying examination must be taken by the end of the third quarter of the third year of study; students who do not meet this deadline without the approval of the adviser would be regarded as making unsatisfactory progress. The qualifying examination committee normally includes all three members of the prospective dissertation committee and two additional members; while the dissertation chair may serve on the qualifying examination committee, he or she may not chair the examination. The student, in conjunction with his or her advisory committee, would recommend names for the qualifying examination committee to the graduate dean. The qualifying examination committee should reflect both the specific areas of dissertation research and the broader aims of the examination. Successful completion of the qualifying examination allows the student to advance to candidacy.

Cultural studies colloquium (CST 290): The student is also required to take a year-long, two-unit, weekly colloquium for three academic years. The colloquium is designed to provide cohort identity and faculty–student exchange. It provides students with the opportunity to present papers, hear guest lecturers and see faculty presentations, gather for organizational and administrative news, exchange information and make announcements. Students must take a minimum of up to eighteen units for credit, with a limit of two units per quarter. Since each Ph.D. student must make at least one presentation, each would have one quarter in which he or she undertakes more work than non-presenting students

to pass the course. Any seeming inequity in grading, therefore, would be evened out by the end of the second year. Since this course, at any rate, is graded pass/no pass, we do not anticipate any problems with this system.

Dissertation: When a student advances to candidacy, he or she, in consultation with his or her advisory committee, would propose names for a dissertation committee with at least three members. At least two members, including the chair, must be members of the graduate group. The committee would be appointed by the dean of graduate studies.

Sample programme

Year 1

First-year sequence, CST 200a–c (twelve units)
Graduate seminars and advanced course work (twelve units)
Cultural studies colloquium, CST 290 (six units)
Research CST 299 or additional course work (six units)

Year 2

Graduate seminars and advanced course work (sixteen units)
Research Seminar, CST 250 (four units) *seminar paper and preliminary exam required*
Cultural studies colloquium, CST 290 (six units)
Research, CST 299 or additional course work (ten units)

Year 3

Directed Research, CST 270a–c (twelve units) *dissertation prospectus and qualifying exam required*
Graduate seminars and advanced course work (eight units)
Cultural studies colloquium, CST 290 (six units)
Research, CST 299, or additional course work (ten units)

Years 4–5

Research, CST 299 (thirty-six units) *dissertation required*

Normative time

Students who have not completed a satisfactory seminar paper by the end of the sixth quarter may be subject to dismissal. Expected time to candidacy would be no more than nine quarters. Full-time students in cultural studies would normally complete the requirements for a Ph.D. within five years of full-time work.

MA degree

Admissions

Admissions for the MA degree would be the same as for the Ph.D.

Programme of study

Specific fields of emphasis: Davis faculty doing cultural studies work have particular strengths in the following areas: (1) gender and sexualities; (2) race, ethnicities and cultural representation; (3) politics, religion, communities and cultural representation; (4) popular culture; (5) national cultures, transnationalism and globalization; (6) science and society; (7) historical studies; and (8) rhetoric and critical theory. These cluster names, however, serve to identify areas of expertise and are not meant to formally delineate fields of emphasis or subprogrammes. In consultation with their course advisory committee, each student would draw on these clusters as well as on the designated emphases and traditional departmental and programmatic curricula, in order to develop his or her plan of study.

We intend to provide a core of rigorous courses useful to all students in cultural studies and to supplement the offerings of other departments in teaching the critical skills needed to do cultural studies work and to compete for jobs in several fields. We expect that students and advisory committees would design individualized programmes of advanced study from the many advanced courses being offered from a cultural studies perspective on the Davis campus.

Advisory committee: During the student's first quarter in residence, the graduate group in cultural studies executive committee would appoint an advisory committee consisting of the first-year guiding professor and two other members to advise the student on course work and other requirements. The advising committee would play a major role in ensuring consistency and balance in course work and intellectual preparation. The advising system would also ensure that all entering students have a 'home' and at least one faculty member taking responsibility for that student while simultaneously allowing flexibility for growth and change of the student's interests. A major professor would be appointed as a 'first-year guide' upon entrance of each student; the other two members of the advisory committee would be faculty with interests related to those of the student. MA students would be expected to select a major professor no later than the end of the third quarter of advanced course work.

The course advisory and thesis committees would evaluate and verify the student's progress in the specific fields of emphasis by reviewing performance in courses, preparation of the MA thesis, progress towards completion of the thesis and of the degree.

Unit requirements: A candidate's total programme for the MA degree must include a minimum of forty-four units of graduate and upper division courses and seminars relevant to teaching and researching in one's area of emphasis. A maximum of twelve of the forty-four units may be in upper division courses. This does not include the cultural studies colloquium, CST 290, or research, CST 299. In addition the student is required to have ten units of CST 299, a thesis, and a minimum cumulative GPA of 3.0 throughout all graduate work at UC Davis. Candidates would be expected to take the first-year sequence (CS 200a, b and c), a second-year research seminar CST 250, and ten units of cultural

Table 4 Required core courses

CST 200a	Theories, Histories and Practices of Cultural Studies (4) (Kaiser, Mechling, Newton and others)[1]
CST 200b	Studies in Theoretical Traditions (Chabram-Dernersesian, Ono and others)[1]
or CRI 200a	Introduction to Critical Theory (4) (Van Den Abbeele)
CS 200c	The Practice of Cultural Studies (4) (Kuhn, Projansky, and others)[1]
CS 250	Research seminar (4) (Staff)[1]
CS 290	Cultural studies colloquium (2) (ten units required) (Staff)[1]

Note: 1 Denotes courses in the process of being proposed

studies colloquium, CST 290, over five quarters. The units formally required would be those specified by general Davis division rules (DDR-500).

Required and recommended courses: Students would pursue a programme of courses chosen in consultation with their graduate adviser and advisory committees (see Table 4, and Tables 2 and 3).

Thesis: By the end of the first year, the student, in conjunction with his or her advisory committee, would nominate names for a thesis committee consisting of three members. The chair and one other reader must be members of the graduate group. The graduate dean would appoint members of this committee.

Sample programme

Year 1

First-year sequence, CST 200a–c (twelve units)
Graduate seminars and advanced course work (twelve units)
Cultural studies colloquium, CST 290 (six units)
Research or related course work, CST 299 (six units)

Year 2

Graduate seminars and advanced course work (sixteen units)
Cultural studies colloquium, CST 290 (six units)
Research, CST 299 (fourteen units)

Normative time

Full-time students in cultural studies can normally complete the requirements for a MA within two years.

Section III: Projected need

Student demand

Graduate student interest in cultural studies is increasing nationwide. Graduate students at Davis are also keenly interested in cultural studies work and are

currently piecing together research programmes out of traditional departments and designated emphases in feminist theory and research, critical theory, and social theory and comparative history. Some students are currently pursuing 'Individual' Ph.D. programmes in cultural studies. Realizing the depth and breadth of faculty expertise in this area on the Davis campus, many more students have expressed serious interest in such study. The executive committee for the graduate group in cultural studies, for example, sent a flyer to graduate students asking for their input on our cultural studies Ph.D. proposal. Over thirty students expressed interest in the proposal and virtually all claimed that they would have pursued such a degree had it existed when they entered Davis. Several expressed a strong desire to take advantage of such a programme before they graduated, and at least half a dozen potential graduate students, some Davis undergraduates, have talked of delaying their entry into graduate school in hopes that this programme would begin soon. Those of us on the cultural studies list server, finally, receive regular enquiries about cultural studies programmes, and Davis faculty in diverse areas ranging from the arts to textiles and community development are regularly approached with similar requests.

Opportunities for placement of graduates

The proposed cultural studies programme would produce Ph.Ds qualified to teach in a wide number of departments in humanities and social science and in interdisciplinary programmes as well. Most jobs appropriate to a Ph.D. student in cultural studies would not be in cultural studies programmes and would not necessarily be labelled cultural studies. There are many advertised positions, however, for which a student trained by the proposed graduate group in cultural studies at Davis would be well prepared. These would include positions in ethnic, women's and American studies programmes, jobs in film (often referred to as film and cultural studies), in media (often referred to as media and cultural studies), in the increasing number of interdisciplinary departments which call for candidates with interdisciplinary or cultural studies training, and in traditional departments which advertise for candidates with expertise in cultural studies, gender studies, ethnic studies, popular culture and so on. That we propose to offer students the option of taking a disciplinary emphasis or minor only increases the likelihood that they would be competitive for several of these jobs.

Because a student taking a cultural studies degree at Davis, for example, would have access to the designated emphasis in feminist theory and research and because there are forty faculty in the group whose primary research is on gender and sexuality, students in the cultural studies programme could obtain a Ph.D. focused on feminist cultural studies. This would certainly prepare them for positions in women's or gender studies. Depending on their disciplinary emphasis or research focus, they would be competitive for positions in feminist theory and research in traditional departments as well.

Because twenty faculty conduct primary research on race/ethnicity, many students in the programme obtain a Ph.D. focused on comparative race/ethnicity. Students in the programme might choose, for example, to take a DE in native American studies or in African-American and African studies (one is being created). Or since the entire faculty of Asian-American studies is participating in the group, they might choose to focus on Asian-American studies, perhaps in combination with East Asian languages and culture, since that programme has also endorsed the Ph.D. programme. The same is true for Latina/o studies. There are not many places where it is possible to get a Ph.D. focused in these ways.

Finally there are jobs listings in cultural studies in an increasing number of interdisciplinary departments such as social theory and cross-cultural studies; environmental studies; literature and film; cultural and international studies; comparative cultural studies; American history; theory and criticism; feminist and cultural studies; culture, ideas and values; politics and history; humanities and arts; radio, television and film; dance; liberal studies; arts and humanities; educational and social policy, and politics and history. In our reading of the autumn 1997 Modern Language Association job list, moreover, there are eight positions in cultural studies advertised in interdisciplinary departments such as English/humanities (advertising for film and cultural studies); literature, communication and culture; English and journalism (advertising for someone who has a cultural studies methodology); media and cultural studies; communication studies (advertising for a position in media, culture and society); a programme within comparative literature in cultural studies and rhetoric; humanities; performance studies; English, general literature and rhetoric; excellence in humanities; leadership studies, and cultural studies and comparative literature. The existence of these programmes, several of them new, indicates a trend towards the further institutionalization of cultural studies research.

Finally, cultural studies faculty do not perceive the job market for cultural studies students as being restricted solely to the academy. Many faculty in the graduate group in cultural studies at UCD are invested in having graduate education play an important role in public and educational policy and are keenly interested in educating students who may go on to do this kind of work. Graduates of History of Consciousness also go on to take careers in administration, counselling, law, health, television, curating, and management in both for-profit and non-profit organizations. An MA in cultural studies would also attract persons having or planning careers in secondary education, state agencies and so on, particularly in California, where issues of identity are so central and cultural analysis so complex.

Importance to the discipline

Cultural studies has emerged as a discrete field of interdisciplinary teaching and research over the last twenty-five years and is now well known as a field of study

in the US, Europe, Australia, China, Africa, India and Latin America. Cultural studies at Davis developed in a number of different departments, programmes and disciplines as it has in many other institutions. In the early stages of its evolution, this diffusion of cultural studies among many related disciplines was not only natural but probably essential for the health of the field. As fields of intellectual endeavour evolve, however, they often reach a point at which their future development is significantly enhanced by the organization of the participants into a functional academic unit with the field as its primary focus. In the opinion of its practitioners the field of cultural studies has now evolved to this point and greater organizational focus has already developed in other institutions.

A graduate programme in cultural studies would provide a vehicle for the Davis campus to bring together its excellent faculty in this area in a way that nourishes the further development of cultural studies on the campus, enhances the probability of fruitful interactions and collaborations, serves the needs of the numerous departments and programmes with ties to this mode of research, fulfils the increased demand on the part of graduate students for training in this field, and makes individual Ph.Ds unnecessary. A graduate programme, in short, seems necessary for the coherent development of cultural studies as a discipline at Davis.

Meeting the needs of society

The social transformations which we all face provide an additional rationale for instruction and research in cultural studies. It seems clear, for example, that students, especially those living in California, would conduct their social and work lives in arenas of rapid demographic, social and technological change. Social tensions having to do with race, gender, sexuality, class, and national identities and relations are increasingly significant, moreover, not only in California and the United States but worldwide. Training in the analysis of these identities and relations is at the heart of the cultural studies Ph.D. programme which we propose.

Relation to research and professional interests of faculty

The University of California at Davis is in the unusual situation of having one of the largest and individually best known faculties in cultural studies in the nation. Cultural studies at Davis, however, has not been highly visible outside our own campus because our courses in cultural studies have been scattered throughout the curricula of various departments, making it virtually impossible for current graduate students to integrate cultural studies into their programmes in a coherent or comprehensive manner. A strong, integrated graduate programme

in cultural studies would unify and identify our impressive cultural studies resources, foster an exciting intellectual environment, increase the productivity of existing research programmes, strengthen existing designated emphases, and place successful graduates into other university programmes, research institutions and agencies. We are confident that this would secure cultural studies at Davis significant national and international recognition.

Programme differentiation

Davis would offer a cultural studies programme unique within the UC system for the range of faculty which comprise it – sixty-three faculty from twenty-four departments and programmes and from two colleges. (Unlike some other cultural studies programmes that are dependent on two or three individuals, the Davis programme has a critical mass of faculty ensuring that its courses can be regularly taught.) In its embrace of the graduate group concept, moreover, the Davis campus is exceptional in providing a ready-made and well-established structural base for such wide-ranging programmes. Our proposed graduate group is also unique in its racial and ethnic diversity. On no other UC campus, for example, does a cultural studies-type programme involve faculty from Asian-American, African-American and African, and Chicana/o studies. The cultural studies programme would draw upon the resources of these excellent programmes, provide wider opportunities for students to be mentored by their faculty, and hopefully aid them in developing, or further strengthening, their own graduate programmes.

Section IV: Staff

Initially, the programme would be staffed by the sixty-three faculty members who have joined the graduate group in cultural studies. Faculty wishing to join the graduate programme after its approval would apply to the executive committee.

Section V: Courses

Existing courses

Many of the courses needed for a sound preparation in doing cultural studies research are already being taught on the Davis campus. Our proposed programme, however, requires some new courses. Some will serve as a theoretical and methodological core; others will round out the curriculum.

New courses

Our required and recommended cultural studies core courses have been approved by the Graduate Division Course Committee and are on the agenda for the committee on courses. Many of these courses would be cross-listed with the departments/programmes of the cultural studies faculty.

Section VI: Resource requirements

In general, the new programme would involve a re-allocation of existing resources; no new resources are required to bring the programme into full operation. Specifically, resources required are as follows.

Faculty FTE

No additional faculty FTE are needed to launch the programme.

Library resources

Because this programme draws on so many faculty already doing cultural studies research and because it draws upon many courses that we already have, it should not substantially increase the need for library services and collections.

Computing costs

The graduate division would provide initial funding for computers ($5000).

Equipment

No additional major equipment resources are needed to launch the programme.

Space

The staff and student mailboxes for this group would be housed in Hart Hall.

Other operating costs

Administrative support
Experience with existing graduate programmes indicates that a staff member is needed approximately half-time to handle admissions, correspondence, record keeping, and general coordination and administration. By mutual agreement of the deans and the Office of Graduate Studies, support for this staff position and

for supplies is to be divided equally between the Office of Graduate Studies and the deans of HACS, social science, and agricultural and environmental science. In keeping with the staff organization plan for the College of Letters and Sciences, the half-time staff person would function as part of the central administrative support centre for the Hart Hall programmes.

Delivery of courses

Graduate group programmes at Davis, like most designated emphases, do not usually require buy-out money to deliver their courses. Students in graduate groups regularly take courses which are already being taught in related departments and which have been designated as fulfilling a graduate group requirement. These courses may be cross-listed, cross-referenced, or merely advertised as counting for the graduate group in question. Of the sixty-three faculty who belong to the graduate group, most already teach courses through their home departments and programmes which would be counted towards the cultural studies Ph.D. In other words, cultural studies graduate students would be taking already existing courses in traditional departments. Since we anticipate that many students would be taking what amounts to a disciplinary emphasis, we expect they would be taking regularly taught courses in disciplinary methodologies as well.

Six of the seven core courses in our programme would be taught by faculty whose programmes are willing to release them for this purpose. Several of the programmes involved in the graduate group in cultural studies have faculty who do not have regular access to teaching graduate courses, and they have announced their willingness to release them for teaching core courses. These programmes include American, Asian-American and women's studies, and textiles and clothing.

Section VII: Graduate student support

There are sufficient already existing TA slots in American, Asian-American, women's studies and in science and society to support graduate students at the rate of five a year. American and Asian-American studies, for example, have used their funds, historically, for undergraduate readers because they could not find graduates who were sufficiently expert in their fields. Some graduate students in cultural studies, therefore, would find ready employment in these programmes. Although science and society and women's studies would continue to offer some teaching assistantships to those in traditional disciplines, each of these programmes is eager to have teaching assistants trained in cultural studies as well. Faculty currently teaching the large introductory course in film also report that they prefer students with training in cultural studies.

New programmes, we have been informed by graduate studies, can also

expect to have block grant money from the campus pool. Since block grant funds come from a university-wide and not from a college or divisional source, new graduate programmes administratively housed in the Humanities, Arts and Cultural Studies (HACS) division of Letters and Sciences would not unduly impact that division in terms of block grant funding.

In addition, most of the faculty in the proposed graduate group have faculty research grants and regularly employ research assistants. Here again, given the interdisciplinary nature of the research being carried on by these faculty and given their focus on areas in which cultural studies graduate students would be trained, cultural studies graduate students would be strong contenders for these positions.

Section VIII: Changes in senate regulations

No changes in senate regulations are required.

Acknowledgements

The authors would like to acknowledge the original members of the cultural studies executive committee at UC Davis for their substantial contributions to the proposal: Angie Chabram-Dernersesian, Ruth Frankenberg, Rosa Linda Fregoso, Suad Joseph, Anna Kuhn, Jay Mechling, Janelle Reinelt, Belinda Robnett and Irit Rogoff.

CULTURAL STUDIES' INSTITUTIONAL PRESENCE: A RESOURCE AND GUIDE[1]

compiled by Ted Striphas

This is a list of universities, departments, programmes, centres, institutes, etc. that identify in some form as 'cultural studies'. It has been compiled following two calls for information – the first in January 1997, the second in March 1998 – issued over the worldwide cultural studies e-mail listserv (*cultstud-1@nosferatu. cas.usf.edu*). This list has been assembled with a number of aims: (1) providing a sense of the breadth of cultural studies' institutional presence and its range of institutionalizations; (2) helping to create a network among existing institutions that identify themselves as cultural studies; (3) developing a resource of contacts for persons and groups who are interested in initiating a proposal to institutionalize cultural studies in their own locale; and (4) providing a resource for potential students, visiting scholars, etc.

Two caveats are required. First, although every effort has been made to provide up-to-date information, we cannot guarantee its accuracy. Second, this should not be considered an extensive or exhaustive list. There are, indeed, many noticeable regional absences, including but not limited to Central America, Eastern Europe, the Middle East, and most of Africa, South America and Asia. We welcome any addenda or corrections, as well as information on cultural studies programmes, departments, etc. not listed here. We hope to update this guide periodically in future issues of *Cultural Studies*.

Amsterdam School for Cultural Analysis, Theory and Interpretation
Spuistraat 210
1012 VT Amsterdam
THE NETHERLANDS

tel: 20–525–3874
fax: 20–525–3052

web: *http://www.let.uva.nl/~asca/*
chair: Hent de Vries

During the last decade, universities all over the world have reassessed their priorities, redirecting goals and refocusing their activities. Especially in the humanities, the future lies in concentrating resources and pooling research, with the aim of 'centres of excellence'. The Amsterdam School for Cultural Analysis, Theory and Interpretation (ASCA) is one such centre. Located at the University of Amsterdam – one of the oldest in the world – it brings together scholars active in literature, philosophy, the fine arts and popular culture, comparative religion, and cultural anthropology. Specialists in their respective fields, they also share a commitment to working within an interdisciplinary framework and to maintaining a close connection with cultural expression outside the academic world. Within ASCA they have joined forces to provide a stimulating environment for scholars and professionals both from the Netherlands and elsewhere. ASCA offers regular seminars, organizes workshops, and frequently hosts international conferences. It publishes a monthly newsletter and a yearbook. In addition to maintaining contact with similar institutions in Europe and the United States, ASCA is also assisted by an International Advisory Board.

California Institute of the Arts
School of Critical Studies
24700 McBean Parkway
Santa Clarita, CA 91355
USA

tel: 805–253–7803
fax: 805–255–0177
e-mail: *admiss@calarts.edu*
web: *http://www.calarts.edu/bulletin/cbullfrm.htm*
contact: Mady Schutzman
dean: Dick Hebdige

The School of Critical Studies offers a varied curriculum which is designed to broaden students' general knowledge and introduce them to the methods and disciplines of the humanities and the social and natural sciences. In developing the curriculum, the faculty has taken into account the special interests and needs of students as practising artists. Courses are often interdisciplinary and address aesthetic, political, social and ethical issues relevant to contemporary art practice. A number of courses focus on the historical development of an art-form. The curriculum acknowledges the diversity and dynamism of cultural and intellectual heritage and aims to promote an active understanding of cultural innovation and social conflict as well as continuity, cohesion and tradition. All classes

emphasize critical thinking and encourage open intellectual enquiry and clear communication of ideas. Classes are usually structured as seminars, offering students an opportunity to engage in lively debate and in-depth discussion.

Claremont Graduate University
Cultural Studies Department
710 North College Avenue
Claremont, CA 91711
USA

tel: 909–607–1271
email: *cultural@cgu.edu*
web: *http://www.cgu.edu/hum/cul*
contact: Ranu Samantrai (acting chair)

Claremont University's Cultural Studies Department was established in 1995. It is a graduate-only programme that grants MA and Ph.D. degrees in cultural studies. The interdisciplinary curriculum trains students to research and analyse the nature, origins, production, distribution and persistence of contemporary and past cultures. Students study cultural change and continuity, the operation of contemporary cultural forms, the construction of knowledge, the emergence and functioning of power relationships, and the shaping of cultural identities and their interactions with other cultural phenomena.

Curtin University of Technology
School of Communication and Cultural Studies
Bentley Campus
Perth
Western Australia 6845
AUSTRALIA

tel: 08–9266–7132
fax: 08–9266–7726
e-mail: *nrichards01@cc.curtin.edu.au*
web: *http://www.curtin.edu.au/curtin/dept/ccs/*
contact: Noreen Richards
head: Tony Nicholls

The School of Communication and Cultural Studies has been a leader and innovator in literary, performance and cultural studies for more than twenty-five years. It pioneered courses in Australian studies and was one of the first tertiary institutions to offer journalism as a major stream and to give students the opportunity to combine theoretical studies with practical applications. Recently, the

school has led the development of gender and masculinities studies. This forward-looking approach has made the school's courses strongly sought after, consistently attracting high-quality under- and postgraduate students and highly qualified staff, many of whom are nationally recognized practitioners in their disciplines.

Drake University
Cultural Studies Program
2507 University Avenue
Des Moines, IA 50311–4505
USA

tel: 515–271–2158 or 515–271–2853
e-mail: *Jody.Swilky@Drake.Edu*
web: *http://www.english.drake.edu/cs/cs.html*
contact: Jody Swilky (director)

Established in 1990, Drake University's Cultural Studies Program is a multi-disciplinary endeavour made up of courses for students and a series of forums, colloquia and lectures for the university community. There is no cultural studies 'department', and no cultural studies 'major'. Instead, the courses that make up its curriculum come from a variety of arts and sciences departments and from the School of Journalism, including English, speech communications, honours, sociology, history, political science, women's studies, foreign languages, and first-year seminars. A cultural studies concentration, which requires eighteen hours of study including an independent study/research project, is compatible with majors in these departments/programmes.

Duke University/University of North Carolina
Program in Latin American Studies

Duke University
2114 Campus Drive, Box 90255
Durham, NC 27708–0255
USA

University of North Carolina
223 E. Franklin Street, CB 3205
Chapel Hill, NC 27599–3205
USA

tel: 919–681–3980
fax: 919–681–7966
e-mail: *las@acpub.duke.edu*
web: *http://www.duke.edu/web/las/duke-unc.html*
contact: Deborah Jakubs (director)

After more than half a century of informal cooperation, in the late 1980s the University of North Carolina and Duke University joined to create the Duke-UNC Program in Latin American Studies. The Program's objective is to enhance

the Latin American curriculum on both campuses, provide research and training opportunities for students and faculty from all disciplines, and increase public awareness of the importance of Latin American cultures and traditions. Undergraduate and graduate students affiliated with any university department or professional school are encouraged to document their specialization in the region by earning a certificate in Latin American studies in conjunction with their Master's or Doctoral degree.

Federal University of Rio de Janeiro
Programa Avangado de Cultura Contemporanea
(Advanced Program in Contemporary Culture)

e-mail: *pacc@omega.lncc.br*
web: *http://pub1.lncc.br/prcc*
contact: Heloisa Buarque de Hollanda (coordinator)

Founded in 1994, the Advanced Program in Contemporary Culture (PACC/UFRJ) is a permanent international teaching and research forum in cultural studies. It proposes to encourage – through interdisciplinary research in the fields of literature, art, architecture, anthropology, philosophy and politics – transnational partnership in comparative cultural studies. PACC meets the new demand for specific research practices that correspond to the need for bringing a critical reading of cultural production into the discussion of the processes of identity, citizenship and democratization formation, in the context of national spaces which are currently being globalized by economic and political powers. PACC has also been working on the creation of a graduate studies programme in the critical theory of culture, in association with other universities, both on a national and international level. The graduate programme aims at stimulating transnational partnerships in comparative studies of culture as well as consolidating the field of cultural studies in Brazil, creating, in this way, a university that is involved in the production, academic transmission and public dissemination of knowledge concerning issues that gravitate around the democratic improvement of relations between the state and society.

George Mason University
Cultural Studies Program
MSN 5E4
Fairfax, VA 22030–4444
USA

tel: 703–993–1432
fax: 703–993–2852

e-mail: *cultural@gmu.edu*
web: *http://www.gmu.edu*
contact: Mark Jacobs (director)

George Mason's programme is one of only a few completely interdisciplinary doctoral programmes in cultural studies in the USA. That is, the programme is not housed in any one specific department. It links the social sciences and the humanities, combining methods of interpretation and reception in production, distribution and consumption of cultural objects in their social contexts. Internships, research collaboratives, community outreach and interdisciplinary team-teaching opportunities are connected to the programme.

Georgia Institute of Technology
School of Literature, Communication, and Culture
Ivan Allen College
Atlanta, GA 30332–0165
USA

tel: 404–894–2730
fax: 404–854–1287
web: *http://www.lcc.gatech.edu/index.html*
contact: Richard Grusin (chair) or Anne Balsamo (director of graduate studies)

Georgia Tech's School of Literature, Communication, and Culture (LCC) is participating in the fundamental reconfiguration of the role of higher education in an increasingly technological, multicultural environment. The school's faculty share a commitment to interdisciplinary work at the theoretical and applied levels, as well as to the integration of new technologies into humanities and communication education. To aid in this endeavour, LCC offers several programmes and resources designed to enrich the college experience. Currently offering a Master's degree in Information Design and Technology (IDT), a Bachelor's degree in Science, Technology and Culture (STAC), and a minor in Women, Science and Technology (WST), LCC is also responsible for providing general courses in literature, communication and culture to all Georgia Tech undergraduates. In addition to current offerings, the School of LCC has an eye towards developing a Ph.D. programme in the history, theory and practice of technologies of representation.

Goldsmiths College, University of London
Department of Media and Communications
New Cross
London SE14 6NW
UK

tel: 0171–919–7600
fax: 0171–919–7616
e-mail: *s.sheehan@gold.ac.uk*
web: *http://www.gold.ac.uk/cms/dept/mcintro.htm*
contact: Sheila Sheehan
head: David Morley

Established in 1978, the department offers undergraduate degrees in media and communications, and joint degrees in anthropology and communications and communications and sociology. At the MA level it offers degrees in media and communications (a theoretical course), television drama, television documentary, image and communications (involving work in photography and computer graphics), journalism, and radio. It also runs a large Ph.D. programme in the college with twenty-five doctoral students expected to be enrolled in the next session. The department has a strong interdisciplinary theoretical team, along with a strong commitment to media practice and research equivalent activity. Within this environment students are encouraged to engage critically with different approaches to the media in a variety of academic and practice disciplines, to develop skills in research and presentation, and to explore creative possibilities across a range of media.

Griffith University
Australian Key Centre for Cultural and Media Policy
Faculty of the Humanities
Brisbane, Queensland 4111
AUSTRALIA

tel: 07–3875–5350
fax: 07–3875–5511
e-mail: *CMP@hum.gu.edu.au* or *K.Perkins@hum.gu.edu.au*
web: *http://www.gu.edu.au/gwis/akccmp/home.html*
contact: Karen Perkins (manager)
acting director: David Saunders

The Australian Key Centre for Cultural and Media Policy is one of a number of key centres established by the Australian Research Council as part of its research centres programme. Its designation as a *key* centre indicates that its purpose is to develop a programme of research and postgraduate studies in close consultation with government and/or industry partners. The role of the Australian Key Centre for Cultural and Media Policy, accordingly, is to play a leading and co-ordinating national role in developing cultural and media policy research and graduate programmes in ways that are closely informed by the needs of, and advice from, Australia's cultural and media industries and government policy

agencies. The intellectual orientations of the centre are primarily concerned to (1) establish a productive interface between the concerns of cultural studies and the practical concerns of contemporary cultural and media policy, and (2) to incorporate a policy perspective into the concerns of cultural studies, particularly in its theoretical and historical understanding of the relation between government and culture.

Hampshire College
School of Cognitive Science and Cultural Studies
893 West Street
Amherst, MA 01002
USA

tel: 413–582–5502
e-mail: *admissions@hamp.hampshire.edu*
web: *http://www.hampshire.edu/Hampshire/ccs/html/ccs.html*
contact: Meredith Michaels or Neil Stillings (co-deans)

The School of Cognitive Science and Cultural Studies at Hampshire College represents a unique enterprise in American undergraduate education. The school brings together faculty in the fields of psychology, computer science, linguistics, philosophy and mass communications who share common interests in the nature of knowledge and information. Cognitive science attempts to understand the human being as a 'knowing' organism. Cognitive scientists are concerned with language and memory, with the nature of belief and emotion, and with the relationship between 'mind' and 'brain' and between minds and machines.

Harvard University
Center for Literary and Cultural Studies
The Barker Center
12 Quincy St.
Cambridge, MA 02138
USA

tel: 617–495–0738
e-mail: *lundeen@fas.harvard.edu*
web: *http://www.fas.harvard.edu/~clcs/*
contact: Lesley Lundeen
director: Marjorie Garber

The Center for Literary and Cultural Studies (CLCS), founded in 1984 with a grant from the Andrew W. Mellon Foundation, provides a locus for interdisciplinary discussions among Harvard faculty, faculty from other area institutions,

and graduate students in a variety of fields, including literature, psychology, history, art history, philosophy and archaeology. The CLCS has established itself as a significant force for the enhancement of the study of literature and cultural criticism at Harvard. It presently sponsors thirty-three ongoing faculty/graduate student seminars; it also supports lectures, conferences, workshops and informal occasions for the exchange of ideas and the sharing of scholarly work. Faculty and graduate students from Harvard and other area institutions, and independent scholars in the greater Boston area, are welcome.

Institut Fuer Kulturstudien (IFK)

Danhausergasse 1
A-1040 Wien/Vienna
AUSTRIA

tel: 0043–1–2145737
e-mail: *ifk@ifk.ac.at*
contact: Vanessa Redak
director: Dr. Gotthart Wunberg (Universität Tübingen/Wien)

The IFK was founded in 1992 through the initiative of Erhard Busek, former Austrian Federal Minister of Science. The institute is sponsored by the Austrian government, but has no status as a university. Currently, the IFK sponsors a visiting fellowship, junior fellowships, conferences, the Vienna Colloquia in Cultural Studies, and several in-house seminars. Its current research programme, 'imagined communities', explores themes of memory, experience and innovation.

Kansas State University

The Program in Cultural Studies
Department of English
106 Denison Hall
Manhattan, KS 66506–0701
USA

tel: 785–532–6716
fax: 785–532–2192
e-mail: *csdirector@ksu.edu*
web: *http://www.ksu.edu/english/culturalstudies*
contact: Linda Brigham or Gregory Eiselein

Kansas State University's Department of English has offered an MA with specialization in literature and cultural studies since 1992. Course work in the programme includes the theory and practice of cultural studies, a seminar in cultural studies, as well as other advanced courses in literature, criticism and

theory, and cultural studies. Students also select relevant courses outside the English Department in order to pursue interdisciplinary study in areas such as anthropology, history, sociology, philosophy, modern languages, political science and mass communications. Most students in the Program in Cultural Studies are eligible to receive financial assistance in the form of graduate teaching assistantships.

Lingnan College (Lingnan University in 1999)
Bachelor of Arts (Hons.) in Cultural Studies
School of General Education
Tuen Mun
NT
HONG KONG

tel: 852–2616–7489
fax: 852–2572–5170
e-mail: *joetsui@ln.edu.hk*
chair: Stein H. Olsen
contact: Stephen C. K. Chan

The BA (Hons.) degree in cultural studies aims to provide a challenging bilingual (Chinese–English) education which will enable students: (1) to engage themselves productively in the contemporary study of culture; (2) to become sensitive to, and critical of, the issue of identity and value to which various forms of culture are tied; (3) to understand the complex issues of modern self, society and history through the dynamic structure of an interdisciplinary curriculum, in which the understanding and integration of multiple perspectives will become crucial to all their core work in the analysis and criticism of culture; and (4) to open themselves intellectually to the wide-ranging voices of dissent today, by studying those texts and contexts that have been changing their views of others, so as to develop independent judgement on the multifarious cultural practices and social institutions in the contemporary world. The programme will be inaugurated in the academic year 1999–2000.

Middlesex University
School of English, Cultural and Communication Studies
White Hart Lane
London N17 8HR
UK

tel: +171–362–5000 or +171–362–6036
e-mail: *L.Young@mdx.ac.uk*

web: *http://www.mdx.ac.uk*
contact: Lola Young (tel: +171-362-6036)

Media and cultural studies at Middlesex University is an interdisciplinary subject area focusing on 'race' and representation, gender and sexuality, ethnicity and identity and the globalization of popular culture. At the undergraduate level, students develop their research skills and in their final year are offered a range of options including work placement. Supervision of postgraduate research is offered in black cultural studies, postcolonial studies, masculinity and sexuality.

Monash University
Center for Comparative Literature and Cultural Studies
Clayton Campus
Wellington Road
Clayton, Victoria 3168
AUSTRALIA

tel: 3–9905–2152
fax: 3–9905–5593
e-mail: *Chris.Worth@arts.monash.edu.au*
web: *http://www.arts.monash.edu.au/cclcs/*
contact: Chris Worth

The centre is an interdepartmental unit, maintained by the Faculty of Arts, with responsibility for teaching, and research in three main areas of work: comparative literature, cultural studies and critical theory. The centre has been a part of the Arts Faculty at Monash University, Melbourne, since 1970. The centre's research seminars are open to all staff, postgraduates, and visitors with an interest in the topics. Recent seminars have included: transient aesthetics: installation, judgement and suicide; the ontological function of poetics: logic, performance and the body; and linguistic vulnerability and objectification: sites of the subject-at-risk in Butler and MacKinnon.

New York University
Program in American Studies
285 Mercer Street, 8th Floor
New York, NY 10003
USA

tel: 212–998–8538
fax: 212–995–4371

web: *http://www.nyu.edu/gsas/program/amerstu/*
director: Andrew Ross

The Program in American Studies offers courses of study leading to the degrees of Master of Arts and Doctor of Philosophy. It is designed to prepare students for advanced work and teaching in American studies. Interdepartmental by definition, the student's course of study is arranged by the director and the director of graduate studies and involves seminars offered in the programme and selected courses in the departments and programmes of Africana studies, anthropology, cinema studies, comparative literature, English, fine arts, history, journalism and mass communications, liberal studies, music, performance studies, philosophy, politics, and sociology. The programme's committee is made up of faculty from many of these departments. The programme interprets 'American' in a broad sense to include assessments of the historical role of the United States in the Americas and, more generally, in world affairs. Inasmuch as the programme has a regional focus, special attention is given to studies in urbanism and to New York in particular, a global city that comprises many world cultures.

Open University Worldwide
The Berrill House
Walton Hall
Milton Keynes
MK7 6AA
UK

tel: +1908–858791
fax: +1908–858787
e-mail: *ouwenq@open.ac.uk*
web: *http://www.open.ac.uk/Partners/OUW*
contact: Anji Kellett

Professor Stuart Hall is a major contributor to a new set of multi-media resources entitled *Culture, Media and Indentities*, providing a broad based exploration of the interdisciplinary fields of culture and media studies. They analyse current theoretical ideas and debates about culture and chart its growing importance in many aspects of contemporary life. Key topics include: The growth of the new technologies and their impact on everyday life and popular culture, the analysis of media messages and images, how culture constructs new identities and the rise of new multi-media culture industries which dominate the networks of circulation. The resources are comprised of six self-study workbooks, six audio cassettes and supplementary material assuming no specialist knowledge. They will be of particular value to academics and lecturers teaching these subjects in their own institutions.

Trent University

Cultural Studies Program
Peter Robinson College
Petersborough
Ontario K9J 7B8
CANADA

tel: 705–748–1771
fax: 705–748–1826
e-mail: *CultStudies@Trentu.ca*
web: *http://ivory.trentu.ca/www/cu/*
contact: Ian McLachlan (chair)

This programme, founded in 1977, is Canada's first undergraduate programme in cultural studies. It is a four-year interdisciplinary programme aimed at the study of modern culture and unique in its emphasis on the arts in its plan of education. It offers courses in social and cultural theory, as well as media and popular culture, music, theatre, film, the visual arts and literary studies. Many members of the Cultural Studies Program also teach and undertake research within various of Trent's interdisciplinary graduate programmes; the majority are associated with the MA in methodologies for the study of Western history and culture and/or the Frost Centre's MA in Canadian studies.

University of Arizona at Tuscon

Comparative Cultural and Literary Studies
1239 North Highland
Tucson, AZ 85721
USA

tel: 520–626–8693
fax: 520–626–8694
e-mail: *dawnw@u.arizona.edu*
web: *http://grad.admin.arizona.edu/idps/ccls/ccls.html*
director: Marv Waterstone

Established in 1987, the graduate programme in Comparative Literature and Literary Theory (CPLT) quickly achieved considerable strength, attracting many of the best scholars and teachers in the College of Humanities and elsewhere, as well as excellent students, many of whom are from other countries or are members of under-represented groups in the United States. The focus of the programme, however, shifted to literary and cultural studies, and was officially reorganized in 1992 as the graduate programme in Comparative Cultural and Literary Studies (CCLS) to reflect this development. The programme encourages students to explore similarities and differences within and among

national cultures and literatures, as well as in the work of individual authors. Such studies focus on the production, circulation, and interpretation of meaning and value in a variety of discursive formations from literature and art to cultural performances and political economies. It confers MA and Ph.D. degrees.

University of Birmingham
Department of Cultural Studies and Sociology
School of Social Sciences
Edgbaston
Birmingham B15 2TT
UK

tel: 0121–414–6060
fax: 0121–414–6061
e-mail: *Y.L.Jacobs@bham.ac.uk*
web: *http://www.bham.ac.uk/CulturalStudies/*
contact: Yvonne Jacobs
head: Michael Green

The University of Birmingham's undergraduate major in media and cultural studies, offered through the Department of Cultural Studies and Sociology, gives a broad introduction to the shape of contemporary society (including its historical formation and the various lines of its possible future development), and to some key issues within it. These include, centrally, 'mass' media and also other forms of cultural production, such as popular music, or public and private uses of photography. But we want to look as much or more at social groups and social divisions of class, of gender, of 'race'; at the cultural and political forms which they generate; and at the ways we form meanings, prejudices, stereotypes, values and identities around and about them. We are also intrigued by the centrality of culture and by all the ways in which the term is used: we can refer to cultural institutions (museums, the British Council, the BBC); to high culture, mass culture, popular culture, women's culture, black culture, 'enterprise' culture; to youth and other subcultures; to cultural production, cultural policies, cultural industries. The department offers a number of postgraduate programmes, conferring both MA and Ph.D. degrees.

University of California at Santa Cruz
Center for Cultural Studies
Oakes College
Santa Cruz, CA 95064
USA

tel: 408–459–4899
fax: 408–459–4979
e-mail: *cult@hum.ucsc.edu*
web: *http://humwww.ucsc.edu/DivWeb/CultStudies/CSC*
contact: Gail Hershatter

The Center for Cultural Studies at the University of California at Santa Cruz (UCSC) was founded in the spring of 1988. Through an ensemble of research clusters, conferences, workshops, visiting scholars, publications, film series, and a Rockefeller Residency Program, the centre has encouraged a broad range of research in the rapidly evolving field of cultural studies. In 1995–96, the centre embarked upon a three-year project on post-Marxism, postsocialism and postcommunism. This project is designed to capture a range of intellectual, political, economic and social phenomena consequent to the breakup of socialist regimes and the decline of Marxist doctrine in the late twentieth century.

University of California at Santa Cruz

History of Consciousness Program
218 Oakes College
University of California
Santa Cruz, CA 95064
USA

tel: 408–459–4616
e-mail: *alexandra_armstrong@macmail.ucsc.edu*
web: *http://humwww.ucsc.edu/histcon/HisCon.html*
contact: Alex Armstrong
chair: Victor Burgin

History of Consciousness is an interdisciplinary graduate programme centred in the humanities with links to the social sciences and arts. It is concerned with forms of human expression and social action as they are manifested in specific historical, cultural and political contexts. The programme stresses flexibility and originality. Interest is focused on problems rather than disciplines. Although students are prepared to teach in particular fields, the emphasis is on questions that traverse a number of different ones. Over its thirty years of existence, History of Consciousness has won increasing recognition as a leader of interdisciplinary scholarship. Programme graduates are prolific scholars at prominent universities, and recent dissertations are regularly published by major academic presses. Graduates currently find employment in a wide range of disciplines, including literature, women's studies, science studies, anthropology, sociology, American studies, cultural studies, ethnic studies, communications and philosophy.

University of East London
Department of Cultural Studies
Longbridge Road
Dagenham
Essex RM8 2AS
UK

tel: 181–849–3545
e-mail: *a.oshea@uel.ac.uk*
contact: Alan O'Shea (head of department)

The BA in cultural studies began in 1980 (while the institution was known as North East London Polytechnic), as a collaboration between the School of Education and Humanities and the Sociology Department; a separate Department of Cultural Studies was established in 1986. Its primary aim has been to offer an analysis of cultural processes and the power relations inscribed in them, but also to develop skills in communicating these insights in a variety of media. Its distinctiveness has been its strongly historicized version of cultural studies, offering a historical and theoretical understanding of mainly British culture. Since 1991, the department has offered an MA in cultural studies, and since 1996, an MA in women's studies as well.

University of Guelph
Centre for Cultural Studies
047 MacKinnon
Guelph, Ontario N1H 2M9
CANADA

tel: 519–824–4120 x6049
fax: 519–821–0287
e-mail: *culture@uoguelph.ca*
web: *http://www.uoguelph.ca/culture*
contact: Susan Callan
director: Christine Bold

Opened in January 1996, the Centre for Cultural Studies is a research centre that welcomes participation by faculty, students, and other members within and beyond the university. The centre supports a wide range of activities that connect interdisciplinary cultural analyses with the larger community: colloquia, lecture series, talks, round-table debates, reading groups, etc. It is particularly committed to developing collaborative scholarship and publication in the field through their seminars. These research groups currently focus on cultural studies pedagogies, cultural studies methodologies, jazz and cultural memory. The centre works to bridge the traditional gap between the 'two

cultures' of the humanities and the sciences and to foster cross-disciplinary collaboration.

University of Illinois at Urbana/Champaign
Unit for Criticism and Interpretive Theory
608 South Wright Street
Urbana, ILL 61801
USA

tel: 217–333–2581
e-mail: *pgarrett@ux1.cso.uiuc.edu*
web: *http://criticism.english.uiuc.edu/*
contact: Peter Garrett (director)

The Unit for Criticism and Interpretive Theory is an interdisciplinary programme developed within both the Graduate College and the College of Liberal Arts and Sciences at the University of Illinois at Urbana-Champaign. Drawing upon the expertise and resources of nineteen humanities and social science departments, the unit promotes a broad range of teaching, research and related scholarly activities. Through designated courses, the ongoing work of the faculty criticism seminar, regular exchanges of work in progress, a monthly colloquium, and visits to campus of distinguished scholars from other institutions, the unit provides both students and faculty with an interdisciplinary vantage point for their own teaching and research. To graduate students enrolled in MA or Ph.D. programmes in participating departments, the unit also offers a formal programme leading to advanced certification in criticism and interpretive theory.

University of Melbourne
Cultural Studies Programme
Department of English
Parkville, Victoria 3052
AUSTRALIA

tel: 3–9344–5506 or 3–9344–5507
fax: 3–9344–5494
e-mail: *c.healy@english.unimelb.edu.au*
web: *http://www.unimelb.edu.au/HB/areas/ACULTUR.html*
contact: Chris Healy

The University of Melbourne, Faculty of Arts offers cultural studies programmes at undergraduate and postgraduate levels. The programme was established on the initiative of the Department of English in 1992. Specific appointments have been made to cultural studies and, as an interdepartmental programme, it has involved

scholars working in English, art, history, cinema studies, history, women's studies, political science, criminology and philosophy. The undergraduate programme allows students to complete a BA to Honours level. At a postgraduate level, the programme offers both an MA and a Ph.D. in cultural studies.

University of Minnesota
Cultural Studies and Comparative Literature
350 Folwell Hall
9 Pleasant Street SE
Minneapolis, MN 55455–0195
USA

tel: 612–624–8099
fax: 612–626–0228
e-mail: *meiss001@tc.umn.edu*
web: *http://www.folwell.umn.edu/cscl/*
contact: David Meissner

Cultural Studies and Comparative Literature (CSCL) offers interdisciplinary and cross-cultural studies of how varying modes of discourse (for example, art, architecture, literature, music, philosophy, religion) are both rooted in and active within history, society and culture. The objective is an improved understanding of the complex interrelation of ideas, values, social patterns and material realities, with attention to the subtleties inherent within different styles of thought, genres of expression, cultural contexts and historic moments. The Department of Cultural Studies and Comparative Literature offers both major and minor programmes at undergraduate level. In addition, it also offers two graduate school programmes: comparative studies in discourse and society and comparative literature.

University of Natal
Centre for Cultural and Media Studies
Durban 4041
SOUTH AFRICA

tel: 31–260–2505/2298
fax: 31–260–1519
e-mail: *govends@mtb.und.ac.za*
web: *http://www.und.ac.za/und/ccms/index.htm*
contact: Susan Govender
head: Keyan G Tomaselli

The Centre for Cultural and Media Studies (CCMS) is the Southern African region's premier graduate research and educational unit in media studies. The

staff, research and publications of the centre are internationally renowned and read, and its leading staff members have been visiting professors in a variety of universities all over the world. The centre was established after the Soweto uprising of 1976, in order to develop strategies of cultural resistance through media and culture. The aim of the centre was to teach critical media and cultural studies and to actively contribute to political change from inside the anti-apartheid coalition then known as the Mass Democratic Movement. Staff and students set out to develop theories and strategies to enable grassroots empowerment and local media and cultural development projects. The centre offers courses of an interdisciplinary nature, calling on contributions from the faculties of humanities, social science, science, architecture and education.

University of North Carolina at Chapel Hill
University Program in Cultural Studies
CB# 3285, 111 Bingham Hall
Chapel Hill, NC 27599–3285
USA

tel: 919–962–4955
fax: 919–962–3305
e-mail: *upcs@email.unc.edu*
web: *http://www.unc.edu/depts/cultstud/index.html*
contact: Kelly Gallagher
director: Della Pollock

As universities are facing new pressures and scholars are facing the complexities of a changing world, the field of cultural studies has gained both importance and visibility. No model has emerged as the dominant organization of cultural studies as either a research or pedagogical practice. The University Program in Cultural Studies is an interdisciplinary programme with both curricular and scholarly resources and responsibilities at the University of North Carolina at Chapel Hill. Its goal is to encourage interdisciplinary research and education in cultural studies and to help produce a viable and flexible model for cultural studies and its role in the contemporary university by working closely with other and interdisciplinary programmes. In addition to sponsoring an ongoing lecture series and annual conferences, the UPCS awards a BA and a graduate certificate in cultural studies.

University of Pittsburgh
Program for Cultural Studies
1301 Cathedral of Learning
Pittsburgh, PA 15260
USA

tel: 412–624–7232
fax: 412–624–4575
e-mail: *cultural+@pitt.edu*
web: *http://www.pitt.edu/~cultural*
contact: Andre Braga
directors: Nancy Condee and Colin MacCabe

Created in the mid-1980s, the Program for Cultural Studies is an interdisciplinary programme concerned with the dynamics of culture on a global scale. It incorporates faculty from most departments in the humanities and the social sciences, and from several professional schools in the university. It involves over ninety graduate students and one hundred faculty members who wish to work beyond the confines of existing departmental structures. Students who wish to apply to the programme must be enrolled in a graduate or professional programme at The University of Pittsburgh. The Master's certificate in cultural studies is granted only after the completion of all degree requirements for the MA in the student's home department, school or programme; the Ph.D. certificate may be awarded only after the student has been admitted to candidacy for the Ph.D.

University of Queensland
Media and Cultural Studies Centre
Department of English
Michie Building
Queensland 4072
AUSTRALIA

tel: 7–3365–2712
e-mail: *d.marshall@mailbox.uq.edu.au*
web: *http://www.uq.edu.au/mcsc/index.htm*
contact: David Marshall (director)

The Media and Cultural Studies Centre was established in February 1995 to facilitate teaching and research in the study of the media from a contemporary cultural studies perspective. Its aims include: (1) fostering collaborative research projects; (2) the encouragement of international exchanges and visits by researchers in the area; (3) the promotion of postgraduate study in the area of media and cultural studies within the department and within the University of Queensland generally, thereby attracting postgraduate students nationally and internationally; (4) raising the profile of the activities of academic staff and students in the media and cultural studies area; (5) the stewardship of the interdisciplinary media studies major; and (6) the sponsorship and development of the proposed Television Archive to be located at the University of Queensland.

University of Rochester
Graduate Program in Visual and Cultural Studies
Department of Art and Art History
424 Morey Hall
University of Rochester
Rochester, NY 14627
USA

tel: 716–275–9249
fax: 716–442–1692
e-mail: *gael@db1.cc.rochester.edu*
web: *http://www.rochester.edu/College/AAH/programmes/vcs/*
contact: Maureen Gaelens
director: Janet Wolff

An innovative graduate programme with a unique emphasis on visual and cultural studies, Rochester's Graduate Program in Visual and Cultural Studies provides students with an opportunity to study critically and analyse culture from a social-historical perspective. The programme stresses the close interpretation of artistic production within historical and cultural frameworks. The Visual and Cultural Studies Program, housed in the Department of Art and Art History, offers students the chance to earn a Master's or Doctoral degree by doing intensive work simultaneously in several of Rochester's humanities departments. Because the primary faculty work in art and art history, film studies and comparative literature, students are able to relate recent developments in literary and cultural theory to visual works, and to investigate the interrelationships between visual texts and critical theory. Students may also take courses in such departments as anthropology, history, music and philosophy.

University of Teesside
BA (Honours) Degree Programme in Cultural Studies
School of Law, Humanities and International Studies
Middlesbrough
Cleveland TS1 3BA
UK

tel: 1642–218121
e-mail: *d.boothroyd@tees.ac.uk* or *g.hall@tees.ac.uk*
contact: David Boothroyd or Gary Hall

Located in the University of Teesside's School of Law, Humanities and International Studies, the BA (Honours) degree programme in cultural studies was launched in October 1996. The planning and management of the course is provided by the English and cultural studies subject group alongside the BA

(Honours) English degree. The aim of the cultural studies programme at Teesside is, among other things, to: introduce students to the history, traditions and methodologies of cultural studies, and of the major academic disciplines that make up the cultural studies repertoire; prompt students to review and evaluate the assumptions, strengths and blind spots of both the major academic disciplines that make up cultural studies and the project of cultural studies itself; and to enable students to become independent learners and future developers of their own intellects.

University of Tennessee
Cultural Studies in Education Unit
326 HPER Building
Knoxville, TN 37996
USA

tel: 423–974–8555
e-mail: *jallen7@utk.edu*
web: *http://www.coe.utk.edu/units/cultural.html*
contact: Jo Allen
unit leader: Joy DeSensi

Cultural Studies in Education is a graduate unit that derives its intellectual identity and orientation from disciplines such as anthropology, history, philosophy, psychology and sociology. The unit offers concentrations at the Master's degree level in urban/multicultural education, sociocultural foundations of sport, social foundations of education, and motor behaviour/sport psychology. The Ph.D. is also offered in all of these areas except urban/multicultural education. Pending approval of the Graduate Council, MS and Ph.D. concentrations will be added which are based more heavily on social theory and a blending of educational and sport studies.

University of Wollongong
Communication and Cultural Studies Program
Northfields Avenue
New South Wales 2522
AUSTRALIA

tel: 042–21–5746
contact: Dr. Joseph Pugliese (head of programme)

Cultural studies, in the form of an MA in cultural studies, was first introduced at the University of Wollongong in 1991. The integration of the Cultural Studies Program into the Communication and Cultural Studies Program

occurred in November 1996. It is primarily concerned with the deployment of social semiotics, at both research and pedagogical levels, in order to produce critical readings of the broad and heterogeneous range of texts, bodies, artefacts and institutions that are produced and consumed within cultures. The programme is fundamentally concerned with questions of value and is committed to examining the formation of subjectivities in relation to discourses, technologies, policies and cultural practices. It offers a full undergraduate major, a cultural studies MA, and the possibility for postgraduate study at Ph.D. level.

University of Wroclaw
MA Specialization in Cultural Studies
Instytut Filologii Angielskiej
ul. Kuznicza 22
50–138 Wroclaw
POLAND

tel: 0048–71–402439
fax: 0048–71–402440
e-mail: *Joanna.Zylinska@ii.uni.wroc.pl*
contact: Joanna Zylinska and Dorota Kolodziejczyk

At present, cultural studies is taught as an MA specialization for fourth- and fifth-year students in English. The idea for the specialization was developed from the British studies course run in English departments in Poland, designed to describe and explain British life and institutions to Polish students. The most serious disadvantage of the previous model was its ignorance of the fact that British culture was being studied in Polish surroundings by Polish students who, well aware of their own background, necessarily filtered the acquired material through their experience. Thus, the University of Wroclaw's MA Specialization in Cultural Studies has tried to turn this previously one-sided fascination into a 'flirtation' between Polish and Anglo-Saxon cultural discourses through teaching, research and conference initiatives.

Cultural studies resources on the World Wide Web

- Cultstud-l: A Web page devoted to cultural studies:
 http://www.cas.usf.edu/communication/rodman/cultstud/index.html
- The Media and Communication Studies Site, UK
 http://www.aber.ac.uk/~dgc/ukdepts.html#C
- Media Circus: A media/cultural studies group:
 http://hampshire.edu/~mcircus/

- Sarah Zupko's Cultural Studies Center:
 http://www.mcs.net/~zupko/popcult.htm

Note

1 Thanks to Gil Rodman for posting the original call for information to the international cultural studies e-mail listserv. A good deal, although not all of the information in this compilation was accessed by way of Sarah Zupko's cultural studies resource page: *http://www.mcs.net/~zupko/csacad.htm*. Thanks also to Larry Grossberg and John Erni for their helpful suggestions on this guide.

J. Macgregor Wise
CULTURAL STUDIES IN WORDS AND PICTURES
Ziauddin Sardar and Borin Van Loon, *Introducing Cultural Studies* (New York: Totem Books, 1998) 176 pp. ISBN: 1 874 166 98 6 Pbk, $10.95.

The prospect of writing an introduction to cultural studies is a daunting task (or, at least, it should be). As a field, cultural studies is very diverse in terms of method, subject, geography and so on. Furthermore, attempting to summarize or represent a field in which the very idea of representation is critically and politically charged is a risky endeavour, and attempting to reduce a field to cartoons – as this volume does – is even more of a tightrope walk since one runs the very real risk of caricaturing, essentializing and/or reifying the object of study. That this volume does as well as it does is a credit to the author (Ziauddin Sardar) and to the illustrator (Borin Van Loon). However, as such a volume almost inevitably is, the map of cultural studies presented here is incomplete.

Before we get to a list of what the volume lacks, it is important to note what it has covered. The strength of the volume resides in the diversity of subjects that it covers and the range of theorists (many from Asia) that it draws upon. At its heart is a clear and important articulation of a constellation of theories and theorists: British cultural studies, South Asian cultural studies, cultural studies of science, orientalism, postcolonialism, race and identity theory, and theories of diaspora. In particular, the volume focuses on themes of identity and politics. Political concerns about class, culture and identity from early British cultural studies (Hoggart, Williams, Thompson, Hall) are traced through nation, culture and identity in France, and then through notions of the subaltern, of class, and of postcolonial identity in the Indian subcontinent and so on. The book argues that South Asian cultural studies is the last region still following the tradition of explicit political dissent that it claims is the heritage of British cultural studies. The field of 'South Asian cultural studies', Sardar writes, 'evolved through cultural studies of science' (p. 75), providing a link between science studies and British cultural studies. The critique of objectivist science – arguing that science is value-driven and socially contextual – leads the author to discuss ideas of technoculture, technology and development, and technology and identity (Haraway's cyborgs). As the grand narrative of Western science is critiqued, so is the grand narrative of orientalism. The postcolonial response to orientalism is then traced through the work of Gayatri Chakravorty Spivak, Homi Bhabha, Sara Suleri, Cornel West, bell hooks and Henry Louis Gates, Jr., and is linked with issues of race, multiculturalism, diaspora and the Black Atlantic. Sections on gender and queer theory pick up this thread. A cultural semiotic reading of an Indian restaurant in London early on in the book is very useful and indicative of the strengths of this volume. As an alternative to UK–US–Canada–Australia-centric treatments of the field, the book is especially refreshing. However, this does not mean that one can ignore or dismiss North American or Australian cultural studies.

As a map of the field the book is frustratingly incomplete. The frustration comes from the title of the volume – *Introducing Cultural Studies* – which carries with it a claim that this is an introduction to the entire field, but there is no introduction to the Introduction which establishes the context of this work and its authors. So one gets little sense of where the book is coming from or what it may be missing. In that it is a characteristic of cultural studies work to be self-reflective, this lack of context is troubling. The volume also lacks direct citations, though it does quote from numerous unnamed sources. Not attributing quotations further disconnects this volume from the field it is introducing; it appears self-enclosed, and makes it harder to connect the debates here to debates in other work (and is an excuse to be frustratingly vague at times and to present arguments without the support of other sources). For example, Sardar states, 'Indeed, as one critic has noted, cultural studies has tended falsely to unify itself around a small number of highly problematic articles by Stuart Hall' (p. 35). Which critic? Where? Which articles? Why are they problematic? and so on. One is given no chance to respond to the critique.

The main problem with the volume, however, is in the incomplete map it gives us of cultural studies. The book gives some areas of work more attention than others (indeed, if there is a clear, overall organizational logic to the book, this is not readily evident; many of the connections traced above are implicit only). We get a very detailed map of South Asian cultural studies, including discussions of competing schools, major figures and positions. However, this is one quite polemical reading of these schools and positions. We get little detail of American cultural studies (by which they mean the United States), Canadian cultural studies or Australian cultural studies, just broad, overly general descriptions of cultural contexts and major themes. Indeed, we are treated to caricatures and cultural stereotypes (some egregious) of Americans, Canadians and Australians (and a loutish, Andy Capp-ish figure representing the British working class) in marked contrast to the sensitivity given the representation of South Asians. Perhaps this reversal of traditional Western stereotyping practices is intentional, but such a point could easily be made without resorting to the same tactics they implicitly decry. The book argues that American cultural studies in particular has become institutionalized and depoliticized, drifting from cultural studies' original direction (however, cultural studies has institutional homes worldwide; this is not unique to the United States. If they mean that cultural studies has become a discipline in its own right in the US, this is not true, and the book doesn't provide support for this). But later on the volume draws on prominent American cultural studies figures such as Cornel West, bell hooks, Henry Louis Gates, Jr. and others in its discussion of race and identity. How does the work of these scholars fit within the pomo, pop culture crazy version of American cultural studies that the authors describe here? There are also substantial gaps within the description of US cultural studies work.[1] James Carey's cultural approach to communication, Angie Chabram-Dernesesian's Chicana/o studies, James Clifford's anthropology, Henry Giroux's critical pedagogy, Lawrence Grossberg on rock and politics, Janice Radway's work on popular readerships, and one could go on (and these are major omissions, not just dropped citations). Indeed, in the section on Further Reading, Sardar points the reader to Grossberg, Nelson and Treichler's edited collection *Cultural Studies*, but then apparently ignores much of the work represented in that book. And while it is nice to see cultural studies of science and technoculture get an extensive

treatment in an introductory volume on cultural studies, critical media studies – traditionally a major site of cultural studies work – gets comparatively little.

An even more egregious example is the treatment of Australian cultural studies (at least Americans are cited elsewhere in the book) which is summarily dismissed as being concerned solely with media studies and nationalism (and caricatured as a field of sheep). This treatment ignores work on aboriginal culture by Stephen Muecke and also Eric Michaels, not to mention cultural policy studies (Tony Bennett, Stuart Cunningham and many others), and the important work of Meaghan Morris, McKenzie Wark and so on. Canadian cultural studies is similarly marginalized (what of the traditions following Harold Innis? What of Martin Allor, Jody Berland, Will Straw, etc.?). There are other global gaps as well (work in Taiwan, Japan, Finland and Italy comes immediately to mind).

All this said, the commitment of this volume to a politicized cultural studies is admirable, and its range of topics and emphasis on issues of South Asian cultural studies, postcolonialism, orientalism and race is important. It is also important to illustrate that cultural studies doesn't exclusively rotate around the UK–US–Canada–Australia axis. But there is far too much omitted, or presented polemically, to make the book pedagogically useful as a general introduction to the field as a whole for undergraduates (or even graduate students). This is not to say that people should not make polemical arguments within cultural studies (and even in introductions to cultural studies), but to present such a work divorced from context or indications of how to pursue alternatives is, at best, disingenuous.

Note

1 What follows is a brief and necessarily incomplete list; constraints on space prevent me from going further. In addition, though it is not my intention to reduce cultural studies to biographies, citing people is the easiest way to mark specific absences in the text; each person listed is representative of a range of work.

Daniel Mato

ON THE MAKING OF
TRANSNATIONAL IDENTITIES IN
THE AGE OF GLOBALIZATION: THE
US LATINA/O–'LATIN' AMERICAN
CASE[1]

Abstract

Representations of a transnational US Latina/o–'Latin' American identity
are being produced and circulated by multiple social actors. The develop-
ment of representations of this transnational identity does not have any par-
ticular pre-assigned meaning. Speculations about whether it may result in
being more or less strategically beneficial are also taking place, but 'for
whom?' and 'how?' become the obvious questions. The overall argument
presented in this article may be summarized as follows. Identities are not
legacies passively received but representations socially produced, and – in
this sense – matters of social dispute. The case under discussion presents
particular dimensions in connection with both the context of the present
age of globalization and the histories of the US and the different 'Latin'
American countries. Every and each collective identity construction high-
lights assumed similarities while obscuring presumed differences that at
times may become more or less significant. Current representations of a
US Latina/o identity as well as of a 'Latin' American identity and of an all-
encompassing transnational US Latina/o–'Latin' American identity entail
images that, according to several social actors' representations, obscure
differences that are significant. The existence of assertions of difference
does not invalidate per se any social practices based upon representations of
a US Latina/o–'Latin' American identity. Nevertheless, the existence of
these assertions of difference makes it unavoidable to think that these iden-
tity representations by means of those representations of difference, be

they related to race, ethnicity, class or socioeconomic status, gender, sexual orientation, local experiences, international and transnational relations of domination, or any other relations of power.

Keywords

identity making; Latinas/os; 'Latin' America; transnational relations; transnational identities; globalization

'. . .
Oye latino, oye hermano, oye amigo
 nunca vendas tu destino
por el oro y la comodidad
nunca descanses, pues nos falta andar bastante'
. . .
'. . .
Orgulloso de su herencia, de ser latina
de una raza unida, la que Bolívar soñó.
Siembra:
Panamá,
Puerto Rico,
México,
Venezuela,
Perú,
República Dominicana,
Cuba,
Costa Rica,
Colombia,
Honduras,
Ecuador,
Bolivia,
Argentina,
Nicaragua sin Somoza,
el barrio,
la esquina.'[2]

(Rubén Blades, excerpts from his song 'Plástico')

WHAT IS THE united race invoked in this song by Rubén Blades, produced and recorded in the United States, which contains other lyrics alluding to US Latinas/os, and which is included in an album also containing other lyrics referring to US Latinas/os? Who are those constituting the united race ('raza

unida') *community* that Blades both visualizes himself and would stimulate us to visualize?

Have you noticed that through the lyrics of the quote, and others like them, he simultaneously appeals to and proposes the existence of a *transnational community* that binds together so-called US Latinas/os, whole 'Latin' American countries, and specific urban communities like 'el barrio'?[3] Have you also noticed that the expression 'el barrio' has two meanings? Depending on the context of interpretation it may be a particular New York 'Latino' neighbourhood, and more in general each and every *barrio* – the generic Spanish word for neighbourhood, and more particularly for 'popular' neighbourhoods – in every 'Latin' American city where his song is heard?

Blades' lyrics are a way of interpreting and representing certain social experiences, and, in doing this, they also stimulate our feelings and imaginations. They both express feelings and build meaning. The circulation of these representations and their appropriation by diverse social agents take part in larger social processes of both visualizing and developing a transnational community.

But these lyrics do not operate in a vacuum. This 'Latina/o united race' transnational community is not the exclusive reference of Blades' lyrics. It is also the subject of, or at least it is embedded in, the discourses of a significative number of social actors throughout the American continent. In this way, Blades' lyrics also constitute a significant hint to larger ongoing transnational social processes.

These lyrics, as other similar representations, are indicative of the existence of significant ties linking, if not the daily practices, at least the souls, imaginations and feelings of diverse populations spanning from one end to the other of this continental mass called America. Do Blades' lyrics include all of them? Are there not any exclusions or significant reductive homogenizations? These are key questions that underlie this article's discussion.

As I said, Blades is not alone. Nor has his expression reached us through several kinds of media just by chance. His expression overlaps with those of a whole list of several kinds of artists made up not only of poets and singers, but also of writers, musicians, visual artists, and video, television, cinema and theatre creators who increasingly and diversely appeal to our consciousness and subconsciousness with different representations of that more or less same *imagined transnational community*. I have to state clearly that beyond any possible debates regarding the interpretation of Anderson's idea of *imagined community* (1991), I am not using the adjective 'imagined' as opposite to 'real', but to emphasize the existence and importance of a mental image of such a proposed community. In a certain way, assuming that any specific group of people constitutes a community always involves a mental image of that group which emphasizes the importance of certain common factors over others that may comprise

references of differences among them, or us – depending on whether or not we are part of the community in question. In this sense any community would be imagined, but in the particular case of this transnational community the import-ance of such a mental image is perhaps even greater because of the immensity of the proposed community.

The issue is that those producers of influential representations of such a transnational community are not lonely spirits dreaming in a vacuum. Their works reach us through specific means: books, magazines and newspapers, films, television, performances, compact discs and tapes, festivals, exhibitions, multi-media events, etc. The production of these concrete means involves the creative initiatives, and the voluntary and/or waged energy, that is the work of many indi-viduals. All this also involves capital expenditures in producing, promoting and making these creators' images available to different audiences, readerships and viewerships. With this in mind, our list of producers of representations of this transnational community must be enriched by adding to it other key players such as entrepreneurs, corporate managers, advertising campaign creators and organ-izers, actors and actresses, models, etc. In addition, in making this enhanced listing of producers of images of that *imagined community* we cannot ignore the roles played by scholars, intellectuals, social leaders, politicians and state agen-cies from different countries. Moreover, we have to take into account that these images are also diversely supported, enjoyed, co-imagined, and – in certain ways co-produced – by millions of individuals who at the same time constitute the audiences, readerships, viewerships, followers or clients of those makers of *public images*, among whom also exist diverse kinds of mutual or complementary relations.

All this means that the different representations of such an imagined com-munity, '*una raza unida*', elaborated and advanced by all these particularly influ-ential kinds of public image-makers resonate – in diverse ways – in the souls, heads and bodies (questionable partitions of the selves, but suggestive for the present purposes) of several million people. This does not mean that all the incumbent representations and associated social, political, cultural and economic practices traversing the continent – as well as some latitudes beyond – are alike, but that there are significant resonances among them.

The former reflexive (and also self-reflexive) description is to call our atten-tion to the fact that numerous social actors are advancing representations of peoplehood that would bind large populations throughout the American conti-nent, spanning countries' borders. This is to say that representations of a *trans-national US Latina/o–'Latin' American identity* are being produced and circulated by multiple social actors.

The development of representations of this transnational identity is not good or bad in itself. It does not have any particular pre-assigned meaning. But it is taking place. Speculations about whether it may result in being more or less

strategically beneficial are also taking place; but 'for whom?' and 'how?' become the obvious questions.

As an intellectual who feels part of these ongoing historical social processes, I consider it necessary to contribute to its development by producing and encouraging both conscious critical reflection and open dialogue.

The overall argument I will present below may be briefly summarized as follows. Identities are not legacies passively received but representations socially produced, and – in this sense – matters of social dispute. The case under discussion presents particular dimensions in connection with both a certain historical macrocontext, the present age of globalization, and the histories of the US and the different 'Latin' American countries. Every and each collective identity representation highlights assumed similarities while obscuring presumed differences that at times may become more or less significant. Current representations of a US Latina/o identity as well as of a 'Latin' American identity and an all-encompassing transnational US Latina/o–'Latin' American identity entail images that, according to several social actors' representations, obscure differences that are significant.

I do not believe that the existence of certain significant assertions of difference may invalidate *per se* any social practices which are based upon or promote representations of a US Latina/o–'Latin' American identity, but I do think that the existence of these assertions of difference makes it unavoidable to think these identity representations by means of those representations of difference. Explicitly, I state that it is necessary to think representations of a US Latina/o–'Latin' American identity by means of significant representations of difference, and to adopt a conscious posture towards avoiding homogenizing traps. I am conscious that perhaps this position is not shared by other people. I do not know how acceptable such a position would be from, for example, the perspective of marketing campaigns' producers, whose main interest seems to be to expand the scope of the category 'Latinos', or sometimes 'Hispanos' (*sic*, and even taking the masculine forms as paradigmatic), as much as possible, as a way of reaching the widest possible audiences with their campaigns. But, I think that, if one is to develop a social practice that in any way embodies representations of such an all-encompassing identity, and – at the same time – is aimed at lessening social, political and economic injustices, one cannot avoid thinking of such an identity by means of those assertions of differences, be they related to race, ethnicity, class or socioeconomic status, gender, sexual orientation, local experiences, international and transnational relations of domination, or any other relations of power.

Before expanding on the Latina/o–'Latin' American case, I will present a few preliminary theoretical remarks that will enhance our discussion of the case. They are related to three specific issues: the idea of globalization, the social processes of identity-making, and the social processes of identity-making in the present age of globalization.

On the idea of globalization

The use of the word *globalization* has become a widespread phenomenon these days. I think that this fact is revealing of the worldwide development of something that we may call a *consciousness of globalization*. It does not matter at this moment how differently globalization is represented by the many and various narratives of the phenomenon we may find throughout the planet. But the point is that forms of a consciousness of globalization are currently being developed throughout the world. An important consequence of the development of this consciousness is that it informs the social practices and representations of numerous social actors everywhere (not just economic agents, but also political, cultural, etc.).

This consciousness is a relatively new phenomenon. An indication of its newness may be that the word *globalization* was included in the *Webster Dictionary* only in 1961. Nevertheless, I would say that globalization is not a recent phenomenon, which would be just a consequence of certain business practices, communication technologies and neoliberal macroeconomics, as it is often portrayed. Globalization may be more fruitfully analysed as a long-standing historical tendency towards the worldwide interconnection of the peoples of the planet, their cultures and institutions, resulting from many different social processes. These social processes produce – among other things – forms of tendential worldwide interconnection, and because of this they may be called *globalizing processes*, or *globalization processes*.

In view of widely assumed misconceptions, it is particularly important to highlight that the keyword to explain globalization is worldwide interconnections, and not homogenization. The diverse ongoing processes of globalization have different outcomes: while some may be said to produce homogenization, others foster differentiation, and still others have combined effects. This is a matter that we do not have space to discuss here, but that I have addressed in previous writings (Mato, 1995, 1996a).

Although globalization is an old phenomenon, there are good reasons to characterize our present times as the age of globalization. This present age of globalization exhibits three significant characteristics that are particularly relevant to our discussion. The first is the already mentioned worldwide development of a consciousness of globalization. The second is that because of different historical circumstances those previously mentioned interconnections have – for the first time – acquired nearly a worldwide scope. Interconnections are not just flows of ideas, symbols and commodities, but of permanent relationships among social agents (this concept, of course, includes economic agents but is not limited to them). Striking among the historical circumstances that have made possible that interconnections became almost fully planetarian have been: (1) the development of an almost planetarian system of production and exchange of goods and services; (2) the growing diffusion of communication technologies; (3) the

dissolution of the old colonial empires and the (quasi) end of the cold war and the associated barriers to direct relations between social agents in certain regions of the planet; and (4) the development of numerous international and trans-national organizations and institutions whose very rationale is global linking. I believe that this latter circumstance, the development of numerous international and transnational organizations, is at the same time the third significant charac-teristic of this age of globalization.

As we will see below, these three characteristics of the age of globalization are crucial in discussing current identity-making processes worldwide.

On the social processes of identity-making

A good number of recent case studies illustrate how cultural identities, as other social representations, are socially produced and not passively inherited legacies. Representations of identities are continuously produced by individual and col-lective social actors who constitute and transform themselves through both these very symbolic practices, and their relations (alliance, competition, struggle, negotiation, etc.) with other social actors. It may be said that the work of pro-ducing symbolic representations is permanent and that it may include, at least in theory, cases ranging from fully unconscious-making to fully intentional con-structions – this latter sometimes named 'inventions'. Although not always explicitly differentiating between so-called 'invention' and 'construction', and beyond diverse theoretical differences, numerous studies may be cited as pre-senting examples that illustrate this argument (e.g. Anderson, 1991; Fox, 1990; García-Canclini, 1989; Habermas, 1989; Handler, 1988; Herzfeld, 1982; Hobs-bawm, 1983; Linnekin, 1992; Mato, 1994a, 1995, 1996b, 1996c, 1997, 1998a, 1998b; Rogers, 1996; Wagner, 1981).

The constructed character of identities is not asserted here as opposed to something presumably more 'real'. From my point of view, the proposed dilem-mas 'real vs. imagined', 'authentic vs. false', or 'genuine vs. spurious' are simply not pertinent. Asserting that identities are socially constructed does not imply that they are false or arbitrary, but that identities are not things, but matters of social dispute.[4]

Collective social actors form and transform themselves through identity-making processes. Social actors take part in identity-making processes in a wide range of social collectivities, like so-called ethnic, local, regional and national societies. They participate in these processes, advancing and transforming their own representations – whether consciously or unconsciously elaborated. In the present age of globalization identities – as other representations – are socially produced in contexts that are increasingly interconnected, both internationally and transnationally.

On the social processes of identity-making in the age of globalization

In the present age of globalization there are practically no fully isolated social units. Although some exceptions may exist, most social aggregates, or at least some social actors within them, are in one way or another internationally and/or transnationally linked.

According to the scope of their practices social actors may be classified in local, regional, national, international, transnational and global. Limits are of course difficult to assert with precision but this differentiation may be helpful in explaining differences in the representations and orientations of practices among several actors participating in any given process. Global social actors like the multilateral banks, US and Western European countries' governmental agencies, non-governmental organizations based in these same countries act tendentially almost everywhere, and do this by advancing their own representations of, for example, democracy, citizenship, justice, race, gender, etc. This implies that not only the media – as often recognized – but also this wide diversity of social actors take part in varied ways in identity-making processes throughout the world.

A brief example may be illustrative. In these days Amazon indigenous peoples' identity-making processes take place in the context of the complex and varied relations they maintain not only with neighbouring ethnic groups and mestizo populations, state and country governmental agencies, non-governmental organizations and professionals, but also with distant indigenous peoples with whom they interact in an increasingly complex system of transnational meetings. But our list of meaningful interrelations cannot end here. It must also include conservationist and indigenous peoples' advocacy organizations, anthropologists, environmentalists, journalists, cinema producers, agents of oil, timber, pharmacological, biochemical corporations, bilateral development agencies, the World Bank and the Inter-America Development Bank, etc. However different these agents may be, all of them – through their relations – advance their own representations of self and other, and some of them even promote and/or finance projects that encourage the development of certain representations to the detriment of others. It is in this sense that I say that all identities are nowadays made in transnationally and internationally linked social fields. This does not imply any assumption regarding the possible shapes and meanings of these identities and other representations. In other words this does not imply that local identities are shaped or influenced by global agents, but rather that they are made by local actors in social fields directly and indirectly (for example, through the media) exposed to the practices and representations of global agents.

If the previous description based on my and others' research (e.g. Amodio, 1996; Brysk, 1994; Chirif et al., 1991; Conklin and Graham, 1995; Gnerre and Botasso, 1985; Jackson, 1995; Mato, 1992, 1996c, 1997, 1998a, 1998b) on the

cases of Amazonian and other South American indigenous peoples makes it meaningful to understand how identity-making processes of supposedly remote and isolated peoples are affected by transnational and international relations, it may also be at least suggestive to understanding identity-making processes in a wide variety of local, regional and national societies more openly – although not necessarily more intensely – interconnected.

To finish this preliminary theoretical consideration I must explain both the distinctions I am pointing out through using the adjectives 'transnational' and 'international' applied to relations, and the distinctions I will be indicating between transnational and pan-national when talking of identities in the next section.

According to current usage among some international relations literature, I call 'international relations' those maintained among states, or state agencies, or among them and intergovernmental organizations. I call 'transnational relations' those maintained between agents from two or more states, when at least one of these agents is not a governmental agent (Keohane and Nye, 1971). Consistent with the implicit meaning of the word 'nation' in this usage, I call 'pan-national identities' those encompassing the dominant representations of national identities of significant groups of countries, and 'transnational identities' those proposed as binding segments of populations of two or more countries across international borders.

I have decided to adhere to this usage of the word 'nation' in order to avoid complicating the presentation of my arguments through the incorporation of too many *ad hoc* categories. Nevertheless, there are some problems with this terminology that in the context of a discussion on the making of identities and other representations – -like the present – must at least be mentioned. This whole set of categories carries implicit the assumption that the word 'nation' is an equivalent of the words 'country' and 'nation state'. I have to make explicit that these equivalencies have been criticized from at least two perspectives that are relevant to our present discussion. First, because they imply that states are equivalent to nations, and to the extent to which no further specifications are made, they also imply that governments and states actually represent whole nations, or whole country populations, as if these populations were practically homogeneous. Second, because of the ethnic dimension of the word 'nation', which in the 'Latin' American context has motivated a number of indigenous peoples' organizations to argue that it tends to delegitimize their own claims of being nations.

International and transnational relations in the making of 'Latin' American identities

As it already emerged when discussing the word 'nation', words, or at least some words, are not neutral. They carry particular meanings, some of which are highly political and/or become politicized over time. As I said before, these sorts of

questions cannot be avoided when discussing matters of social representations. To make matters more difficult, some words evoke quite different meanings for different audiences. I therefore have to make it explicit that I use the word 'America' to name the whole continental mass, the word 'United States' or its abbreviated expression 'the US', to name this particular country, and the abbreviated adjective 'US' to identify individuals, institutions or phenomena based on or taking place in this country. This usage is not personally mine, but well extended in 'Latin' America. This is not the time to explore the different meanings that the word 'America' has for US and 'Latin' American readerships, but it is necessary to mention the point to communicate the following ideas more clearly.

While I use the term 'Latin America', I find it problematic too, and this naming problem is central to the present discussion. The expression is problematic in various respects, but for the moment I would like to draw your attention to only the first of them, which is related to the word 'Latin' in this name. This word recalls a long-term process of the making of social identities and differences and still serves as a subtle legitimating device for certain social groups, and simultaneously legitimate discriminations against other population groups in America – that is, in the continent.

Nineteenth-century *Latinoamericanismo* may be characterized as a nationalist ideology advancing the idea of a quasi-continental 'nation' (Zea, 1986). Its roots – not the expression itself – come from the period of the anticolonial movements. As with almost any nationalist ideology it advanced representations of cultural homogeneity that contributed to obscuring social differences and legitimating social discrimination along the lines of those differences.

At that time, white and mestizo elites began building new nation states upon the system of exclusions of the colonial period. Those elites assumed that they, not the so-called *indios*, nor the imported African slaves and their descendants, were 'the people'. The alliances developed during the quasi-continental anticolonial war were the origin of the making of the interdependent system of national identities and interstate-crafted representations of what later came to be called 'Latin American culture'.

Nevertheless, it must be noted that the expression 'Latin America' did not exist in the lexicon of the independence movements of the end of the eighteenth and beginning of the nineteenth century. At that time the names for the whole region that lies south of the United States and which today is called 'Latin America' were *Nuevo Mundo, América, América del Sur, América Meridional*. The portion under Spanish colonial rule was also called *América Española* and *Hispanoamérica*. The idea of *latinness* and its application as an adjective to this region was crafted by the French intellectual Michel Chevalier in 1836. On the other hand, 'Latin America' as a compound name first appeared in writing in a book by the Colombian intellectual José María Torres Caicedo in 1865 (Ardao, 1980). Interestingly, as Arturo Ardao has pointed out in his documented study on the genesis of the name Latin America, to understand this name it is necessary to

place it in the context of the ideas and historical facts that made it emerge as one of the two elements of 'the antithesis Saxon [sic] America-Latin America'. As he said, this terminological creation was the result of very complex historical circumstances, 'the dominant of which came to be the annexation of Texas, the invasion and dismembering of Mexico, and the Central American incursions of William Walker. All this in the context of the intense ethno-cultural speculation of romantic historicism' (1980: 8; my translation).

This genealogical reference of the use of the expression 'Latin America' cannot be ignored in our present discussion because it reminds us of at least three meaningful circumstances. First, that the name 'Latin America' has itself emerged from complex international and transnational circumstances. Second, that it emerged in oppositional terms to that which was regarded as a different part of America, the United States. And third, that since that very period, since 1848, when Northern Mexico became the US Southwest, and a large Mexican population became foreign, or estranged, in its own homeland, a stateless people within the United States, since that very moment the United States became incurably pregnant of Mexicanness, and potentially of Latinness. As we will see below, this latter element is crucial in discussing the making of a Latina/o identity in the US.

Let us for the moment go back to so-called 'Latin' America. The interdependent making of both national identities and a Latin American all-encompassing pan-national identity did not cease in the nineteenth century. 'Latin' American political ruling groups controlling state apparatuses are also nowadays involved in different international systems of mutual support and legitimation for their participation in the social processes of constructing culture and power in their home countries.

Cultural, educational and political relations and the coordination of policies are cultivated in the name of – and mutually reinforce – the idea that a language (or a pair of related romance languages) and a colonial and postcolonial history are the common and distinctive features shared by the millions of inhabitants of so-called 'Latin' American countries. State bureaucracy and ruling group discourses assume and address these millions of people as 'latinoamericanos' as if they (we) were a sort of extended ethnic group, homogeneous crowd, undifferentiated in terms of class, gender or race, 'la raza cósmica'. Such a pretended extended ethnic group has its own mythology of origin, which has long been crafted through educational systems and other social institutions. Such a mythology begins with the arrival of Columbus, yearly celebrated in 'el Día de la Raza' or 'Día del Descubrimiento de América', and the subsequent process of 'mestizaje'. School books and thousands of statues constantly remind us of this founding myth. The European root has been overemphasized everywhere, while the American and African roots – not to mention some specific others – have been practically ignored in 'Latin' American states' practices and discourses. This 'mestizo' identity has been crucial in providing meaning and legitimating diverse social, cultural and economic mechanisms that have historically undermined the

situation of both indigenous peoples and diverse populations constituted by the descendants of the African slaves within these national societies, including forms of open exclusion (Agostinho *et al*., 1972, Fernándes 1959, Klor de Alva 1992, Stavenhagen 1988, Wright 1990).

Apart from their long-standing regional networking and construction of what I would call an 'official interstate "Latin" American identity', mutually supportive with the related 'national identities', these 'Latin' American states have recently been participating in other international systems of relations. Significantly, most of them also take part in the construction of a supposed 'Latin' identity at a planetary level, which is advanced by the 'Unión Latina', an intergovernmental body, mainly promoted by French diplomacy in which are represented about twenty-five nation states in which the official language is a Romance language. It seems interesting, however, to point out that the Unión Latina has recently confronted dilemmas in accepting the demands for incorporation made by some ex-colonial African states in which Romance languages are the official language. On the other hand, as the Quincentenary was approaching, another version of such European root-centred cultural representations became notorious, a postulated Ibero-American identity, which has been celebrated as binding the peoples of 'Latin' America and those of the Iberian peninsula. This identity has been the subject of intensive interstate networking in recent years. Related discourses and actions were deployed during not only the celebration of the Columbus Quincentenary but also in its preparation, including the associated series of Ibero-American Presidential Summits, as well as numerous cultural and educational activities, long-term programmes and permanent mechanisms for policy-making coordination.

Paradoxically, the Quincentenary has been a benchmark in the history of the conflicts around the making of an extended socio-symbolic representation of the peoples of so-called 'Latin' America and the associated system of 'national identities'. Even those less concerned about these matters noticed that the Quincentenary was commemorated not only by official celebrations but also by numerous critical or alternative events and demonstrations. On the very day, 12 October 1992, different groups publicly voiced their alternate points of view in most capital cities of the region, as well as in many other regional and extra-regional localities. While most of these groups were Amerindian, some were Afro-American groups (remember that I use this denomination in relation to the whole continent). Such a coordinated display was not incidental; it was the public emergence of the transnational practices of numerous non-governmental agents of diverse kinds. Nor was this display purely circumstantial and exclusively related to the Quincentenary. There are many public evidences that this display was just one coordinated action, among many others, emerging from the transnational relations maintained by a large number of social agents engaged in the making of transnational and related local identities in the region (Mato, 1994b, 1996c, 1998a, 1998b).

In constructing both national identities and a 'Latin' American identity, states' policies and practices regarding Amerindian and Afro-American peoples have not been totally homogeneous. They have varied with countries' peculiarities and with historical circumstances. Even in the same country and period they have differed according to varying constructions of ethnic and racial identities of these populations. Nevertheless, in one way or another, these peoples have been subject either to systematic discrimination or to paternalistic policies of integration and 'modernization'.

The case is that in response to both of these long-term issues and the problems and opportunities that the globalization process entails for them, the social and political organizations of these excluded groups – particularly of the indigenous peoples – have begun to develop diverse transnational practices as well as to construct local and related transnational identities. These identity-making processes are meaningfully interconnected with other ongoing transnational phenomena, and must be analysed in the context of these interconnections. Three interconnected phenomena have been particularly striking in this regard. One has been the increasing importance of the practices of transnational corporations of diverse sectors, including, among others, those in the mass media and entertainment industries. Another has been the increasing importance of transnational migration movements, which have been related to diverse political and economic factors, not a few of them related to global phenomena like civil wars that have been nurtured by cold war schemes, and/or the application of structural adjustment programmes. Yet another has been the increasing importance of the practices of a diversity of international and transnational organizations that have in different ways promoted linkages among social movements and non-governmental organizations throughout the continent.

In connection with all this, 'Latin' America has become the locus of various processes of construction of transnational identities and related social movements, as well as of local identities diversely associated to them. There are diverse kinds of transnational identities, and it is worthwhile to differentiate between them. Chronologically speaking, the first transnational cultures and identities were those which we would call 'border ethnic transnational identities'. They were a consequence of the new international borders that modernist nation states set up across the former territories of particular ethnic groups. Cases of this kind remain numerous and culturally and politically relevant. Two significant examples would be the cases of the Aymaras (Argentina, Bolivia, Chile and Peru), and the Mayas (Mexico, Belize, Guatemala and Honduras), but there exist many others. Discussing this conceptual sub-class of transnational identities is not the subject of this text. Nevertheless, this class has to be mentioned for two reasons. First, to avoid projecting a partial image of the category 'transnational identity' as if it were the whole. Second, because some of these ethnic transnational identities are significant in discussing the Latina/o–'Latin' American case, as I will illustrate below. A different kind of transnational identity in border regions began

to develop later and was not necessarily centred around indigenous peoples' eth-nicities. These more recent border identities acquired new characteristics and importance in connection with the activities of transnational corporations and free trade regional agreements (NAFTA and Mercosur). The US–Mexico border case is not only a notable example in this regard, but also meaningful to our present discussion because it is interwoven with the US Latina/o case.

Other kinds of transnational identities are those constructed in connection with the practices of transmigrants and their organizations (Basch *et al.*, 1993). This conceptual class has probably been the most studied, to the point that it is sometimes the only case that comes to mind when discussing transnational identities. Various significant transnational identities of this class have been advanced by diverse social actors throughout the continent and several of them are also significantly interwoven with the Latina/o–'Latin' American case that we are discussing. It is interesting to note that many of these cases may be said to have 'national identities' as their symbolic referential axis, such as, for example, the Mexican, Puerto Rican, Cuban, Dominican and Colombian cases in the US. Instead, other cases have a particular local community or an ethnic identity as their reference, like the case of US residents from specific Mexican localities, or the Mixteco and Zapoteco identities which constitute the refer-ence of transnational identities currently advanced by US residents of Mixteco, or Zapoteco, indigenous origin in connection with their ethnic fellow indi-viduals and organizations in Oaxaca, Mexico (e.g. Georges, 1990; Kearney, 1992; Smith, 1992).

Finally, another class of transnational identities could be called 'extended racial transnational identities', and would include three currently significant cases: Afro-American, Amerindian and Latina/o–'Latin' American. Note that this latter transnational identity, which is the focus of our present discussion, is mainly advanced by a wide range of non-governmental subjects and should not be confused with the 'pan-national' case promoted by 'Latin' American govern-ments, although both have their common roots in nineteenth-century *Latino-americanismo*, and overlapping and mutual influences among them must also be recognized. The making of these three extended transnational racial identities involves social actors throughout 'Latin' America and even beyond its currently assumed borders, including related groups in the United States and Canada. Some of them are interwoven in different ways not only with processes of iden-tity-making at local and national level, but also with cases of transmigrant and transnational border identities (Mato, 1994b, 1995). For the present discussion, the relevant issue regarding these extended identity-making processes is that these constructions of identity inform and legitimize the practices of organiz-ations and individuals that are important producers and disseminators of public representations as well as producers of political agendas (for example, certain social movements, non-governmental organizations, civil leaders, artists, intel-lectuals, etc.).

Transnational relations and the US Latina/o–'Latin' American connection

On 19 September 1993, the famous *salsa* singer and – at the time – Panamanian presidential candidate Rubén Blades gave a concert in San Antonio, Texas. This concert, which was organized by the Guadalupe Cultural Arts Center of San Antonio, may be significant in various respects. First of all, the concert was in part a 'progressively' oriented politicized meeting. Some Panamanians were present, waving Panamanian flags and voicing their support for Blades' campaign. They were echoed by non-Panamanian people as well. The exchanges between the public and the singer mainly expressed rejection of corrupt politicians, military governments and paramilitary actions; and the hope for freedom, redemption and progress towards a 'united Latin America', most of these expressions also constituting themes poetically elaborated in Blades' and others' *salsa* compositions. Second, and more significantly for this article, the concert was an example of the ongoing making of what some Latina/o intellectuals called a 'Latino unity' (Padilla, 1989) in the United States. In the audience there were Chicanos, Puerto Ricans, Panamanians and Peruvians, who made public their national affiliation in various ways, but, based upon the research I conducted during as well as before and after the event, I can say that there were also other Central Americans and South Americans of diverse national origins, as well as what in the US would be considered diverse 'colours'. Such a mix partially represents what Rubén Blades' lyric calls 'the united race dreamed by Simón Bolívar' (the quasi-continental anti-colonial leader) (my translation of Blades' lyrics).

While the song's lyrics merit discussion themselves, what I consider more significant is their appropriation by social actors. These and other lyrics of key cultural political meaning were first disseminated as such in an album released in 1978. Since then they have been constantly echoed by grassroots cultural and political activists throughout the region, as well as sung by concert audiences and groups of people at private and public *fiestas*. These and other politicized *salsa* lyrics, as well as others less and non-politicized, have achieved an amazing dissemination through live concerts and recorded productions. What is significant about them is that they have been taken, re-sung and even transformed by the public in an extended 'Latin' America, one that in this system of representations explicitly includes 'Latina/o' populations in the United States. From my own participation in diverse cultural and intellectual circles in various 'Latin' American countries as well as from interviews with participants in others, I can attest that these lyrics have acquired a sort of emblematic status.

One simplistic interpretation of *salsa*'s success is to assume that it is just a commercial musical phenomenon produced by the record industry. It would also be simplistic to attribute *salsa*'s success exclusively to the lyrics' mix of political and romantic content. But the reality seems to be more complex than these one-dimensional interpretations. While we need specific studies of the subject, it

seems reasonable to assume provisionally that on the one hand the record indus-
try and the media pursue their profitable business, while on the other hand that
business is possible because large groups of people far away from each other feel
certain connections related to both such a powerful musical fusion and those pro-
gressively politicized lyrics. It is also likely that such a convergence of feelings
happens because – among other reasons – some other connections do exist
between such audiences. Unfortunately, my limited knowledge does not allow
me to discuss the significance of the music itself, which in this case constitutes a
powerful element. Nevertheless, I can at least mention that *salsa* brings together
elements borrowed from several Puerto Rican and Cuban popular rhythms
which already combined elements of African and Spanish musical traditions, and
reworks them with an important influence of jazz. However, let me briefly note
a few thought-provoking facts in relation to those connections throughout
involved audiences.

I once heard that for us so-called Latin Americans, 'Latin' America became
a reality because of the multiple exiles and economic migrations in the 1970s that
came together in Mexico and Venezuela 'Latin' Americans from diverse latitudes.
I have personally experienced this phenomenon. Reflection on it was pervasive
among groups of exiled or simply migrated 'Latin' Americans in Venezuela,
where I have lived since I left Argentina, where I grew up. I have more recently
become acquainted with the argument of some Latina/o intellectuals that *salsa*
is an expression of the 'Latinos'' amalgamating experience in the United States
– closely associated to their common experiences of racism – and of their per-
manent relations with their countries of origin (Padilla, 1989). The making of
such a 'Latino' identity in the United States has not been a process free of differ-
ences and conflicts. It has sometimes been contested and at other times helped
by the making of more particularistic identities and social movements, most
notably those of Chicanos and Puerto Ricans.

This is not the time to attempt a comprehensive theorizing on these social
processes. Nevertheless, it seems that significant moments and events have been:
the transformation of Northern Mexico into the US Southwest since 1848 and
the associated incorporation of a Mexican population within the US; the later
trans-border movement of both family linked and non-linked Mexicans; the war
between the US and Spain and the quasi-colonial incorporation of Puerto Rico
to the US since 1898; the increasing migrations of populations from other and
diverse 'Latin' American countries; the experiences with racial discrimination of
these populations; the civil rights movement; the creation of the Hispanic label
by the US government, its incorporation into numerous public policies and prac-
tices, and thus the exposure of populations to the term in highly racialized social
contexts. The point I want to make here is that these historical references con-
tribute to an understanding of the multiple discourses of identity through differ-
ence that some Latina/o intellectuals advance (Acosta-Belén and Santiago, 1995;
Flores, 1993; Flores and Yudice, 1990; Giménez, 1992; Oboler, 1992).

Beyond the particularities of these developments in the US and different 'Latin' American sites, it seems that quasi-continental and criss-crossed networks of diverse kinds of individuals and organizations have developed throughout the continent. It also seems that at least some of these networks create overlapped spaces of political activism, cultural production and consumption, and a panoply of related business. These criss-crossing networks play significant roles in the ongoing making of this transnational culture and particularly in the production, marketing and consumption of certain common cultural products. I have learned from personal experience and fieldwork that political subjects, literary reader-ships, film, theatre and musical audiences, as well as other groups of cultural con-sumers and producers, create overlapped realities in particular neighbourhoods – for example, Mount Pleasant in Washington, DC, the so-called Harlem Latino or Hispano in New York City – and in diverse kinds of spaces in certain cities in the United States, Mexico and Venezuela – for example, bookstores, cultural centres, academic institutions and social clubs. The Guadalupe Cultural Arts Center in San Antonio, which hosted Rubén Blades' concert, is just one example of this kind of organization.

I noted that the Rubén Blades concert was organized by the Guadalupe Cul-tural Arts Center. Let me now say that Rubén Blades did not request – nor did he receive – any honorarium for his performance. It was a generous contribution on his part to the work of the cultural centre. Due to its geographical location and constituency, the Guadalupe Cultural Center is mainly a Chicano centre, but it is open to other streams of the 'Latino' / 'Hispanic' world. It annually organizes an International Latino Film and Video Exhibition. During its sixteenth festival, US Latino productions of diverse backgrounds were presented alongside pro-ductions from Argentina, Brazil, Cuba, Ecuador, Mexico, Nicaragua, Puerto Rico and Venezuela. Similarly, the Guadalupe Cultural Arts Center, among other activities involving artists from 'Latin' America, hosted a concert of the famous Argentine politically progressive folk singer Mercedes Sosa.

At the time of Rubén Blades' concert, the Guadalupe Center's director was also the second chairperson on the board of the National Association of Latino Arts and Culture (NALAC), a recently created arts service association that coordinates the activities of several important US Latino cultural organizations. NALAC's agenda explicitly includes the development of international relations with the 'communities of historic origin' of participant organizations. The Caribbean Cultural Center of New York is one of those organizations. On 20 to 23 October 1993, it held a conference that it presented as the third biannual international gathering of scholars, artists and 'culturalists' who actively promote 'cultural rights' and 'social equity'. Among the cultural groups participating in this conference were three so-called traditional music groups representing 'Latinoamerica Negra' 'direct' from Cuba, Mexico and Venezuela. Among the sponsoring agencies were the Guadalupe Cultural Arts Center and the National Association of Latino Arts and Culture. Among the participant scholars was a

member of the Centro de Estudios Puertorriqueños (CUNY–Hunter College). At that time, this centre was also hosting a fellowship-in-residence programme entitled 'Claiming Social Equity and Cultural Rights', which – according to its brochure – encourages comparative studies to 'help to build alliances and construct social visions of the future'. This centre maintains active relations with Puerto Rico, Mexico, Cuba and the Dominican Republic, and constantly receives expressions of interest in developing collaborative relations from academic institutions and advocacy groups throughout 'Latin' America and the Caribbean. The fellowship programme of the Centro de Estudios Puertorriqueños was supported by the Rockefeller Foundation. Other activities of the Center dealing with questions of equity and cultural rights receive support from the Rockefeller and Ford foundations, among others. These two foundations were also founders of the conference at the Caribbean Cultural Center. The National Association of Latino Arts and Culture has already received a grant from the Rockefeller Foundation. The Guadalupe Cultural Arts Center has received support from the National Endowment for the Arts, the Rockefeller Foundation and the Ford Foundation, among other major supporters.

The interconnected practices of all these organizations around that set of events is not an isolated case. It is just one significant example of the kinds of practices of some transnational organizations, which I earlier pointed out as characteristic of this age of globalization. It is also revealing of ways in which transnational identities are constructed in our historical time, and it is also suggestive of how some representations of this particular transnational identity are advanced. But there are several different circuits, which do not necessarily advance the same kind of representations of this imagined community.

As I said, Rubén Blades is just one case. The activities and productions of other individuals and organizations are also echoed, announced and disseminated by local 'Latino' / 'Hispanic' radio stations, journals and newspapers in the United States. Some musical and audiovisual productions also reach mainstream markets, and in some cases, like that of Rubén Blades, they are even televised. In connection with this, let me mention that Univisión, a television corporation co-owned by US investors Televisa of Mexico, and Venevisión of Venezula, is watched in eighteen 'Latin' American countries and reaches '91 percent of all US Hispanic households through 36 broadcast affiliates and more than 600 cable affiliates' (Subervi-Vélez, 1994: 349). The interesting point here is that this television corporation is simultaneously exposing US 'Latinos' to soap operas, news and other productions from 'Latin' America, and 'Latin' American audiences to news and other programmes that allow them to learn about the lives of 'Hispanos' in the US. Through several programmes it celebrates the national independence days of many 'Latin' American countries, as well as diverse elements of their national identities. It also maintains very good coverage of significant political news in these countries as well as for Hispanos in the US. Both audiences are becoming familiar with each other's daily lives, and both are directly

addressed as 'Hispanos', through some editorial programmes like Noticias Uni-vision, and as Hispanos or Latinos through different programming. From what I have observed personally, these representations have became familiar among, and partially incorporated in the vocabulary of, members of viewerships in at least Argentina, Bolivia, Peru and Venezuela. In this way, Univision is participating as a major player in the making and dissemination of representations of a large trans-national community that is relatively new in the minds of many 'Latin' Ameri-cans. It incorporates thirty million new brothers and sisters from the US – whose existence many had ignored until quite recently – into the already large trans-national community that others have been proposing. This imagined transnational community as represented by Univision speaks Spanish, and therefore does not include the numerous US Latinos who only speak English, nor does it include Brazilians, and again it leaves aside at least those indigenous populations who do not speak Spanish.

Final Remarks

As I said at the beginning of this article, current representations of a US Latina/o identity as well as of a 'Latin' American identity and of an all-encompassing transnational US Latina/o–'Latin' American identity encircle images that according to several social actors' representations obscure differences that are significant.

In order to stimulate reflection and debate I would like to conclude this article by restating something that I already said above: I do not believe that the existence of certain significant assertions of difference may invalidate *per se* any social practices which are based upon or promote representations of a US Latina/o–'Latin' American identity. However, I do think that the existence of these assertions of difference make it unavoidable to think of these identity rep-resentations by means of difference. Explicitly, I state that it is necessary to think of representations of US Latina/o–'Latin' American identity by means of sig-nificant representations of difference, and to adopt a conscious posture towards avoiding homogenizing traps. I am conscious that perhaps this position is not shared by other people, for example, those involved in marketing campaigns who represent these populations as undifferentiated. However, I think that, if one develops a social practice that in any way embodies representations of such an all-encompassing identity, and – at the same time – is aimed at lessening social, political and economic injustices, one cannot avoid thinking such an iden-tity through those assertions of differences, be they related to race, class or socioeconomic status, gender, sexual orientation, local experiences, inter-national and transnational relations of domination, or any other relations of power.

Notes

1 This article is a revised version of the text I prepared as a basis for my lecture as the E.L. Tinker visiting professor at the Institute of Latin American and Iberian Studies at Columbia University, in the summer semester of 1996. This version has benefited from the discussion following that presentation, as well as from the comments and suggestions that some friends and colleagues have made on former presentations of some of the ideas offered in this text. They are Olivia Cadaval, Juan Flores, Néstor García Canclini, Nina Glick-Schiller, Lawrence Grossberg, Richard Handler, Michel Kearney, Agustín Lao, Alberto Moreiras, Marvette Pérez, Federico Subervi-Vélez, George Yúdice and Patricia Zavella – of course, they are not responsible for my opinions and mistakes.

2 'Listen Latino, listen brother, listen friend / never sell your destiny / for gold or comfort / never rest, for we have a long way to go.' 'Proud of his heritage, of being Latino/ of being a united race, as Bolívar dreamt/ Sow: Panama, Puerto Rico . . . Nicaragua without Somoza, *el barrio*, the corner.'

3 'El Barrio' is the name colloquially given by its inhabitants – and many others – to a sector of East Harlem (New York City) predominantly inhabited by Spanish-speaking people. References to 'el Barrio', literally 'the neighbourhood', are also made in a number of *salsa* compositions.

4 I have discussed the ideas of invention and social construction in more detail in Mato (1994a, 1995, 1996b).

References

Acosta-Belén, Edna and Santiago, Carlos E. (1995) 'Merging borders: the remapping of America'. *The Latino Review of Books*, 1(1): 2–11.

Agostinho, P. *et al.* (1972) *La Situación del Indígena en América del Sur*. Montevideo: Tierra Nueva.

Amodio, Emanuel (1996) 'Los Indios metropolitanos'. In D. Mato, M. Montero and E. Amodio (eds) *América Latina en Tiempos de Globalización*. Caracas: UNESCO-ALAS-UCV.

Anderson, Benedict (1991) *Imagined Communities*. London, New York: Verso.

Ardao, Arturo (1980) *Génesis de la idea y el nombre de América Latina*. Caracas: CELARG.

Basch, Linda N., Schiller, Glick and Blanc, C. Szanton (1993) *Nations Unbound*. Langhorne: Gordon and Breach.

Brysk, Alison (1994) 'Acting globally: Indian rights and international politics in Latin America'. In Donna Lee Van Cott (ed.) *Indigenous Peoples and Democracy in Latin America*. New York: St Martin's Press, 29–54.

Chirif, Alberto, García, P. and Smith, R. (1991) *El Indígena y su territorio*. Lima: COICA and Oxfam-America.

Conklin, Beth and Graham, Laura (1995) 'The shifting middle ground: Amazonian Indians and eco-politics'. *American Anthropologist*, 97(4): 695–710.

Fernándes, Florestán (1959) *Brancos e negros em Sao Paulo*. Sao Paulo: Companhia Editora Nacional.

Flores, Juan (1993) ' "Qué assimilated, brother, yo soy asimilao": the structuring of Puerto Rican identity'. In his *Divided Borders*. Houston: Arte Público Press, 182–95.

Flores, Juan and Yúdice, George (1990) 'Buscando América: languages of Latino self-formation'. *Social Text*, 24: 57–84.

Fox, Richard (ed.) (1990) *Nationalist Ideologies and the Production of National Cultures*. Washington, DC: American Ethnological Society.

García-Canclini, Nestor (1989) *Culturas Híbridas: Estrategias para Entrar y Salir de la Modernidad*. Mexico: Grijalbo.

Georges, Eugenia (1990)) *The Making of a Transnational Community: Migration, Development, and Cultural Change in the Dominican Republic*. New York: Columbia University Press.

Giménez, Martha E. (1992) 'U.S. ethnic politics: implications for Latin Americans'. *Latin American Perspectives*, 19(4): 7–17.

Gnerre, Mauricio and Botasso, Juan (1985) 'Del indigenismo a las organizaciones indígenas'. In AA.VV. (*sic*) (ed.) *Del Indigenismo a las Organizaciones Indígenas*. Quito: Abya-Yala, 7–29.

Handler, Richard (1988) *Nationalism and the Politics of Culture in Quebec*. Madison: University of Wisconsin Press.

Herzfeld, Michael (1982) *Ours Once More: Folklore, Ideology, and the Making of Modern Greece*. Austin: University of Texas Press.

Hobsbawm, Eric (1983) 'Introduction: inventing traditions'. In E. Hobsbawm and T. Ranger (eds) *The Invention of Tradition*. Cambridge: Cambridge University Press, 1–14.

Jackson, Jean (1995) 'Culture, genuine and spurious: the politics of Indianness in the Vaupes, Colombia'. *American Ethnologist*, 22(1): 3–27.

Kearney, Michael (1992) 'Beyond the limits of the nation-state: popular organizations of transnational Mixtec and Zapotec migrants'. Paper presented at the 91st Annual Meeting of the American Anthropological Association, San Francisco, 2–6 December.

Keohane, Robert O. and Nye, Joseph S. (eds) (1971) *Transnational Relations and World Politics*. Cambridge, MA: Harvard University Press.

Klor de Alva, Jorge (1992) 'La invención de los orígenes etnicos y la negociación de la identidad Latina'. In Manuel Gutiérrez Estévez *et al*. (eds) *De Palabra y Obra en el Nuevo Mundo*. Madrid: Siglo XXI, Vol. 2: 457–488.

Linnekin, Jocelin (1992) 'On the theory and politics of cultural construction in the Pacific'. *Oceania*, 62(4): 249–63.

Mato, Daniel (1992) 'Disputas en la construcción de identidades y "literaturas orales" en comunidades indígenas de Venezuela: conflictos entre narradores y papel

de investigadores y editoriales'. In *Revista de Investigaciones Folklóricas* (Universidad de Buenos Aires) 7: 40–7.

Mato, Daniel (1994a) 'Teoría y política de la construcción de identidades y diferencias'. In his (ed.) *Teoría y Política de la Construcción de Identidades y Diferencias en América Latina y el Caribe*. Caracas: UNESCO-Nueva Sociedad, 13–29.

Mato, Daniel (1994b) 'Procesos de construcción de identidades en América "Latina" en tiempos de globalización'. In his (ed.) *Teoría y Política de la Construcción de Identidades y Diferencias en América Latina y el Caribe*. Caracas: UNESCO-Nueva Sociedad, 251–61.

Mato, Daniel (1995) *Crítica de la Modernidad, Globalzación y Construcción de Identidades*. Caracas: Universidad Central de Venezuela.

Mato, Daniel (1996a) 'Globalización, procesos culturales y cambios sociopolíticos en América Latina'. In D. Mato, M. Montero and E. Amodio (eds) *América Latina en Tiempos de Globalización*. Caracas: UNESCO-Asociación Latinoamericana de Sociología-UCV.

Mato, Daniel (1996b) 'On the theory, epistemology, and politics of the social construction of "cultural identities" in the age of globalization'. *Identities*, 3(1–2): 205–18.

Mato, Daniel (1996c) 'International and transnational relations, the struggles for the rights of indigenous peoples in "Latin" America and the transformation of encompassing societies'. *Sociotam*, 6(2): 45–79.

Mato, Daniel (1997) 'Culturas indígenas y populares en tiempos de globalización'. *Nueva Sociedad*, 149 (May–June): 100–115.

Mato, Daniel (1998a) 'The transnational making of representations of gender, ethnicity and culture: indigenous peoples' organizations at the Smithsonian Institution's festival'. *Cultural Studies*, 12(2): 193–209.

Mato, Daniel (1998b) 'On global agents, transnational relations, and the social making of transnational identities and associated agendas in "Latin" America'. *Identities*, 4(2): 167–212.

Oboler, Suzanne (1992) 'The politics of labeling: Latino/a cultural identities of self and others'. *Latin American Perspectives*, 19(4): 18–36.

Padilla, Félix (1989) 'Salsa music as a cultural expression of Latino consciousness and unity'. *Hispanic Journal of Behavioral Sciences*, 11(1): 28–45.

Rogers, Mark (1996) 'Beyond authenticity: conservation, tourism, and the politics of representation in the Ecuadorian Amazon'. In Jeremy Beckett and Daniel Mato (eds) *Indigenous Peoples/Global Terrains*, special issue of *Identities*, 3(1–2): 73–126.

Smith, Robert (1992) ' "Los ausentes siempre presentes": the imagining, making, and politics of a transnational community between New York City and Ticuani, Puebla'. *Working Papers on Latin America*. Institute of Latin American and Iberian Studies, Columbia University.

Stavenhagen, Rodolfo (1988) *Derecho Indígena y Derechos Humanos en América Latina*. Mexico: El Colegio de México.

Suberví-Vélez, Federico *et al.* (1994) 'Mass communication and Hispanics'. In Félix

Padilla (ed.) *Handbook of Hispanic Cultures in the United States*. Houston, TX: Arte Público Press, 304–57.

Wagner, Roy (1981) *The Invention of Culture*. Chicago, Ill: The University of Chicago Press (originally published 1975 by Prentice Hall).

Wright, Winthrop (1990) *Café con Leche: Race, Class, and National Image in Venezuela*. Austin: University of Texas Press.

Zea, Leopoldo (ed.) (1986) *América Latina en sus ideas*. Mexico DF: Siglo XXI.

Notes on Contributors

Tony Bennett was Professor of cultural studies and Director of the Australian Key Centre for Cultural and Media Policy at Griffith University when he wrote his article. He has since taken up the position of Professor of sociology at the Open University. His most recent book, *Culture: A Reformer's Science*, is co-published by Allen & Unwin in Australia and by Sage Publications internationally.

Susan Kaiser is Professor of textiles and clothing at the University of California, Davis.

J. Macgregor Wise teaches courses in mass media and theory in the Speech and Communication Studies Department of Clemson University, South Carolina. His book, *Exploring Technology and Social Space*, was published by Sage Publications in 1997.

Daniel Mato is Professor of social sciences and Director of the Program on Globalization, Cultural Processes and Sociopolitical Change at Universidad Central de Venezuela. He has also been a visiting professor at several universities in Latin America and the United States.

David Morley is Professor of communications, Goldsmiths College, University of London. His most recent publication (co-edited with Kuan-Hsing Chen) is *Stuart Hall: Critical Dialogues in Cultural Studies* (Routledge, 1996).

Meaghan Morris is an Australian Research Council Senior Fellow at the University of Technology, Sydney. Having co-edited two cultural studies project journals in the 1970s (*GLP* and *Working Papers in Sex, Science and Culture*) she now edits, with Stephen Muecke, a refereed journal, *The UTS Review*.

Judith Newton is Professor of women's studies at the University of California, Davis.

Kent A. Ono is assistant professor of both American studies and Asian-American studies at University of California, Davis.

Alan O'Shea is Head of the Department of Cultural Studies at the University of East London. He has recently published (co-edited with Mica Nava) *Modern Times: Reflections on a Century of English Modernity* (Routledge, 1996).

Ted Striphas is a Ph.D. candidate in the Department of Communication Studies at the University of North Carolina at Chapel Hill, USA. He is associate editor of *Cultural Studies*.

 © *Routledge 1998*

SPECIAL EDITORIAL

One measure of the success and vitality of cultural studies is the appearance of new journals in the area. This is a very good sign, and one that we welcome. Some of these journals are brand new; others have been around for a little while but have not received the attention they deserve, and still others have been revitalized with new editors or publishers. We encourage readers and subscribers to *Cultural Studies* to check out these journals, both as sources of new material and as possible publication outlets. To that end, we include here the names and contact addresses of some of these.

Angelaki
 managing editor: Gerard Greenway
 contact: 44 Abbey Road
 Oxford OX2 0AE, UK
 e-mail: *greenway@angelaki.demon.co.uk*
Arena Journal (new series)
 editors: John Hinkson, Geoff Sharp and Simon Cooper
 contact: 35 Argyle Street
 Fitzroy 3065, AUSTRALIA
 e-mail: *arena@vicnet.net.au*
European Journal of Cultural Studies (published by Sage)
 editors: Pertti Alasuutari, Ann Gray and Joke Hermes
 contact: Department of Sociology and Social Psychology
 University of Tampere
 PO BOX 607
 33101 Tampere, FINLAND
 e-mail: *sspeal@uta.fi*
International Journal of Cultural Studies (published by Sage)
 editor: John Hartley
 contact: Cardiff University
 Wales Bute Building
 King Edward VII Avenue
 Cardiff CF1 3NB, UK
 e-mail: *IJCS@cardiff.ac.uk*
Journal of Communication Inquiry (published by Sage)
 editor: Mia Consalvo
 contact: W-615 Seashore Hall
 University of Iowa
 Iowa City, IA 52242, USA
 e-mail: *jci-editor@uiowa.edu*

Keywords
 editors: Roger Bromley, Macdonald Daly, Jim McGuigan, Morag Shiach and
 Jeff Wallace
 contact: School of Humanities and Social Sciences
 University of Glamorgan
 Pontypridd, Mid Glamorgan CF37 1DL, UK
 e-mail: *jwallace@glamorgan.ac.uk*
Polygraph
 editors: collective
 contact: Art Museum 104
 Box 90670
 Duke University
 Durham, NC 27708-0670, USA
 e-mail: *polygraph@duke.edu*
Soundings (published by Lawrence and Wishart)
 editors: Stuart Hall, Doreen Massey and Michael Rustin
 contact: Lawrence and Wishart
 99a Wallis Road
 London E9 5LN, UK
Space and Culture
 editors: Rob Shields, Joost van Loon and Ian Roderick
 contact: Box 797, Station B
 Ottawa K1P 5P8, CANADA
 e-mail: *roderick@pathcom.com*
 rshields@ccs.carleton.ca
Topia
 editor: Jody Berland
 contact: Department of Humanities
 Atkinson College
 4700 Keele Street
 York University
 North York, Ontario M3J 1P3, CANADA
UTS Review (published by John Libbey & Co)
 editors: Meaghan Morris and Stephen Muecke
 contact: Faculty of Humanities and Social Sciences
 University of Technology Sydney
 PO Box 123
 Broadway, NSW 2007, AUSTRALIA
 e-mail: *s.muecke@hum.uts.edu.au*

This list is not meant to be exhaustive, so we apologize to those journals we have
left out. We will endeavour to add to this list in future issues.

Special Issue
Cultural Intermediaries
Edited by Sean Nixon and Paul Du Gay

We are planning a special issue of *Cultural Studies* focusing on the role, status and dispositions of cultural intermediaries. These are the group of practitioners and workers – highlighted most notably by Pierre Bourdieu – who provide symbolic goods and services and who are found most prominently in the fields of advertising, design, management consultancy, radio, television and print journalism. They also include a new breed of consultants in areas from marriage guidance to feng shui.

The expansion in numbers and more central role in economic and cultural life of this group of workers has often been cited as one of the distinctive developments in late modern societies. We are interested in papers which explore in both a theoretically informed but empirically grounded way the role played by these practitioners in the circulation of goods and services and the broader aestheticization of everyday life.

Papers which use the analysis of this group of workers to open up questions concerning the relationship between culture and economy, in particular, the cultural constitution of economic practices and identities, would be particularly welcome.

Papers might also consider the relationship between critical intellectuals working in cultural studies and these other experts in culture; the place of cultural intermediaries within an expanding 'social middle'; the role of cultural intermediaries in public and private sector organizations. We are also keen to invite papers which bring a historical dimension into the analysis of this category of person and also to encourage comparative studies of different formations of practitioners.

Papers should be sent to Dr Sean Nixon, Department of Sociology, University of Essex, Wivenhoe Park, Colchester, Essex CO4 3SQ, UK.

Deadline for submission of papers 15 December 1999.

Call for Papers

SPECIAL ISSUE: BECOMING 'HONG KONG' IN POSTCOLONIAL TIMES

As a 'global city' within the Chinese nation-state, Hong Kong today is a curious historical construct. This special issue will interrogate the reconstruction of Hong Kong as a 'postcolonial' cultural space that interfaces with transnational and global culture. It hopes to address these and other relevant questions:

- How is 'postcoloniality' in Hong Kong being defined at the intersection of local and international discourses?
- How is it manifested in cultural terms through popular culture, arts, literary works, urban planning, education, economic discourses and so on?
- What implications are there for the performance of cultural identity and belonging in HKSAR (Hong Kong Special Administrative Region) around gender, sexuality, capital, ethnicity and other political and social realities?
- How can a critical consideration of 'becoming Hong Kong' serve to rearticulate cultural studies as a transnationalist practice located within Asia?
- How can this consideration facilitate an understanding of the various formations of the diasporic communities of Hong Kong Chinese in different parts of the world?

We seek scholars, writers, artists, and/or activists, especially those from Hong Kong or other Asian locales (although not exclusively so), to contribute essays or artworks from a wide range of perspectives and disciplines.
Please send works and inquiries to:
John Nguyet Erni, Special Issue Editor,
Department of Communication, University of New Hampshire, Horton SSC, 20 College Road,
Durham, NH 03824–3586, USA.
Tel: 603–862–3709; Fax: 603–862–1913; email: jne@cisunix.unh.edu

DEADLINE FOR SUBMISSIONS: September 1999.

Call for Papers

Virginia Woolf: Turning the Centuries
June 10–13, 1999
University of Delaware
Newark DE

Directed by Ann Ardis and Bonnie Kime Scott

This conference takes Woolf towards the new millennium by inviting participants to focus on Woolf's work as a feminist historian interested in various periods, transitional markers, disciplinary traversals and on applications of her work to concerns of the 21st Century.

Our interests include Woolf in new perspectives on race, queer theory, sexuality, subjectivity and ecology as well as applications on new electronic media to Woolf studies.

10 copies of 250 word proposals for panels paper, 1 act plays and alternative formats should be postmarked by January 15 1999.

Send to
Virginia Woolf Conference
Department of English
University of Delaware
Newark DE 19716 USA
website: http://www.english.udel.edu/woolf/.

INDEX – VOLUME 12

Articles

Commentary

Reviews